THE PHOTOGRAPH

A Strange Confined Space

THE PHOTOGRAPH

A Strange Confined Space

❖

Mary Price

STANFORD UNIVERSITY PRESS, STANFORD, CALIFORNIA

Stanford University Press
Stanford, California
© 1994 by the Board of Trustees of the
Leland Stanford Junior University
Printed in the United States of America

CIP data appear at the end of the book

Stanford University Press publications
are distributed exclusively by Stanford University Press
within the United States, Canada, Mexico, and Central
America; they are distributed exclusively by Cambridge
University Press throughout the rest of the world.

Original printing 1994
Last figure below indicates year of this printing:
04 03 02 01 00 99 98 97 96 95

To Martin

Acknowledgments

My most enduring debt is to Martin Price, whose sharpness as critic was never blunted by deference to any other role. I profited greatly from his early readings. The Center for Independent Study, a resource for writers, scholars, artists, and translators who are not connected with an institution, has offered steady encouragement. The following past or present members have been directly or indirectly helpful: Roger Baldwin, William Burney, Ellen Chirelstein, Phyllis Crowley, Marlene Demarque, Lila Freedman, Liliane Greene, Ruth Hein, Shelagh Hunter, Eve Ingalls, and Leslie Jackson.

Ellen Graham, June and Jacques Guicharnaud, John Hollander, Joseph Reed, and Patricia Meyer Spacks read all or part of some earlier draft. The criticism of each was generous and acute.

Tom Hricko taught me the procedures of photographing. Alan Trachtenberg has been supportive of my interest in photography for a long time.

Thomas Victor, a New York photographer, some years ago taught a seminar on photography in Silliman College, of which I was then a Fellow. Some of the questions the class raised for me are those I have attempted to deal with here. I owe Tom and the class members thanks.

I must also add general thanks to Paul Pickrel, my predecessor at *The Yale Review*, and to John Palmer, former editor. And among those who set standards, Margaret and Bill Wimsatt.

Trudie Calvert was the able and meticulous copyeditor. Helen Tartar, Humanities Editor at the Stanford University Press, was indeed a humane

editor. John Feneron helped transform the manuscript into a book. I am grateful to everyone connected with the Press for their attention to detail and their interest in the book.

The responsibility for the book, however, belongs to me, O Lord, to me, and to none of the above.

M. P.

Contents

٭

Illustrations

❖

THE PHOTOGRAPH
A Strange Confined Space

1

Introduction

This is a book with two major emphases. The first is that the language of description is deeply implicated in how a viewer looks at photographs. Description may be title, caption, or text. The more detailed the description, the more precisely the viewer's observation is directed. This leads to the second emphasis, that the use of a photograph determines its meaning. The language of description may reveal, impose, or limit use. Descriptions must be tested for accuracy by reference to the actual photograph and, in addition, by reference to its use. A news photograph with a caption will occur first in the daily newspaper but may be exhibited some time later on the walls of a museum with additional or different information. The news photograph will look as it did originally but instead of being seen as news may at the later date be described and consequently seen in terms of, for example, history, sociology, or art. Susan Sontag's greatest insight in *On Photography* is calling attention to use: "As Wittgenstein argued for words, that the meaning *is* the use—so for each photograph."[1] If use determines the meaning of photographs, as I believe it does, no single meaning is absolute. The discovery that differing descriptions and uses are possible ought not, however, to encourage arbitrary interpretations. The range of uses for a single photograph is limited by its visible content. The dark spaces of slum dwellings are never going to be a landscape, portrait, or still life. They are never going to support the environmentalists who want to save the Brazilian rain forests. Use is limited by the image even as the image lends itself to varying uses. What the pic-

ture is *of* limits meaning even while it encourages the exploration of meaning.

The language of description and the uses of photographs can be discussed and illustrated by reference to actual photographs. Actual photographs, however, are not the only source of insight. In some imaginative literature, photographs are described without having any other existence. Within a literary work of the imagination, such as novels by Proust and Robert Musil, a photograph will be described for a *use* implicit in the novel. Photographs can be invented for literary purposes as much as any other novelistic furnishings. Discerning the ideas of photography revealed in described photographs will be an important part of this study. It will be my contention that photographs without appropriate descriptive words are deprived and weakened, but that descriptions of even invented photographs may adumbrate a richness of use that can extend the possibilities of interpreting actual photographs.

Three caveats must be entered here. First, the meaning of *description* in this book is limited to description in words. The possible use I exclude is that way of recording or seeing, called descriptive, applied to the objects and depictions within a photograph. The difference in the two uses is exemplified in the sentence "Walker Evans's photographs are descriptive, but Aaron Siskind's are abstract." Historically, the difference between these two modes of vision has been described as documentary (descriptive) or pictorial (artistic), but for the most part that distinction will not be relevant.

Second, words within a photograph are not what I include in the meaning of description. If such words as the name of a store or a gas station or letters that exist in the scene photographed appear in the photograph, they have a meaning intrinsic to the scene itself. They may be descriptive, but they are also part of what has to be described. So also with words imposed upon the photograph mechanically, like the reproduced signature of a movie star on a publicity photograph, or superimposed words on photographs advertising a product. Practices that have become inert with repetition may be interesting as conventions, but they have little interest as description.

The third caveat is the exclusion of motion picture photography. A still photograph stops time in two dimensions. A moving picture prolongs time in such a way that it must become narrative in what is apparently

three dimensions. Projecting the rapid movement of frames so that the audience sees what looks like real people moving through time is different from isolating a segment of such reality in a still photograph. Light registering on film is the means by which moving pictures are made, and it is usual to comment on the photography in motion pictures as if it were separate from narrative, but such comment is a condition of language. It is impossible to talk about the photography of a movie without giving the impression that it can be separated from the subject. No subject, no narrative movie, would exist without photography, by definition. The photography is inseparable from the narrative except in language. In moving pictures photography serves, and is subservient to, narrative. Photography of motion pictures does not come into being as a discrete element of the final picture. It may be complementary, subversive, or integral to the narrative, depending on how competent the persons involved are. Nevertheless, the end of the moving picture is not the photography but the whole produced completed narrative, of which the photography is a component. To tackle the subject of motion picture photography would involve all the elements of the finished picture. A discussion of still photographs may be helpful as a prerequisite to the more complicated work necessary to explain what is involved in motion picture photography, but that further work is beyond the scope of this book.[2]

In summary, description will refer to language and will not be applied to a choice of subject or technique of photographing. Words inside the photograph will be elements among all other elements to be described. Description and use will pertain only to still photographs.

As soon as description and use are foregrounded, the question comes to mind whether the terms are to be confined to photographs, or whether they are equally necessary categories for, say, painting. The answer is threefold. First, it would be absurd to think description out of place for any work of visual interest. Second, public exhibition is one common use for all works of visual interest, and other uses will occur as the ensuing chapters unfold. But third, a key difference is that a photograph is available for many uses inappropriate for painting. One reason for this is the cheapness and multiplicity of photographs, but the primary reason is that the photograph has a direct and physically governed relationship to the external world of objects.

The camera may be thought of as comparable to the eye. The differ-

ence is that the camera is not more than an eye. It does not think. Any connection with judging, choosing, arranging, including, excluding, and snapping has to be with the photographer, or, in such special cases as aerial photographs, the programmer of the camera for the purpose required. Because of the disjunction between the thinking, seeing photographer and the camera that is the instrument of recording, the viewer finds it more difficult than with other visual artifacts to attribute creativity to any photographer. In the next chapter this disjunction will appear as a symptom of inauthenticity assumed whenever a machine is interposed between maker and artifact.

In most contemporary circumstances, the convention of the photograph will be made clear by a setting governing the expectations of the viewer. In a newspaper, photographs of action or situation will be expected and found; in a gallery, photographs that are presumed to have intrinsic visual interest; in a snapshot album, snapshots; in a book, photographs of visual interest complementing or illustrating a text. These examples are so commonplace, and they and other examples so numerous, that it seems almost unnecessary to think about them. They are part of the context of everyday life. I shall try to make it interesting to think about them, beginning with the problem of description.

Arthur Danto, in *The Transfiguration of the Commonplace*, sets the problem of description brilliantly.[3] He formulates the possibility of two identical photographic negatives with different relations to their subjects. His photographs look the same but, according to Danto, are actually of different subjects. His point is that it takes more than visual resemblance to postulate identity of cause, or subject. In *paintings* that look identical but have different subjects, the differences, unseen but real, have to be described in order to establish the facts; these paintings are not to be seen as copies or duplicates. It is as possible to conjecture that photographs will be identical in appearance as it is to conjecture that paintings will appear identical even though they happen to be of different external subjects.

Danto's witty proposition is that if red squares of paint identical in appearance but differently described in each case constitute separate entities, purportedly conceived in isolation, then each will be viewed with responses conditioned by the descriptions. The red squares he proposes are the following:

1. The Israelites crossing the Red Sea.
2. A work entitled "Kierkegaard's Mood," inspired by the knowledge that the first painting was described by Kierkegaard, who explained that "the Israelites had already crossed over, and the Egyptians were drowned."
3. "Red Square," a Moscow landscape.
4. A minimalist painting also called "Red Square."
5. "Nirvana," a metaphysical painting based on a knowledge of Indian beliefs.
6. "Red Table Cloth," by a pupil of Matisse.
7. A canvas grounded in red lead, prepared by Giorgione for a work never painted.
8. A piece of canvas painted red.

To this list Danto adds an example by a political painter with egalitarian attitudes who insists that his painting, "Untitled," which strongly resembles the other red paintings, be included. Which of the works is a work of art is the question Danto sets himself, as well as how he will decide. What seems most useful to me is how the act of description governs the associations necessary for looking at each one. Description provides the interpretation.

If description is necessary to complete the meaning of a photograph or to interpret the visual aspect by identifying its elements in words, the question might arise of who is qualified so to describe. The answer is, Anyone who is persuaded to look. Descriptions will be more or less competent, sophisticated, accurate, and useful. Accuracy is checked by reference to the visual evidence. In the case of Walter Benjamin's comment on Atget, that he photographed deserted Paris streets for the purpose of establishing evidence, as if they were scenes of crime, this is a spectacular bit of special pleading that does not persuade by reference to the actual photographs of the actual deserted streets; it persuades because the idea of absence is so powerful that one believes Benjamin in spite of the evidence rather than because of it. Benjamin imposes a political explanation, which may not be acceptable at all. His putative "Israelites crossing the Red Sea" can be, in another descriptive interpretation, "Kierkegaard's Mood." It just happens that no one has yet written that description.

Describing is necessary for photographs. Call it captioning, call it ti-

tling, call it describing, the act of specifying in words what the viewer may
be led both to understand and to see is as necessary to the photograph as
it is to the painting. Or call it criticism. It is the act of describing that en-
ables the act of seeing.

For painting, descriptions may verify facts relevant to the subject. A
diachronic account of St. Sebastian gives a norm to which one can speak
of an artist's conforming or from which he departs. This belongs to the
history of ideas. In the history of art another vocabulary of description
belongs to the chemistry of paint, optical knowledge, and other scientific
considerations. Social aspects are reflected in speculation about how a
work will be received on the market, in the museum, or in the gallery.

These already categorized aspects of art apply as well to photography,
not because I claim the designation of art for photography but because
photographs are in fact, if not by necessity, treated the same way as paint-
ings. Photographs are hung on the wall both at home and in museums;
their market value is increased by limiting their production; book pub-
lication is designed to separate them from the mundane snapshot or the
commonplace news photograph.

Yet the difference between painting and photograph is more than the
difference between those visible and intelligible physical differences,
paint and emulsion. The essential difference is that the photograph has
the causal connection with the world of objects that allows it to hold in
fixed form the piece of the world a photographer chooses and also re-
stricts him to such a piece of the world. There are no unicorns in the pho-
tograph, and if one occurs, disbelief is imperative. The explanation will
not occur in the world of fact and object but in the world of mind and
deception. That photograph will be an arranged fake, intentionally de-
signed for the gullible viewer. Understanding and trust in the process of
photography depend on belief in the integrity of the causal connection,
but a simple belief in that connection is inadequate to explain what ap-
pears in the photograph.

Contemporary critics writing about photography discuss the one-to-
one causal relationship between objects and print in terms such as *index*[4]
and *transcription*.[5] Photographs are without code.[6] All three terms, *in-
dex*, *transcription*, and *without code* refer to a neutral, affectless, phys-
ical impression of light on film, without reference to an operative cause,
that is, without reference to human control. They eliminate the element

of metaphoric instrumentality implied by the most famous phrase in the history of English photography, William Henry Fox Talbot's "pencil of nature."[7]

Transcription is the neutral term and the most exact way of thinking about the removal of an impression from objects to film. If a photograph suggests representation, it is because it has an analogic relationship to painted subjects. A portrait has primary identity in being *of* somebody; the physical being is the same whatever the medium. Secondarily, the portrait is an example of its medium and technique. The "reality" the painter creates is a combination of the attributes and appearance of the subject with the stubborn resistance of a separate vision, the artist's own. Although the photographer's vision may discern the same "reality" as the painter's, use the same effects of light, and value the same qualities of both character and appearance, it is subject to such different restrictions of time and material that the quantitative differences make a qualitative difference. Thus it is that Stanley Cavell can say: "I am . . . asking that we ask . . . what a photograph is, and I feel you are missing its strangeness, failing to recognize, for example, that the relation between photograph and subject does not fit our concept of representation, one thing standing for another, disconnected thing, or one forming a likeness of another. . . . A representation emphasizes the identity of its subject, hence it may be called a likeness; a photograph emphasizes the existence of its subject, recording it, hence it is that it may be called a transcription."[8]

Although transcription is direct, a discrepancy may be remarked between reality as it is perceived by any viewer and the photograph of that reality. The discrepancy in perception will be expressed by differences in description and interpretation. Directness is therefore no guarantee that viewers will agree on the meaning of the photograph. The relationship between the external world and the photograph has not been clear and innocent in spite of Fox Talbot's description of light on emulsion as the pencil of nature, an instrument of light directly inscribing itself on the receptive paper.

Transcription is one thing standing in a necessary, not in an invented, conceived, or imagined relationship to another, and is a name for the relationship between the external world and the photograph. I find *transcription* the most useful term because it suggests the schematic diagrams showing lines going straight from object through camera lens to plate or

film, a literal cross-writing. *Indexical*, which refers to the same phenomenon, contains no visual image unless its connotation of pointing to the object becomes explicit. Whichever terms are used, they can be applied to the whole body of still photography without regard to period or inventions because the reaction of light-sensitive surface to light is the same for the daguerreotype as for the Polaroid and for all the physical and chemical photographic inventions between.

The third term, *without code*, is purely formal or theoretical. It is useful in specifying an apparent lack of context for random segments of reality "caught," "taken," or "captured." Uncertainty of signification is then interpreted as lack of signification. But in actually looking at, talking about, or writing about photographs, viewers both discern codes by identifying the codes into which the objects caught, taken, and captured can be fitted and identify their own codes by the structure of their discourse. Descriptions and uses will be coded.

The following two statements, or rather statement and counterstatement, illustrate how far apart approaches to photography may be.

The first is from Roland Barthes's *Camera Lucida: Reflections on Photography*. The occasion for these reflections was the death of Barthes's mother, much loved and mourned. He set out to find a photograph of her, among the many taken during her lifetime, that would give him back some sense of her being. His meditation on the meaning of photographs is the subject of *Camera Lucida*.

The realists, of whom I am one and of whom I was already one when I asserted that the Photograph was an image without code—even if, obviously, certain codes do inflect our reading of it—the realists do not take the photograph for a "copy" of reality, but for an emanation of *past reality: a magic*, not an art. To ask whether a photograph is analogical or coded is not a good means of analysis. The important thing is that the photograph possesses an evidential force, and that its testimony bears not on the object but on time. From a phenomenological viewpoint, in the Photograph, the power of authentication exceeds the power of representation.[9]

The second statement, specifically commenting on Barthes, is by John Tagg:

At every stage, chance effects, purposeful interventions, choices and variations produce meaning, whatever skill is applied and whatever division of labour the

process is subject to. This is not the inflection of a prior (though irretrievable) reality, as Barthes would have us believe, but the production of a new and specific reality, the photograph, which becomes meaningful in certain transactions and has real effects, but *which cannot refer or be referred to a pre-photographic reality as to a truth*. The photograph is not a magical "emanation" but a material product of a material apparatus set to work in specific contexts, by specific forces, for more or less defined purposes. It requires, therefore, not an alchemy but a history, outside which the existential essence of photography is empty and *cannot deliver what Barthes desires: the confirmation of an existence; the mark of a past presence; the repossession of his mother's body.*[10] (Emphasis added.)

These statements cannot be reconciled even though they are not altogether contradictory. Reconciliation would involve establishing facts, whereas facts are precisely the source of disagreement. Barthes says the photograph is a magical emanation; Tagg says it is not. Barthes says the photograph is evidence of something existing in the past; Tagg says it is evidence of something to be determined by investigation of material history and use.

Tagg's argument would be perfectly understandable if only he did not insist on denying Barthes's argument. One difference between the two statements is that Barthes is subtle, poetic, and at home with both imagination and imaginative language, whereas Tagg seems afraid that if he entertains Barthes's imaginative construal of the photograph he will relinquish both contingency and specificity.

If one thinks of that straight line from object through lens to photograph, with indexical correlation, that transcription, the question arises, How can Tagg say the photograph "cannot refer or be referred to a pre-photographic reality as to a truth"? Is the line not straight? Yes, the line is straight; the idea of transcription can be kept, and it will correspond to fact. Fact in turn, to become meaningful, requires interpretation, context, and correspondence to other facts. Tagg's "reality" and Barthes's "authentication" can both refer and be referred (by means of the imagined straight line) to the pre-photographic scene. Tagg's two realities are, first, the irretrievable original scene, and second, the new and specific reality, the photograph—the first, I would say, transcribed into the second. Barthes's term, *authentication*, is the confirmation of meaning not in the represented scene itself, not in Tagg's new and specific reality, but in the photograph as evidence that the scene at one past time existed. Tagg's de-

nial that Barthes can identify the very portrait of his mother that restores the sense of her being (not, as Tagg has it, "the repossession of his mother's body") is outside the possibility of reference to truth. The *truth* of reference can be only to the representable world, in which objects (and the mother) can be pointed to, not to a realm of imagination, where what Barthes says is true *is* true because he has created and experienced that realm and conveys its use to his readers. Barthes is occupied with a passionate demand for a sign from the grave, but the search, as he well knows, takes place in his imagination ("So I make myself the measure of photographic 'knowledge' "[11]).

Tagg believes that the meanings of a photograph are revealed by the bias of interest and also that disclosure of interest is governed by the intended use of the photograph. His difference with Barthes lies in the claim for use of the photograph; either use seems to me defensible: the personal, phenomenological use by Barthes, or the institutional, materialistic use postulated by Tagg. No difference exists in the insistence on the need for interpretation; no difference exists in the belief that the photograph registers objects by means of transcription; no difference either in the belief that the objects interrupting the light existed. Tagg places the difference in their respective definitions of the problem. "The problem is historical, not existential," he insists, and continues, "To conjure up something of what it [the problem] involves today, I suggest in the text that you ask yourself, and not just rhetorically, under what conditions would a photograph of the Loch Ness Monster (of which there are many) be acceptable?"[12] The Loch Ness monster as an example is different from the unicorn because many people do believe there is such a monster, whereas no one believes in a unicorn.

No photographs would ever be acceptable as proof of the monster's existence to those convinced that no such monster exists. For those who believe the monster exists, no proof is necessary, and a photograph simply confirms belief. But this only makes problematic the use of the photograph as "evidence." When faith is involved, evidence is unwanted. Tagg writes: "The very idea of what constitutes evidence has a history—a history which has escaped Barthes, as it has so many labourist and social historians too. It is a history which implies definite techniques and procedures, concrete institutions, and specific social relations—that is, re-

lations of power. It is into this more extensive field that we must insert the history of photographic evidence."

According to Tagg, the function of evidence is circumscribed by the institutional realms of law and law enforcement. The meaning of the photograph is determined by what he says "exceeds representation" and therefore by definition "cannot be articulated." In his case the visible material photograph is the "representation" and the abstractions ("law," "enforcement") are what cannot be "articulated visibly." Use beyond the apparent photograph itself is determined by institutional purposes which involve power structures and the relations of power. The relevant codes are outside the photograph and inside social structures.

Tagg's example of the evidential photograph concerns slum clearance. The photographs taken on behalf of a health authority to demonstrate crowded, insanitary conditions are interpreted as showing these conditions even though the effect may have been achieved by the photographer's manipulation of lens, light, or angle of view.[13] Tagg does not doubt that the photographs were of the slums in question, but he claims that they must be fitted into the codes of interest and that the interpretation by the owner, who wants to maintain the status quo, representing the power structure of landlords, is different from that of the health authority, who wants to let in light and air, representing tenant interests. Interpretation of evidence arises with motives of institutional interest.

Legal evidence is different from phenomenological evidence. The *use* made of photographs must in every case be sustained by interpretation. So one may fully concur in the belief that a photograph does not have an inherent self-evident fixed meaning. But neither does it have a wholly arbitrary meaning. The limits of interpretation are determined by what can be seen in the photograph. The codes invoked, however, seem to be without limit, as Victor Burgin illustrates seriously and David Lodge illustrates parodically.

Victor Burgin, photographer, writer, and teacher, employs the vocabularies of linguistics and semiotics to construct interpretation of photographs based on the terms of classical rhetoric. Similarity (expressed as a simile) may occur, for example, in an advertisement showing cigarettes next to a cup of coffee topped with whipped cream. The message is, "These cigarettes are like (taste as 'smooth' as) cream." In another mes-

sage interpreting cigarettes pictured with a sheaf of wheat: "These ciga-
rettes are like (are as wholesome as) bread baked from natural ingredi-
ents."[14] The simile is the least complicated illustration of his interpretative
code. Other illustrations are no more difficult to understand, although
they have unfamiliar names, among them epitochasm (a figure of accu-
mulation signifying abundance and disorder) and antanaclasis (repeti-
tion with different significations, or one repeated picture with different
captions).

David Lodge has a charming parody of this kind of thinking in his
novel *Nice Work*. A comic confrontation occurs between a young woman
lecturer in English literature, Robyn Penrose, at the fictional University
of Rummidge, and a local factory manager, Victor Wilcox. An admin-
istrator in the university conceives a town-gown goodwill interchange of
ideas, and Robyn is assigned to follow Victor around on Wednesdays.

One Wednesday, as Victor, accompanied by Robyn, drives to an ap-
pointment, they see along the road a billboard advertising Silk Cut cig-
arettes. (Whether the advertisement is a photograph is not clear, but for
purposes of illustrating a vocabulary of interpretation it makes no dif-
ference.) Out of irritation with Victor, and perhaps out of professional
compulsion, Robyn analyzes the ad. Victor "felt his whole philosophy of
life was threatened by Robyn's analysis of the advert." She must have a
twisted mind, he says. Her analysis: "It was in the first instance a kind of
riddle. That is to say, in order to decode it, you had to know that there
was a brand of cigarettes called Silk Cut." Note that it is taken for granted
a code exists, not *in* the visible billboard but in what it depicts.

The poster was the iconic representation of a missing name, like a rebus. But the
icon was also a metaphor. The shimmering silk, with its voluptuous curves and
sensuous texture, obviously symbolized the female body, and the elliptical slit,
foregrounded by a lighter colour showing through, was still more obviously a va-
gina. The advert thus appealed to both sensual and sadistic impulses, the desire
to mutilate as well as penetrate the female body.

The conversation in the car ends with Victor saying, "I can't take any
more of this. D'you mind if I smoke? Just a plain, ordinary cigarette?"[15]

The use of abstract language played off against the ordinary language
of the outraged practical man creates a brilliant comic effect that illu-
minates the opaque solemnity of many theoreticians, including Robyn.

This is not to say that her analysis is incorrect or foolish, although the only verifiable element is the rebus, the picture (icon) showing a flow of highlighted silk in which there is a cut. Victor refuses her Freudian elaboration and makes clear that the subliminal suggestions in the ad of sex, beauty, and sensual pleasure are sharply separate from his smoking a cigarette.

To these insights into public images attributable to history and science (Tagg) or semiotics (Barthes, Burgin, Lodge) can be added those of sociology in the work of Erving Goffman. Goffman refers to the "systematic ambiguities that characterize our everyday talk about pictures." The most ambiguous or confusing locution is "of," that is, what is meant when a picture is "of" something.[16] The photograph is "of" its subject, which may be not simply still life, building, landscape, animal, or figure (person, place, or thing), but *condition*. If the photograph is "of" a person, the subject and condition may be the same. The condition may be one of modeling if an advertisement showing a person is significant primarily in respect to the clothes worn. Or the condition may be portraiture if the person depicted is the important element.

Goffman, in analyzing gender characterizations in advertising photographs, identifies the pose of figures with tilted or bent heads as the "canting posture": "The level of the head is lowered relative to that of others, including, indirectly, the viewer of the picture. The resulting configurations can be read as an acceptance of subordination, and expression of ingratiation, submissiveness, and appeasement."[17] Goffman's illustrations of the canting posture in ads are mostly women with heads bent. One, however, is a drawing of a female dog in the body cant position from Charles Darwin's 1872 *On the Expression of the Emotions in Man and Animals*. Goffman's humor is sardonic.

In the explanations of the advertising images evoked above, from Robyn Penrose's to Darwin's dog, the subject is not the same as the model. The subject of the Silk Cut cigarette ad is a comparison, the implicit simile between silkiness and smoothness of feeling and the taste of the cigarette. The drawing of Darwin's dog has, for subject, posture and sex, not breed or why the dog is cringing. Nor is the subject the same as the model in the photographs of slums cited by Tagg. The photographs were taken not just of specific buildings that provided extremely poor living conditions for tenants but of such areas or buildings that could present (and could be

represented as presenting) the *problems* of slums, that is, unclean, un-healthy living conditions; not bricks and stones and spaces but darkness, shabbiness, and meanness, which could be interpreted as filthy and in-sanitary conditions. Thus, as Tagg points out, the slum owners and the sanitary commissioners advocating clearance willfully saw, in the same photographs, contradictory meanings.

Concealed in the question of what the picture is *of* is the question of the photographer's intention, as one can see in Tagg's discussion of slum photographs. Although Tagg maintains that material objects transcribed onto paper in the form of the photograph have only the meaning that an interpreter purposefully gives them, he does not account for the fact that the very existence of the photograph argues an intention and that some-times the intention of the photographer is the same as that of the inter-preter or viewer. They may be the same person. The interpreter, in Tagg's view, is a rhetorical persuader who ruthlessly insists on the accuracy of slanted terms of persuasion.

To the historian, semiologist, novelist, and sociologist must be added the moralist Susan Sontag. Sontag agrees with Tagg and Burgin that the power of photographs is great and also that photographs greatly mislead. Instead of blaming the rhetorical persuader, decoder, and critic, with their ambiguities of language, she blames the photographer. According to Sontag, W. Eugene Smith cruelly made a beautiful photograph out of human deformity caused by mercury poisoning in Minamata.

The photographs that W. Eugene Smith took in the late 1960s in the Japanese fishing village of Minamata, most of whose inhabitants are crippled and slowly dying of mercury poisoning, move us because they document a suffering which arouses our indignation—and distance us because they are superb photographs of Agony, conforming to surrealist standards of beauty. Smith's photograph of a dying youth writhing on his mother's lap is a Pietà for the world of plague victims which Artaud invokes as the true subject of modern dramaturgy; indeed, the whole series of photographs are possible images for Artaud's Theater of Cruelty.[18]

The factual error in this account is that the young person writhing in the mother's lap is female. The power of the Christian narrative is so strong that any grown person lying face up on the lap of a woman is called a Pietà. The theater of cruelty, the Pietà, and the deformity of the young woman are references to violence, which the Pietà moralizes and cele-

brates. The deformity, a direct result of mercury poisoning, is unacknowl-
edged and indirect violence because, although before the mercury poi-
soning was identified deformity seemed a result of natural causes, when
the deformities were diagnosed as preventable, the management of the
company discharging the poison into the waters refused to acknowledge
responsibility. The photographer did well to expose the sequence. Son-
tag's objection to Smith's photographs, the "Pietà" in particular, lies in
the perfection of his work, her fear that aestheticizing will destroy,
weaken, or contradict the moral-political lesson.[19]

The personal human character of the photographer is subject to all the
descriptive adjectives appropriate for any human being. To emphasize
this is necessary because Sontag's discussion of the morality of the pho-
tographer's ethical position or action in photographing poses a false
choice. She begins: "Photographing is essentially an act of noninterven-
tion." So far, so good. When taking a picture, particularly an action news
photograph, the photographer is not entering or altering the conditions
of the photograph. Sontag continues:

Part of the horror of such memorable coups of contemporary photojournalism as
the pictures of a Vietnamese bonze reaching for the gasoline can, of a Bengali
guerrilla in the act of bayoneting a trussed-up collaborator, comes from the
awareness of how plausible it has become, in situations where the photographer
has the choice between a photograph and a life, to choose the photograph. The
person who intervenes cannot record; the person who is recording cannot inter-
vene.[20]

In most cases, the photographer is not choosing between a photograph
and a life. The choice is not between intervention and nonintervention
but between photographing and not photographing, if, in a situation
where a photographer is present, not photographing might seem the eth-
ical decision. Some photographers have walked away from the horrors
they saw without taking pictures. Others have taken pictures (of the Ben-
gali murders, for example) and documented the horrors. After the Hills-
borough football disaster in the summer of 1989, the British Press Coun-
cil ruled that the business of a photographer was to take pictures.
Whether to publish them is a separate question. At Hillsborough, people
were crushed to death against a wire fence by pressure from behind. The
council ruled that intimate close-ups of dying people should not have

been published but that more distant viewpoints, in which individuals could not be distinguished but their predicament was clear, were appropriate to publish. The decision had to do with the suffering and right to privacy of families, as well as useful public lessons of prevention, not with the ethical decision of the photographers.

Intervention is not feasible and probably not useful for professional photographers in most of the extraordinary situations they encounter— not useful for the victims as well as not useful in the event. A photographer who intervened might well become one of the victims, and although the photographer might suffer or die with a consequently clear conscience, a private conviction of righteousness is no help for other victims, whereas a picture might have public effect. This is not to suggest that intervention is always either impossible or infeasible, only that it should form no part of the role of photographer, who, *qua* photographer, is a witness and recorder, not, properly, an actor.

In real life, in immediate situations, distinctions become blurred. Interventions occur in non-life-threatening situations to heighten what will become the emotional effect of the picture. Such possible interventions (posing figures on the battlefield, shifting the positions of the dead, shouting to public figures so that they will look in a certain direction) are conventions of photographic practice. It is the responsibility of the viewer to interpret a photograph with the sophistication acquired through knowing how intervention of this kind might have occurred and deciding what difference intervention makes.

Extreme situations, such as war and its aftermath, are recorded in various ways. Liberation of the German concentration camps after the Second World War was treated in the early 1950's, before memories and survivors had become public, with a lightly ironic attitude inconceivable in the later twentieth century.

Randall Jarrell's refugee Jewish Austrian professor of music in *Pictures from an Institution* says about "the killing of six million European Jews":

"I can understand killing them. We have our faults. Six million Jews are, after all, six million people." But then his face distorted itself into vivacity, and he exclaimed: "But those poor *gipsies*! What had *they* done?—told people's fortunes, stole people's cows. When I heard that Hitler had killed them all, I thought like Peer Gynt, 'Nature is witty, oh so witty—but economical, no, that she isn't!'

Imagine! The *gipsies* of Europe! It is hard for me not to say: 'I do not want to live in a world that has killed off all the gipsies.'"

The narrator calls this attitude Dr. Rosenbaum's detachment, but Jarrell has accurately caught the self-deprecation and displacement of pain, even the tact of his character in not forcing his audience to face the gross horror. Another character in the novel, a young girl,

> could not help feeling that the Russian-ness and Austrian-ness and Past-ness of the Rosenbaums were of the same use to them that they were to her, just as we look at an old photograph and feel that the people in it must surely have had some intimation of how old-fashioned they were, of the fact that their problems were not *really* problems—we feel this even when the photograph is a photograph of corpses, strewn in their old-fashioned uniforms along an old-fashioned trench.

Although the first quotation from Jarrell was about the Holocaust, the second characterizes the pastness of the photograph. It is not a photograph of a concentration camp but of a First World War trench, with dead soldiers. Jarrell catches the young girl's naïveté in investing the photograph with her own feelings of remoteness from the subjects, whether the remoteness is of time, geography, or death.

Not all young girls after the Second World War were so unsophisticated. Susan Sontag says about her first encounter with concentration camp pictures at the age of twelve that it was "a negative epiphany." "Nothing I have seen—in photographs or in real life—ever cut me as sharply, deeply, instantaneously. Indeed, it seems plausible to me to divide my life into two parts, before I saw those photographs (I was twelve) and after, though it was several years before I understood fully what they were about. . . . Some limit had been reached, and not only that of horror; I felt irrevocably grieved, wounded, but a part of my feelings started to tighten; something went dead; something is still crying." Still, she says, the effect wears off. "The vast photographic catalogue of misery and injustice throughout the world has given everyone a certain familiarity with atrocity, making the horrible seem more ordinary—making it appear familiar, remote ('it's only a photograph'), inevitable."[21] Yet the broad response to the 1980's famine in Ethiopia was activated by photographs. Reports of the famine had appeared in the back pages of newspapers for at least two years, quietly ignored, before the stunning pictures of the gaunt, weary, barefoot men, women, and children walking in the dry,

sandy landscape toward an uncertain destination appeared on television and in newspapers. Money and supplies, governmental and private, poured into Ethiopia from the Western world. How it was used, whether it helped, what the ultimate solution to the problems of famine (if any) should be are not at issue here. The point is that in 1984–85 pictures of starving people aroused strong emotions and generous responses when the bare fact of starvation, unaided by the imagination, had not. Nor need one minimize the effect the pictures taken in Vietnam had on popular attitudes toward that war. The United States seemed at times to be making war primarily on children, stripped of clothes by blast or fire, who ran screaming toward us on a naked road from a distant land.

Sontag goes further in her analysis of the knowledge entailed by photographs. "It will be a knowledge of bargain prices," she says, "—a semblance of knowledge, a semblance of wisdom; as the act of taking pictures is a semblance of appropriation, a semblance of rape."[22] Appropriation, rape, and killing (if one insists on snapshot literally) are acts of violence. The perpetrator, to use a police term, is the photographer, the victim the scene or person photographed (appropriated, raped, or shot). If perpetrator and victim are the first two terms, the third term, neutrally the spectator but in this case more appropriately the witness (as one says witness to the crime), must also be a victim, deluded if not willingly duped. The language itself condemns the photographs: "knowledge" is a high value but "semblance of knowledge" a deception; "wisdom" is a high value, "semblance of wisdom" self-deception.

But if one identifies the rhetoric of pejorative vocabulary—appropriation, rape, snapshot—and also the rhetoric of "semblance," implying the phantasmal, the inauthentic, the copy or reproduction of something trying to pass itself off as an original, one discovers that judgment has been passed before the argument is made.

Some news photographers and paparazzi by definition can be, if thwarted, unpleasantly aggressive. So their behavior, in abstracting from a subject an image with which the subject does not wish to part, fits at least the description of appropriation. To compare it to rape seems to trivialize actual rape and overstate what takes place even on the part of an aggressive photographer. "It will be a knowledge of bargain prices," Sontag says, implying this time not a tawdry likeness but a devaluation. These

are severe pronouncements on the whole of photography for what in fact are limited instances. Sontag's description stacks the cards.

Still another field claiming interest in photography is art history. Rosalind Krauss uses the term "world of the simulacrum" to describe photography as creating a world in which "the possibility of distinguishing between reality and phantasm, between the actual and the simulated, is denied." Within the Platonic conception of the real world as a copy of an ideal world, it follows, for Krauss, that the photograph is a copy of a copy, or even a "false copy": "As I have said, at a certain point photography, in its precarious position as the false copy—the image that is resemblant only by mechanical circumstance and not by internal, essential connection to the model—this false copy served to deconstruct the whole system of model and copy, original and fake, first- and second-degree replication." She concludes that "there *is* a discourse proper to photography; only, we would have to add, it is not an aesthetic discourse. It is a project of deconstruction in which art is distanced and separated from itself." Aesthetic difference, according to Krauss, would mean judgments of "this is good, this is bad, this, in its absolute originality, is different from that," judgments meaningless to make about photographs.[23]

The argument leads to the conclusion that Cindy Sherman, who takes photographs of herself in costumes and poses parodying movie stills and various other advertising images recognizable because of their prevalence, is undermining "the very distinction between original and copy" and thus properly exposing the dependence of copy on original.[24] Others might think in the same terms of Roy Lichtenstein's depiction of comic strip characters enlarged to monumental size and painted with outlines and dots intended to reproduce the techniques of printed comic strips. He is not undermining the distinction between original and copy but emphasizing it, inserting what might otherwise be called "copy" into the world of art, separating it from, at the same time he is referring to, the world of popular culture, the comic strip. The ways the words *original* and *copy* are used differ in emphasis from Krauss's example of Sherman to the example of Lichtenstein. Krauss wants to use a Platonic model: "The whole idea of the copy is that it be resemblant, that it incarnate the idea of identity—that the just man resemble Justice by virtue of being just—and in terms of this identity that it separate itself from the condition

of injustice." But to use the Platonic ideal form, which is abstract not least in the sense of being nonvisual, as the original of a model for the copy, the copy being the visible world, and then to claim that further copies in the form of visual images are not only once-again-removed but very possibly false copies, seems to me to treat the philosophic conception of ideal form as if it were an actual form. It is a mistake to insist that photographs are not in a most literal sense related to and transcribed from their physical subjects. Krauss describes the enumerative description of photographs as useless because such description can only be "a potentially endless list of possible subjects." It reflects, this argument runs, an undifferentiated world.[25]

It is difficult to imagine conceptual interpretation of photographs before naming what is seen in literal description. Nor are the conceptual interpretations necessarily the more interesting. They are interesting only if they reinforce the visually nameable elements, the subject(s), in such a way as to preserve the double vision of literal and conceptual; they are not interesting when they substitute abstractions for subjects.

In the next chapters, the problem of defining the value of a photograph is engaged. The problem does not concern commercial, monetary, or market value; the emphases will be on the actual or potential use of a photograph; on the concept of the photograph's returning the gaze of the viewer (for full discussion, see p. 142); and on the necessity of description as interpretation. Some testimony in Chapter 2 modifies the incorrect formulation of hand-creator versus mindless machine so that a photograph can be understood as an expression of mindful intention. Walter Benjamin's complex metaphor of aura, applied both to a work of (handmade) art and to the photograph, then introduces both a powerful metaphor and Benjamin's influential essays on photography. In Chapter 4 I challenge Benjamin's contention that works of art do not require titles whereas photographs do. Actual descriptions of photographs follow in order to show that descriptions modify and enlarge interpretation and often establish the use of photographs. Chapter 6 gathers together many definitions of the photograph in which "mask" is the metaphor invoked. Chapter 7 begins with a quick look at the history of reflective images (mirror, water) and continues with an amplification of Benjamin's use of aura, the returned gaze, and memory. Then I look at the imaginative use of photograph as metaphor in works of literature by Proust, Robert Lowell, Ro-

land Barthes, and Robert Musil. Chapter 9 concludes that although no photograph has the sacred aura of the unique work of art, many photographs have a secular aura constituted by use, familiarity, description, and interpretation. These considerations will, I hope, add depth to the way a viewer looks at photographs.

2

Presence of Mind

When the camera is thought of as merely a mechanical instrument, then its opposite, the hand, becomes the symbol of an artist's individual creativity. In the distant past all manual labor was the symbol of low, humble, and nonintellectual occupation. Plato did not value manual labor and did not differentiate between art and other manual labor. "Painters and sculptors hardly ranked higher than slaves. . . . Artists are mentioned in the company of barbers, cooks and blacksmiths. In . . . *Alcibiades*, architects, sculptors and shoemakers are lumped together as manual workers. . . . The stigma attached to the visual arts [in Platonic tradition] was never fully overcome in the ancient world."[1] According to Rudolf and Margaret Wittkower, both social (the slave and the artisan were at the bottom of the social structure) and philosophical issues account for the lack of discussion in antiquity of matters that in a period of comparable artistic achievement, the Italian Renaissance, were the subject of lively public interest and extensive documentation.

Edgar Wind points out that Federigo da Montefeltro, the Renaissance duke of Urbino, would not allow a printed book with woodcuts, as opposed to illuminated manuscripts, in his library. "For him the act of reading a classical text was desecrated by the contemplation of the printed page," this to illustrate, according to Wind, the "old belief that art is degraded by mechanization." The printed book made to look like a manuscript was an unacceptable version of a text that lacked the authenticity of the unique handmade copy. Wind goes on to say that Henry Adams's antithesis between the Virgin and the dynamo is "one of those facile and

fallacious disjunctions by which we get trapped when we regard art as naturally opposed to mechanization."² The splendid epithets "facile and fallacious" applied to the disjunction between art and mechanization locate the emphasis I seek.

The argument that art is naturally opposed to mechanization comes up again in Walter Benjamin's essay "The Work of Art in the Age of Mechanical Reproduction."³ The very title of the essay has a downward tilt. Benjamin's opposition of art to mechanization depends on the high value attached to manipulation of materials in the creation of art, thus high regard for the hand, the aura of tradition then accruing to the work, and its depreciation in value when it can be reproduced in an indeterminate number of copies. Benjamin's point is the same as Federigo's.

Benjamin's first argument is that an original work of art establishes authenticity. He excludes from authenticity all kinds of reproduction, from architecture in photographs to recordings of musical performances to moving pictures. Benjamin's conception of authenticity is that it is apparent and unquestioned, acknowledged by virtue of physical place, where everyone knows the work always has been, or by tests, if there is a question of substitution or forgery. A direct connection must exist between artist and work, proved authentic by signature, style, or history. The philosopher Nelson Goodman, in his discussion of authenticity, points out that even if forgery is undetectable at a given time, it may at some time in the future become provable or demonstrable, altering retroactively the previous admission of authenticity. An object of art assumes a history, a presence, and a unique existence.⁴

With the advent of photography in 1839, an instrument of reproduction comparable to the printing press was embraced by artists with joy, insofar as they found it useful, or disdain, insofar as it challenged their own representations. The often quoted "From today painting is dead," attributed to the French painter Paul Delaroche when he saw his first daguerreotype in 1839, expresses the exaggerated value of the new process, exaggerated because painting was not only not dead but painters from that moment on took the new process seriously into account, or even, like Nadar in France or Samuel F. B. Morse in the United States, became practitioners of photography as well as artists.

Federigo's stubborn insistence on valuing the handmade and hand-illuminated book over a printed book illustrated by woodcuts is a sign

that the much earlier Greek attitude, devaluing manual labor, had long
been obsolete. The unwelcome reproducibility of text by the printing
press had made the book lose its status as a unique work; the copyist's
manual labor, superseded by the invention of printing, was now elevated
to the creation of authenticity. The new printed work had lost the former
value of the hand-wrought book as a total experience. Belief in the to-
tality of that experience was exemplified by Federigo's insistence on own-
ing only the old handmade book. But after the invention of printing, the
location of value necessarily shifted primarily to the text, even though a
fraction of published books are still valued for their material appearance,
for elaborate hand binding, handsome illustrations, fine paper, and well-
designed type.

Nelson Goodman locates authenticity (essential identity) not in the
physical object, the book, no matter how made, but in language defined
by the particular, specific author's choice and order of words. To those
who have never seen a manuscript of the kind Federigo owned except in
a library or museum, Goodman's analysis seems the sensible formulation.
Although Benjamin attaches highest value and authenticity to the unique
existence of the work of art, he is not concerned with the book in his dis-
cussion of authenticity and aura. Benjamin even locates the authenticity
of sound in live performance rather than in score. Goodman refutes that
position; he points out that the musical score has the same physical re-
producibility as the book, even allowing for variations in performances
by different conductors, but that identity and authenticity lie in the order
and choice of notes in music as of words in text.

Benjamin says of a work of art that "making many reproductions . . .
substitutes a plurality of copies for a unique existence." But this is exactly
what it does not do. The original exists as it always did, in its place, in its
presence subsuming its past, in its history and authenticity, in its unique-
ness. In the work of visual art there is no text or score, only the true object.
In photography, the authenticity might be attributed to the photogra-
pher's negative, as if it were the score, but also to the print made by the
photographer, as if the photographer were to be both composer and con-
ductor. If many prints (an edition) are made from one negative, the au-
thenticity for convenience of reference is in the negative because it is
unique, but each print might be regarded as a performance. The notion
of authenticity in printings other than by the photographer who took the

picture and made the negative fades in direct proportion to the distance from the maker. Edward Weston's prints made by himself are authentic. Cole Weston's prints made from the same negatives, though they may visually be indistinguishable from his father's, are weakened with respect to authenticity by a factual gap in time and by recognition that the maker of the negative cannot be evoked on behalf of authentication because the maker is dead. The commercial market realistically values the later prints at a lower price. One day, if all documentation and any other evidence about maker and printer should be lost, value might come to inhere solely in the print itself. The discrimination that at the present time is appropriate, even though visually all the prints made from the negative in the given circumstances may look the same, would at that later time be irrelevant.

An original true object is distinguished from its mechanical reproduction by the defining terms of how each is made. "True object" is the object the artist makes, even when, as in casting after the artist's death a sculpture from an artist's mold, the degree of control he actually exerts must be determined. In the artist's lifetime, it is presumably the control the artist considers necessary; after his death, presumably a diminishing control as his student or assistant, the executor, whoever it may be, insensibly substitutes another judgment for the artist's. Or, to think of Roman copies of now lost Greek originals, when the copies are all we have, the question becomes, How do we compare them with originals that do not exist? It becomes necessary to decide what is Greek, what is Roman, aided, to be sure, by surviving Greek bronzes that establish a level of workmanship against which to measure. To claim that it is possible to distinguish between an original object and its *mechanical* reproduction is not to suggest that absolute confidence in that judgment is warranted; if the visual difference is not easily detectable, corroborative historical or other expert evidence must be adduced. The division between "hand" and "mechanical reproduction" is useful only when definitions are narrowed to specific instances. Even then, assumptions about the "hand" creep in.

Paul Rosenfeld, in writing about Alfred Stieglitz, speaks of "the full majesty of the moment. No hand can express it, for the reason that the mind cannot retain the immutated truth of a moment sufficiently long to permit the slow fingers to notate large masses of related detail."[5] This is

no doubt true, but Stieglitz chose as carefully as any artist scenes in which he could control detail, in which parts had to have relation to each other. His photographs of Georgia O'Keeffe are as impressive for their omission of detail as for their erotic elegance. As for the "slow fingers," one has only to think of the exquisite detail in early Flemish paintings to conclude that slow and painstaking execution was freely indulged for the sake of the myriad particulars that enhance the subjects. Large masses of related detail, if desired, are not allowed to appear at random or freely but must enter at the will of the painter or photographer. The photographer controls this factor in a different way from the painter, but control is no less important.

George Bernard Shaw admired photographs in about the same way he admired player pianos, concerned as always to debunk the pretenses of high art and unable to resist the opportunity for brilliant satire. "For surely," he says, "nobody can take three steps into a modern photographic exhibition without asking himself, amazedly, how he could ever allow himself to be duped into admiring and even cultivating an insane connoisseurship"—not content with "amazedly," "duped," and "insane," he is just gathering momentum—"in the old barbarous smudging and soaking, the knifing and graving, rocking and scratching, faking and forging, all on a basis of false and coarse drawing, the artist either outfacing these difficulties by making a merit of them, or else falling back on convention and symbolism to express himself when his lame powers of representation break down."[6] It might have been easier for a lesser man to say that bad artists are unable to represent convincingly, but it wouldn't have been as much fun. Shaw suggests that the amount of work that goes into a production is not a measure of its intrinsic merit, a belief we have already seen is hard to dispel, and yet that must be at least faced if photography is to take its place with knowledge of both what it can and cannot attempt.

The modern critic John Russell says, about Matisse's late cutouts, "something had vanished from the work . . . and that something was the evidence of hard labor."[7] Instead of the interposition of the camera, he is talking about the interposition of Matisse's shears and the consequent disappearance of the evidence of effort. The mechanisms (camera, shears) are labor-saving devices, but the labor they save is improperly lost; the mechanisms limit as well as enable; absence of evidence of labor is ab-

sence of an essential element in the work. In this view, an idea executed by the hand is a necessary condition of creation.

László Moholy-Nagy takes an opposite view:

Artists . . . share the universal fear that mechanization may lead to a petrification of art. They fear that the open revelation of elements of construction, or any artificial stimulation of the intellect or the introduction of mechanical contrivances, may sterilize all creative efforts.

This fear is unfounded, since the conscious evocation of *all* the elements of creation must always remain an impossibility.[8]

Moholy-Nagy used the machine (including the camera) with great sophistication. He continues:

The mechanical and technical requisites of art are of primary importance. Until recently they were condemned on the grounds that manual skill, "the personal touch," should be regarded as the essential thing in art. Today they already hold their own in the conflict of opinions; tomorrow they will triumph; the day after tomorrow they will yield results accepted without question. Brushwork, the subjective manipulation of a tool, is lost, but the clarity of formal relationships is increased.[9]

John Ruskin had a comparable emphasis, without in the least acknowledging the possibility of relinquishing brushwork. "Photography either exaggerates shadows, or loses detail in the lights, and, in many ways . . . misses certain of the utmost subtleties of natural *effect* (which are often the things that Turner has chiefly aimed at), while it renders subtleties of *form* which no human hand could achieve."[10] "Form" or "formal relationships" in these statements is equivalent to drawing as opposed to modeling. Ruskin is saying that "no human hand" can draw lines representing form (as opposed to engineering blueprints or instrument-aided architectural drawings) with mathematical exactitude in the same sense that a machine such as the camera can. J. M. W. Turner's "natural effect" is achieved by a high level of symbolization of which the *camera* is incapable. Painting, recognized as a symbol system, and photography, not a symbol system, that is, not coded, can yet be spoken of together because, despite the differences, they are both typically depictions of objects, often three-dimensional, on a two-dimensional surface. The photographer achieves what Nelson Goodman calls the construal[11] by means that are more limited than a painter's; he works within nar-

rower possibilities. His manipulations are not only restricted but are often less complicated than the term *construal* might suggest. His strength is in calling attention to what is assumed to be there. Photography is weak when it tries to transform or invent and strong when it confirms that "this was a state of affairs," whether the state of affairs is an Edward Weston nude, a Walker Evans interior scene, a Richard Avedon portrait, a Diane Arbus grotesque, or an Aaron Siskind wall.

Whether the photographer must be identified with the camera in its weakness is another question. I would argue that the photographer's *mind* operates significantly in formation of the picture. The weight to give hand or machine continues to be shifty. Ruskin had no doubt of the superiority of painting. Moholy-Nagy invested his faith in the "mechanical and technical requisites of art."

Charles Baudelaire, preeminent art critic in mid-nineteenth-century Paris, was another emphatic advocate of painting, but he was also an enemy of photography. He condemned his contemporary society not only because it confused replication of nature with art but also because such replication was an industry. "A revengeful god," Baudelaire says, "has given ear to the prayers of this multitude. Daguerre was his Messiah." And "our squalid society rushed, Narcissus to a man, to gaze at its trivial image on a scrap of metal."[12] Photography has been living under this savage indictment since 1859, and there are those who have formed no later or different impression of photography. Baudelaire "wrote in constant splenetic awareness of his bourgeois public and of his own chosen pose of aloofness."[13] He always emphasized the transforming power of the imagination, a power alien to his understanding of the practice of photography. This is very different from the description by his contemporary, Nadar, of how photography works: "The idea [for the photograph] rose complete from the human brain, the first induction becoming immediately the finished work."[14]

The difference is between transformed "dream" or imagination and the instantaneous transcription of "idea . . . complete from the human brain" into "the finished work." *Transcription*, which I have adopted to mean the physical transfer to film of an impression, or even metaphoric lifting of a surface onto film, is not the essential element in Nadar's conception of photography. According to his use of "idea" the imprint of the

photograph is derived not from the surface or skin of objective reality but from a mental conception.[15] For Nadar the process begins in the human brain. Although he is known primarily for his portrait photographs, Nadar was a cartoonist and caricaturist as well as a photographer. He collapses the separation of draftsman from photographer, merges their two arts into one, and locates the genius of drawing or photograph in the originating idea, not in the execution by the hand. Marcel Duchamp carries this interpretation one step further, to its ultimate expression in his readymades, his designation for everyday objects chosen for his signature and thus claimed for the category of art without any intervention of handwork. The naming of an object as art, for example the snow shovel, was then reinforced by its exhibition as art. The element of play (in every sense of the word: play on words, gamesmanship, entertainment, the amusing thwarting of expectation) should not be overlooked in Duchamp's choices.

The key words so far are *hand*, *idea*, *mechanical instrument*, and, to choose a neutral term, *result*. The assumption in the use of the *hand* concept is that the hand executes what the eye or mind conceives, providing a direct conduit for the idea but also in actual practice modifying the conception. The origin of the work is found in the executor. Even the printmaker uses his hand to hold the tool, and the hand, eye, and mind work simultaneously to create the final result.

Photography has in common with printmaking the exact repeatability of a picture. But printmaking has in common with painting, drawing, and sculpture the artist's hand as an instrument of the mind. Mind and hand act as one in the creation of the picture. Manipulation of photographic prints is comparatively minimal even when negatives are wittily combined or doubly exposed or when printing variations are introduced as techniques of interpretation.

In photography, the hand does not become the primary instrument of registering or creation. The eye is dominant in the way a photograph is conceived. The eye sees, the segment of reality is framed and isolated by a synaptic leap between eye and reality, the exposure of film to light by means of the instrument camera is activated, the transcription to film occurs; the agency of the hand is comparatively minor. Modifications, insofar as they are made in the process of development and printing, are

decisions of adjustment between the conception of the picture and the range of alterations possible.

To emphasize eye at the expense of hand is to postulate a separation between them. The separation is more than one of language, but if there is opposition between them it exists only in abstraction. Of course it is nonsense to think they work separately or that painters and sculptors are not visually oriented. Painters and sculptors work with materials that must be formed not instantaneously but with comparative deliberation. The energy of conception is a force originating in the imagination and transferred to the created object by the flow of that energy through the hand that participates, by encountering and identifying the resistance and integrity of the materials, in the making of the work of art.

In contrast with this process, taking a photograph seems to eliminate the agency of the hand. "You press the button" is not enough, even though the button is pressed by hand. Kodak added in its first advertisement for cheap cameras, "we do the rest," assuming responsibility for assembly-line performance of the operations that previously had been done individually and personally and that represented operations of the hand. Amateurs, who relinquished for the most part claims to manipulation by taking advantage of Kodak's offer to "do the rest," thereafter took snapshots. Professional photographers took photographs. Whatever the intrinsic worth of the snapshot or photograph, determined both by technical standards and by use, the difference in the number of persons who might reasonably be expected to be interested in the picture is one measure of the difference between them. News photographs, which exist briefly but for a great number of people, can be judged both in the context of information and for level of visual interest, for wide (or narrow) range of reference, and for that mysterious quality of teasing incompletion that compels one to puzzle out its qualities and thus determine their use and description.

Other arts have a comparable lack of hands: music composition, choreography, architecture, and drama, for example. The lack of necessity for hand authentication in these arts seems self-evident. Emphasis on hand execution may be influenced by the importance of direct or empathetic tactile pleasure, a pleasure nonexistent in photography. Execution of music composition, choreography, and drama depends on perfor-

mance by persons trained in each of the arts; in architecture it depends on building craftsmen who can interpret blueprints, or master plans, in the way musicians interpret scores or dancers interpret dance notations or actors and directors interpret a play. The insistence on treating "art" or "arts" as an indivisible whole, by definition including and excluding according to the unexpressed assumption that execution rather than "conception" or "idea" governs a work, is confusing.

Baudelaire's vehemence in the service of painting as opposed to photography emphasizes the exclusion of photography as an art. He accepts it as a craft serving scientific interests. Indeed, much disservice to photography was done by photographers themselves who mistook the nature of photography and, instead of locating its authenticity in the photographer's idea or conception of reality, located it in the artificial arrangement of reality according to would-be pictorial rules. Baudelaire gives horrendous descriptions of staged scenes photographed. Henri Foçillon describes imitations in photographs of Rembrandt's aged men with comparable rhetorical contempt. Unfortunately for Foçillon's persuasiveness, he speaks of the hand as the "five-fingered god" and argues for its creativity in terms that at once seem so exaggerated as to be questionable. Both Baudelaire and Foçillon underestimate photography. If we turn to photographs that combine scientific purpose with the possibility of pleasure, the admittedly scientific purpose will justify the photographs in the lesser category of craft, and there may also be elements that will give pleasure of a kind other than verifying or ascertaining fact.

Eadweard Muybridge furnishes such an example. He not only won Leland Stanford's bet for him, that running horses lifted all four feet off the ground at one position in their running, but, by the same technique of multiple cameras and sequential timing of shots, he showed that human and animal movement can be seen as segments in stopped moments of time. The possibility was powerfully imagined and elegantly realized. The usefulness of the studies has become of historical interest only, his scientific observations accepted. The question therefore arises why the photographs themselves are still enjoyed and reproduced both as book publications and as postcards. "Elegantly realized" gives the claim of pleasure a term to begin with. So far as one can tell from the photographs, however, Muybridge was not primarily interested in pleasing his viewers

but in instructing them. For this reason the linear aspects of the motion photographs, those that correspond to drawing, and not the fine tonal gradations between black and white that transcribe volume, are justifiably reproduced in books even though the quality of the original prints is lost in reproduction. The original prints are as delicately graded in tonal quality as the best of any other photographer. His sequential images of a male or female performing an action such as walking, running, jumping, or going up or down stairs are often reproduced. Interest now lies primarily in the *idea* of the sequence and its visual importance in understanding cubism as well as in understanding Marcel Duchamp's *Nude Descending a Staircase*. The dimensions of interest are not limited to sequence and technique, as one notices in the use artists have made of Muybridge's frame of a paralytic child walking on all fours. Muybridge drives toward the exhaustion of scientific analysis and in doing so catches an imaginative realm of movement beyond exact depiction of its elements.

Muybridge's notes are matter-of-factly descriptive. He uses his plates in *Animals in Motion* to demonstrate how animals walk, trot, or gallop. He includes in the same book the set of photographs of a child who is crippled by polio and walks on all fours like an animal. He is indifferent to any qualities in the pictures except proof of his thesis about the elements of the walk.

A noteworthy confirmation of the law governing the walk was found in the case of a child suffering from infantile paralysis, whose only method of locomotion was by the use of her limbs exactly in the manner of a quadruped. . . . In her progress it was revealed that not only was the regular system of limb movements used, but the support of the body devolved, in their proper sequence, on the laterals and on the diagonals. The diagram in this chapter is as faithful a representation of the consecutive impacts by that child as it is of those by an elephant, a turtle, or a mouse.[16]

What interests Muybridge is impersonal observation of physical locomotion, not the sad condition of the crippled child or the emotional appeal of his photograph. His use of the photograph is scientific.

Not so the use of the same photograph, the paralytic child walking on all fours, by Peter Milton, a contemporary American artist. Milton makes nonsense of the opposition of hand and machine by calmly incorporating Muybridge's evidence, that is, the camera-machine's evidence, into his

1. Peter Milton, *Daylilies*

hand-created etching, in which the mysterious and evocative child walks like an ape. A single frame (No. 2) from Muybridge's sequence is included in Milton's etching called *Daylilies* (illus. 1). The photograph, copied exactly, occupies its own small rectangular demarcation in Milton's large creation of frame upon plane; the illusion of distance is simultaneous with the pressure against the picture surface of the total configuration. It is only one of many references in the etching to photographs. Milton says, "The suggestion of picture within pictures already present began to suggest pictures outside of pictures, and I soon find myself with a whole new world." His new world is one of mantel, mirror, and figures that seem to be observing something and have in turn been observed in certain photographs by André Kertèsz and others. About the paralytic child, he says, "In the next room [seen as recessed space in *Daylilies*] the picture of a boy [sic] is taken from one of Eadweard Muybridge's photographic studies of crippled children. . . . I am enormously fond of this image of afflicted child-

hood, and give it its own space away from, and behind, all the complex accumulations of the rest of the plate. . . . On either side of him the windows contain the barest hints of landscape forms and a darkening sky."[17]

Muybridge's use of his camera and conception of his function were primarily evidential in the studies of human and animal motion. His operation intrigued the Philadelphia painter Thomas Eakins as an instrument for exploration of stopped motion much as dissection was an instrument of anatomy. Neither of them thought of hand as opposed to machine. In their use of the camera, they were closer to the scientific use of instruments to explore, even identify, reality than they were to the emphasis on the use of the hand as the necessary interpreter of the idea.

Peter Milton's *Daylilies* alludes to the connection between Muybridge and Eakins by making a portrait painted by Eakins the largest element in the foreground of the etching. André Kertèsz furnishes other elements. The boy looking out at the viewer is his, and the shadow is a self-portrait of Kertèsz photographing. A daguerreotype, a snapshot of Milton's children, and anonymous photographs from daily newspapers are also elements of the etching, lovingly ascribed each to its source by Milton. "I never in seriousness choose an image for its symbolic quality but for its ability to evoke," he says. What the etching evokes, among other things, is a reticent history of photography emphasizing not only specific photographs but the shadows that are the sine qua non of photography. I do not want to say or imply that this etching is *about* photography. One might say comparably that a set of fashionable clothes is *about* clothing. Both statements seem, if not nonsense, tautological. All paintings are in some sense about painting; all photographs are in some sense about photography; everything one sees or makes to be seen is both self-referential and an element of the larger world to which the clues are more or less obvious. It is the function of the critic to discern and explain the connection of the elements to each other by following, identifying, and explicating those clues, just as Peter Milton has not only made the etching but has then constituted himself as critic and told us what the clues are. His work with his hands (his own hands, by the way, are depicted in the etching) has deliberately involved appropriation of photographs in homage to specific photographers. The function of his hand is to recreate and make his own context for the photographs originally made, if one refers

to the old and mistaken opposition, by a machine; but, as he assumes in his etching, they were in fact made according to the vision of the photographer just as much as the Eakins portrait was made after the vision of the painter.

Peter Milton is only one example of a modern artist's use of the photograph. Richard Hamilton, Robert Rauschenberg, and in a special way, David Hockney, all encompass, possess, and create their own uses of the photograph. Hockney uses photographs as elements of collage compositions. Chuck Close, a photo-realist, challenges the eye to determine what makes a face, whether he painstakingly enlarges every minute element of a photograph onto a huge area or magnifies tiny areas in small compass so that they approach loss of identity.

Locating the genesis of the photograph in the mind of the photographer rather than in the mechanical operation of the camera enables one to modify—not abandon—the idea of a camera without a hand. To propose an intelligence behind the camera is to entertain the possibility of invention that characterizes imagination. Photographic invention operates, however, with different limitations and expectations from those of painting, even though the subjects are for the most part identical and are classified in the same genres, portrait, landscape, still life, and so on. Thus a wide area of overlapping is evident. Yet even if the idea of the photograph is the essential, it may originate or be conceived in any number of ways that will not coincide entirely, perhaps not at all, with the ways in which a painter might imagine a picture, although in both modes sight is the dominant sense.

The shift of perception made in accommodating the idea of invention is a shift away from Benjamin's insistence upon degrading the value of something that is not unique. Benjamin is more offended by the photograph's lack of singularity than by the mechanism of production.

Another way of giving the photograph other than intrinsic value is to discover its historical context, an exercise with recognized criteria of evidence and a defined structure of research. Without some sense of why a photograph is important, however, the context makes very little difference. In one sense the photograph is a self-authenticating document simply because it exists; but what it means has to be explicated. Self-authentication need not exclude fakery; if fakery is involved, that is what has to be explicated. The photograph may be visually striking—by what-

ever criteria are used—and therefore worth explicating. It may be of interest only because of historical details once part of everyday life but visually lost without their recovery in the photograph. Explication of the photograph is most useful when it achieves a combination of precise description, directing the less informed eye what to see and how to see it, and interpretation. If sometimes, as will become evident in Benjamin's description and interpretation of a photograph of Karl Dauthendey, the account is far more interesting than the photograph, this is not a risk but an added benefit. It illustrates the power of description.

3

Walter Benjamin

<center>◈</center>

The invention of the positive-image-on-metal daguerreotype in France (1839) by Louis Daguerre and J. N. Niepce was paralleled in England by William Henry Fox Talbot's fixing a negative image on paper (announced 1839; patented 1841). In contrast to the legally unrestricted French process, Fox Talbot's process was patented. The English patent, which delayed the widespread application of the paper process, did not cover Scotland. So it was that Robert Adamson and David Octavius Hill, who photographed in and near Edinburgh, were able to make photographs on paper.

It has been shown that the Hill/Adamson portrait poses and effects were influenced by the Scottish portrait tradition; that certain poses of women were patterned after fashion plates of 1844; that idealized women shown in Charles Heath's *Book of Beauty* (1840, 1846) furnished attitudes and expressions for Hill's sitters; and that genre paintings and topographical representations were antecedent traditions.[1] Locating the new camera work within contemporary social and artistic traditions is interesting, but it does not explain the effect of the visual images characterized by softly outlined areas of dark and light with none of the knife-edge sharpness that glinted out of the daguerreotype. Knowing what Hill and Adamson knew may explain acceptance of the images as period representations but does not help to understand their appeal now, when viewers may respond to the images themselves without knowing anything about their cultural context.

Walter Benjamin suggested some problems of thinking about photography in "A Short History of Photography" (1931)[2] and in "The Work of

Art in the Age of Mechanical Reproduction" (1936).[3] Some of Benjamin's
assumptions have been generously ignored by those who have read and
depended on his work—perhaps properly, because his insights are pro-
vocative even when his facts are wrong or interpretations open to ques-
tion.

In the "Short History," Benjamin calls it "a striking fact" that "the
flowering of photography, the achievement of Hill and Cameron, of Hugo
and Nadar—occurs in its first decade," an incorrect dating of the work
of these photographers. Benjamin freely gives his references to the books
of photographs he is reviewing,[4] and the Bossert volume in particular is
a source of his misinformation. The translator's note to the "Short His-
tory" observes that " 'its first decade' is an exaggeration. Of the photog-
raphers Benjamin refers to, Hill was the earliest (1839–49 [sic]); Cam-
eron and Nadar were not even active until the late fifties and sixties." In
fact, Robert Adamson's collaboration with David Octavius Hill began
about 1843 and was so important that after Adamson's death in 1848 (at
the age of twenty-seven) Hill did very little new work in photography.
Bossert, however, obviously did not know of Adamson's part in taking
the photographs. The text refers to Adamson only twice, once as Hill's
"chemical assistant" and once as simply "Hill's assistant."[5] Adamson was
the cameraman, developer, and printer in the joint endeavor; Hill was the
composer and director. Benjamin, following Bossert, was not aware how
important Adamson was in the collaboration.

Benjamin's coupling of Hill and Cameron suggests that he lumped
them together as British, as Hugo and Nadar had in common being
French. Julia Margaret Cameron's portraits of Sir John Herschel (1860),
Thomas Carlyle (1860), Henry Wadsworth Longfellow (1865), Charles
Darwin (1865), and the violinist Joseph Joachim (1865) were reproduced
in Bossert. Charles-Victor Hugo, the son of Victor Hugo, took pictures
of his father in the isle of Jersey during his father's exile there. Two of three
reproduced in Bossert are of Victor Hugo (though one is only of his hand)
and the third is of the writer Auguste Vacquerie, all dated 1853–55. Hu-
go's work is of interest primarily because of the subjects, especially his
father.

Nadar, like Cameron and Hill/Adamson, was a great photographer.
But the portrait of Balzac that Bossert attributed to Nadar (dated Paris,
about 1850) was actually Nadar's photograph of a daguerreotype of Bal-

zac that Nadar had bought from the caricaturist Gavarni.[6] Bossert's date of about 1850, required because Balzac died in 1850, neglected the fact that Nadar did not begin to work in photography until 1853.[7] The same dubious dating, about 1850, occurs for what is described as a self-portrait of Nadar. Other Nadar portraits—of Delacroix, Doré, Meyerbeer, Rossini, Champfleury, Baudelaire, Charles Sainte-Beuve, and Wagner—are all dated Paris 1859. Bossert includes several other photographs by Nadar that are all of later dates than 1859, so it is only the two photographs of 1850 that, if the dates were accurate, might have allowed Benjamin to squeeze Nadar into the last year of the "first decade."

Benjamin's "striking fact" is not a fact. Only Hill worked in the first decade after photography was invented, and he did not, as Benjamin says he did, make these photographs himself, though this in no way alters Benjamin's conclusion that "they are what gave his name historical significance, while as a painter he is forgotten."[8]

But Benjamin, in citing Hill and Cameron, Hugo and Nadar, meant only to make the point that the earliest examples of photography that he knew about were, in some sense yet to be explored, its most memorable examples as well as the earliest. Benjamin's point in invoking the "first decade" has nothing to do with a factual history of photography but everything to do with an interpretation of history that would separate the preindustrial from the industrial history of photography, to use Benjamin's terms. A third term invoked for another facet of history is *the marketplace*:

Not to say, of course, that in this early period ["the decade which preceded its industrialization"] the peddlers and charlatans had not gotten hold of the new technology and turned it to profit; they did that on a massive scale. But that was closer to the methods of the marketplace, where even today photography is at home, than to those of industry.

Photography first conquered the field with the visiting card, whose first producer, significantly, became a millionaire. It would not be astonishing if the types of photography which today direct our attention back to the preindustrial flourishing of photography were found to be fundamentally related to the convulsions of capitalist industry.[9]

The millionaire Benjamin refers to is André Disdéri, who devised a method of taking multiple photographs on one negative (patented 1854), popularized in 1859. In that year Napoleon III "at the head of his army

departing for Italy halted his troops in the Boulevard des Italiens while he went into Disdéri's studio to have his photograph taken."[10] Thus the sale of photographs in the marketplace (on the open market; photographs reproducible as demand requires; anyone buys), though not primarily dependent on technological refinement, is not so evident in the first decade (1840–50) after the invention of photography. It is for this reason that Benjamin claims for that first decade the photographers he cites. They were not primarily or simply commercial photographers even when they sold their photographs, as Hill and Nadar did, and none of them was a millionaire.

Hill was a painter and lithographer who in 1843 saw the walkout of a great number of ministers from the General Assembly of the Church of Scotland, protesting the restrictions imposed on the established church by secular authorities. His sympathies were with those ministers, and his tribute to the occasion was to be an enormous group portrait. The problem was that he unfortunately did not paint portraits, only landscapes. When he was introduced to Robert Adamson with the recommendation that he use the new photographic process as an aid to getting likenesses for the ministers' portraits, the partnership with Adamson, who had opened his calotype studio in 1842, was formed. Their subjects were not only the ministers, however.

Benjamin describes one of Hill and Adamson's photographs of women from the fishing village of Newhaven, near Edinburgh (Schwarz, plate 26, see illus. 2): "One encounters something strange and new: in that fishwife from Newhaven who looks at the ground with such relaxed and seductive shame something remains that does not testify merely to the art of the photographer Hill, something that is not to be silenced, something demanding the name of the person who had lived then, who even now is still real and will never entirely perish into *art*."[11] "Relaxed and seductive shame" is a surprising phrase about the woman that one had imagined, on first looking at the photograph, to be stiff rather than relaxed, resting after work rather than melting with a reticent emotion. Benjamin has a talent for characterizing a still photograph as a narrative, implying the beginning and the end of a situation by his dramatic figuration of the middle.

Another description of the photographs is given by Heinrich Schwarz: "The products of Hill's camera are far from being a mirror-image of the

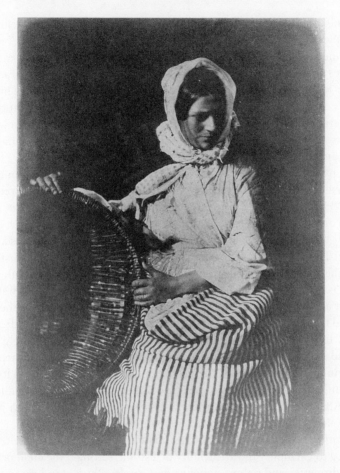

2. David Octavius Hill and Robert Adamson, *Mrs. Elizabeth Hall of Newhaven*

visible world uninformed by the spirit. In his work, as in mezzotints, light separates itself reluctantly from shadow. Soft half-tones, emerging from deepest shade, temper the transition to the bright spots of heads and hands."[12] Benjamin uses his description for one purpose, Schwarz his for another. Benjamin invents a story—instantaneous, compressed, elusive, incomplete—in order to claim reality and a place in the world, including

a name, for the woman whose picture was taken. His further conclusion, that she has a reality that will never allow her to "perish into *art*," is not sustained today. The photograph is a Hill/Adamson before it is *Mrs. Elizabeth Hall, Newhaven.* But to think of the status of the photograph as either reality or art is entirely dependent on the use made of it. The historian or sociologist, the artist, connoisseur, student of photography, or aesthetician, each tends to think of the photograph as revelation in which secrets may be disclosed by careful examination and thoughtful analysis. That analysis will be couched in terms of the critic's profession.

Schwarz's description of Hill's work, that it is not "a mirror-image of the visible world uninformed by the spirit," includes the further remark that "Hill remained true to his primitive mechanical equipment, even when an advanced optics had already mastered instruments which completely vanquish darkness and which delineate phenomena as does a mirror."[13] This is very much like Benjamin's statement in the "Short History" that the early photographs ("incunabula of photography") had an aura that "is not simply the product of a primitive camera. At that early stage, object and technique corresponded to each other as decisively as they diverged from one another in the immediately subsequent period of decline. Soon, improved optics commanded instruments which completely conquered darkness and distinguished appearances as sharply as a mirror."[14] Benjamin refers loosely to "the first decade of photography" and its use of primitive technical equipment. He attributes the elusive originality of Hill/Adamson to that state of the equipment. He may have been influenced in this interpretation by his reading of Schwarz.

Benjamin describes the photograph of Franz Kafka at the age of six, educed to exemplify the artificiality of a studio setting ("the ateliers with their draperies and palms, gobelins and easels, which stand so ambivalently between execution and representation, torture chamber and throne room"):

There in a narrow, almost humiliating child's suit, overburdened with braid, stands the boy, about six years old, in a sort of winter garden landscape. Palm fronds stand frozen in the background. And as if it were more important to make these upholstered tropics even more sticky and sultry, the model holds a huge hat with broad brim like those Spaniards wear in his left hand. He would surely vanish into this arrangement were not the boundlessly sad eyes trying so hard to master this predetermined landscape.[15]

With folly and deceit as background ("Palm fronds stand frozen"), the child, knowledge of whose future as a great writer is inherent in Benjamin's description, tries to "master this predetermined landscape." Yet the child is not looking at the landscape behind him but at the camera in front of him. His "boundlessly sad eyes" see what Benjamin calls a world "isolated and godforsaken," in contrast to the earlier world shown us by Hill and Cameron, Hugo and Nadar. Their subjects had "an aura around them," giving "their glance the depth and certainty which permeates it."

First Benjamin invests the photograph of six-year-old Kafka with a particular character by using terms of rhetorical brilliance, then he contrasts these terms with those he has created for the earlier photographs, which are purposefully categorized in the "Short History" as made in "the first decade" of photography. The falsity of the studio picture stands in opposition to the mysterious truth of the work of Hill and Cameron, Hugo and Nadar. The truth, for Benjamin, depends on the mystery, even when it is mystery intensified by disclosure, as it is in the reproduction of nature's details unseen by the eye before photography's revelations. The mystery of time was powerfully suggested by the long exposure to light endured by models, whether outdoors or in the studio. It is even more powerfully suggested by Benjamin's description. Darkness, above all other terms, characterizes the condition of mystery belonging to early photographs. "As in mezzotints the light in Hill's work torturously wrestles its way out of the dark." "Soon, improved optics commanded instruments which completely conquered darkness and distinguished appearances as sharply as a mirror."[16] It was not artistry, according to Benjamin, that produced the evocative earlier work, but the fortuitous correspondence of object and technique. Once lenses and cameras had been improved technically, photographers tried to recapture the lost aura of darkness by the retouching that Shaw calls "the old barbarous smudging and soaking, the knifing and graving, rocking and scratching, faking and forging."[17]

George Santayana holds a view comparable to Benjamin's. Benjamin specifies aura as the necessary accompaniment to the unique work, and Santayana emphasizes the transforming idealizing power of the unique work; Benjamin sees the disappearance of aura as a characteristic of photographs, and Santayana emphasizes the faithful realism of photographs. Santayana says about photography, "We are grateful to any art which re-

stores that sensuous filling of experience, which was its most lively and substantial part in passing, but which now is so hopelessly past." He believes that the photograph shows "every aspect of life in its instantaneous truth. . . . There is the unalloyed fact. . . . The sophisticated concern about art sinks before the spontaneous love of reality." So far he seems to share Benjamin's attitude.

Santayana explains that he is spared "the impertinent medium of a reporting mind" because the photograph is for him "unalloyed fact." In contrast to Benjamin, Santayana neither imagines a story about any photograph nor wants to be presented with a story. "The impertinent medium of a reporting mind" is the instrument of distortion. It gets in his way and interferes with his "spontaneous love of reality." There is no such phenomenon for him as a "reporting mind" interfering with a work of creative art because such works occur as "substitutes for reality that transform it into the materially impossible, in order to bring it within the sphere of the persuasive and the divine." The enlarging dimensions of Platonic terms for the argument are suitable only for works of creative art, which exist in the realm of the ideal rather than in the palpable world of bodily sensations, but where do the terms of description come from for the photograph, bound as it is by its nature to the earthly world of the senses? For Santayana, who insists more than once on comparing the camera as machine to the brain as if it were a machine,[18] the camera lacks intention, whereas the brain makes "intentional transformations." Use of that construction, "the camera lacks intention," conceals the bias toward thinking of the camera as entirely impersonal and totally mechanical. As soon as one says "the photographer lacks intention," the bias is disclosed. The photographer has a brain, therefore he must bring about "intentional transformations," if only in the act of exposing the film. Nevertheless, Santayana's distinction between the photograph and ideal art is interesting apart from the inadequacy of the opposition between artist and camera: "The accidental transformations of the image in photography and memory are consequently defects and imperfections, while the intentional transformations of ideal art are beauties. For the function of photographs and of mental images is to revive experience, but the function of creative art is to interpret experience." The coupling of photograph and mental images emphasizes Santayana's belief that each reflects direct sense impressions, although of the two he recognizes that the mental im-

age is the more fragile and corruptible. The use of the photograph for him is "to help us in the weakest part of our endowment, to rescue from oblivion the most fleeting portion of our experience—the momentary vision, the irrevocable mental image."[19]

This position does not allow for the difference in experience from one person to another. Somehow the photograph is sufficient unto itself and to each person's experience only so long as it is not the subject of communication. The photographer's mind is not impertinent. It transcribes or presents mutely. Once the photograph is spoken about or written about, the impertinence of the reporting mind is inevitable. Any photograph invites some comment. It is not necessary, however, to accept Santayana's description of such a reporting mind. Comments on photographs might not characterize "the reporting mind" but "the critic as interpreter." As critic, the interpreter is wholly respectable, far from impertinent, and takes a place in the literature of photography. Benjamin is the most brilliant example. He breaks the rules of fact, not with intent to deceive but carelessly and in pursuit of the larger truth, and convinces his readers by sheer force of imagination that certain photographs can be interpreted as dramatic narrative. His interpretation is not impertinent because no one has a personal investment in the photographs he is writing about. It is impossible to know the six-year-old Kafka or the Newhaven woman. No one can welcome an interpretative description that contradicts the visible elements of the photographs, but anyone can welcome a description that adds imaginative depth to the experience of looking at the photographs. If, however, Mrs. Elizabeth Hall, Newhaven fishwife, had been a relative, if this photograph had been the subject of family stories handed down since the days of Hill and Adamson, and if the stories contained elements that deepened the family pieties, then it would be impossible to accept Benjamin's description as anything but unpleasant and deniable fiction. Luckily, no one has come forth with such denials.

The reason for evoking the unlikely relatives as critics of the Hill/Adamson photograph is to carry Santayana's assumptions to their logical conclusion. He has narrowed the possibilities of interpretation by claiming a restrictive, private, limited, literal significance for the photograph and has denied the interfering function of interpretation. Benjamin, by contrast, has broadened the possibilities of criticism by his creative inter-

pretations. Benjamin, not Santayana, has inspired continuous interest in photography.

In Benjamin's "Short History," his next subject is Eugène Atget, whose photographs are also described in imaginative terms. Atget's achievement was "to strip the makeup from reality"; "he began the liberation of the object from the aura"; "such pictures [as Atget's of Paris] . . . suck the aura from reality like water from a sinking ship." These are terms of praise, yet Benjamin had previously said that aura was reverence for tradition, the sacred aspect of the unique work of art. Is one now to think of aura as "makeup" from which the "object" must be liberated? The answer seems to be that the "object" in this context is either natural or man-made, as in Atget's scenes of the city, but not an object that was, in the first discussion of aura, the unique work of art. Benjamin's second definition of aura follows:

What is aura? A strange web of time and space: the unique appearance of a distance, however close at hand. On a summer noon, resting, to follow the line of a mountain range on the horizon or a twig which throws its shadow on the observer, until the moment or hour begins to be a part of its appearance—that is to breathe the aura of those mountains, that twig.

Nothing of the original cluster of associations about the unique work of art is expressed here. "Unique distance," like "unique work of art," is the unrepeatable, singular experience, in the case of distance; or unrepeatable, singular object, in the case of art. The contemplative observer is out of doors, resting or idling with absorptive attention to "a distance, however close at hand." He becomes aware of the scene and himself in it "until the moment or hour begins to be a part of its appearance." An atmosphere is created, figuratively expressed by the term *aura*, literally, then, "breathed."[20]

The mood of the account within the same paragraph then changes as quickly as, in Laurence Olivier's movie of *Henry V*, the soft perambulation of Henry among the soldiers at night cuts abruptly to the noisy bright daylight trumpets of impending battle. Benjamin continues: "Now to bring things themselves closer—and closer to the masses—is as passionate a contemporary trend as is the conquest of unique things in every situation by their reproduction. Day by day the need becomes greater to take possession of the object—from the closest proximity—in an image and

the reproductions of an image." A "passionate trend" is not necessarily good. The "conquest" of unique things is not necessarily desirable. It is, at any rate, a far cry from reverence. Benjamin's tone is that of a critic reluctantly coming to terms with a condition of which he does not approve but which sweeps him forward "day by day" into a bleak mechanized future. He continues:

And the reproduction, as it appears in illustrated newspapers and weeklies, is perceptibly different from the original. Uniqueness and duration are as closely entwined in the latter as transience and reproducibility in the former. The removal of the object from its shell, the fragmentation of the aura, is the signature of a perception whose sensitivity for similarity has so grown that by means of reproduction it defeats even the unique.[21]

Clearly this is a return to the definition of the aura specifying the object as original work of art "closely entwined" with uniqueness and duration. The reproduction is similarly entwined with transience and reproducibility. Further, it is easy to tell a reproduction from the original. The reproduction is "perceptibly different." The last sentence of the quotation can be expanded to make more sense. The subject is clear enough, "the removal of the object from its shell, the fragmentation of the aura." The shell is the aura in one figurative sense, as if the object could be removed like an oyster. The aura in the second phrase is the less substantial but still potent surround (of association, tradition, reverence) that is susceptible to fragmentation; that fragmentation exposes the object as much as does the removal of a shell. That removal of shell, or of associative surround, characterizes ("is the signature of") a realization ("perception") that homogeneity in the world ("whose sensitivity for similarity") has so grown that by means of reproduction it wrests aura even from ("defeats even") the unique. To paraphrase, the removal of aura discloses a homogeneity in the world increased by means of reproduction. Replications substitute for the original. If the aura, here as elsewhere, is good, its removal is not. It would follow that the increasing sameness (homogeneity) in the world, so valued that it is furthered by reproductions of images that are the means of removing the aura, is not good. Benjamin, who admires Atget's photographs, finds himself thus in the position of admiring works that "suck the aura from reality like water from a sinking ship."

It may be helpful in this impasse to introduce the figure of the mask.

Benjamin himself says, "Atget was an actor who became disgusted with that pursuit, took off his mask and then went on to strip the makeup from reality as well." This is the mask of Comedy or Tragedy, or even the mask superimposed by greasepaint and pretense. Benjamin's language makes us understand that when Atget took off this mask and went on to strip the makeup from reality, both actions were good. It is one thing to strip aura from unique works of duration, and another to strip the makeup from reality. Disclosure of reality by stripping away falsity is good. Reality, then, may in this metaphoric mode be said to wear a mask.

Following Benjamin's oblique tropes might seem difficult enough without introducing a new metaphor here to explain *aura*, but it may help to clarify *aura* more than "mask of reality" does. Benjamin's two uses of aura are (1) reverential attention to the original work of art, which is unique and lasts through time, thus traditional, with the atmosphere of the sacred; and (2) the obfuscation, falsity, and pretense hiding reality. Thicken atmosphere and it becomes cloud. The first use of aura corresponds to the cloud, nimbus, aureole of the upper atmosphere, where sacred gods have sway and myth is powerfully evident. The second use corresponds to cloud on the ground, fog or mist, obscuring objects and hiding the face of reality.

Benjamin's superficially contradictory, or at best paradoxical, uses of aura might be an example of what Peter Demetz calls in Benjamin's writings "an intricate surfeit of paradoxes, abrupt changes of orientation, internal contradictions, and thoughtful self-subversions."[22] But the idea of aura does not change in Benjamin's use. Benjamin's aura is always imagined in visual terms, as if the invisible aura could be acted upon and spoken of as a palpable entity, like cloud or fog. He envisages changes only in what happens to the aura. It can either accrue about a reverenced object or be stripped from an object or scene. Benjamin's use of the reverential aura suggests that value (of art, of cult object) is intrinsic to the object and that the accrued aura is tribute to that value. The fog of illusion and inattention constitutes the aura to be stripped from reality.

Benjamin's thoughts were more like pieces of a mosaic than like causal linear thinking from *a* to *b* to *c*. In some other writer's work, the construction of a reverential aura and the destruction of aura in order to disclose reality might suggest a change of mind and development of disillusion. It is true that Benjamin posits the unique cult object with aura as

a long-ago phenomenon, succeeded by the phenomenon of dissolution of aura to expose reality. But this sequence is metaphoric, not a result of temporal progression. When the cult or art object has aura, the object may exist in the present time, even though a present time more usually strips the aura from reality. It is the aura's function that changes from cloud to fog, but the functions can actually coexist in time. The implications of aura depend on Benjamin's choice of emphasis. Aura is capable of either enveloping (some sense of concealment is involved here too), or, by its removal, disclosing. In a later chapter, Proust will be used to illustrate how a beloved person is seen only through an aura of tenderness and how that aura, when it is withdrawn for a single moment, must then be gathered again about the beloved person.

Benjamin's description of Atget's photographs is that they strip the aura from reality. Benjamin goes on to characterize the photographs in ways that help to explain, in his next leap of thought, the photographic illustrations for André Breton's surrealist novel *Nadja*. Atget's "Porte d'Arcueil fortifications are empty, as are the regal steps, the courts, the terrace cafes, and as is appropriate, the Place du Tertre, all empty." Benjamin continues: "They are not lonely but voiceless; the city in these pictures is swept clean like a house which has not yet found its new tenant. These are the sort of effects with which Surrealist photography established a healthy alienation between environment and man, opening the field for politically educated sight, in the face of which all intimacies fall in favor of the illumination of details."[23] For Benjamin's specific discussion of *Nadja*, one has to turn to his essay on surrealism, where he recalls Breton's passage on the bar in a particular café, "the last restaurant designed for love": "In such passages in Breton, photography intervenes in a very strange way. It makes the streets, gates, squares of the city into illustrations of a trashy novel, draws off the banal obviousness of this ancient architecture to inject it with the most pristine intensity toward the events described, to which, as in old chambermaids' books, word-for-word quotations with page numbers refer."[24] The streets are deserted in the *Nadja* photographs, as in Atget's. Their depictions have the specificity of the world of things, "the illumination of details." But in a typical reversal, Benjamin describes this process of illustration as a special revelation of the real meaning of the ancient architecture, which is its relation to Breton's text, the "events described." These photographs, as well as At-

get's, "suck the aura from reality like water from a sinking ship." The intervention of photography, which Benjamin calls strange, is strange indeed. The photographs are the banality drawn off, whereas the text fills the ancient architecture (and thus the city) with pristine intensity. The text creates the city of Breton's imagination, which is at the same time the real city of Paris. The city is created anew, and thus seen anew by the text; photographs are devices to draw off significance from, by drawing attention to, the banal conventional nonseeing aspects of the streets and buildings.

Several factors are ignored in Benjamin's criticism, which makes parallel comments on Atget's photographs and the illustrations to *Nadja*. Somebody, somewhere, looking at the illustrations and reading the *Nadja* text, must have been laughing, whereas nobody laughs when looking at Atget's work. What these photographs have in common is the magic of Benjamin's words, heavy with implications of political sensibility and revolutionary ardor informing empty streets. The illustrative photographs for Breton's novel show deliberately reductive scenes stripped of nostalgia. Not only are there no people, but the photographs are taken from a distance that does not allow one to distinguish details of the street or the architecture. The photographs are connected with the text by the "word-for-word quotations with page numbers," but with such absurd repetitions as, for Plate 1, "My point of departure will be the Hôtel des Grands Hommes (see page 23)," and in the photograph above the caption, a huge sign is stretched across the facade of the building reading "Hôtel des Grands Hommes." Or with absurdity of a different kind, the caption for Plate 44 reads, "I envy (in a manner of speaking) any man who has the time to prepare something like a book (see page 147)." Plate 44 is a photograph of André Breton, looking very solemn, by Henri Manuel. Page 147 begins a chapter with the words, "I envy (in a manner of speaking) any man who has the time to prepare something like a book and who, having reached the end, finds the means to be interested in its fate or in the fate which, after all, it creates for him." Some of the photographs have credits, some do not. Man Ray was one of the photographers, Jacques Boiffard another.[25]

Benjamin seemed not to be interested in naming or perhaps knowing the photographers who made the pictures used in *Nadja*. Nothing that involves Man Ray can be taken as deadly earnest, although this is not to

call into question the seriousness of Breton. Man Ray, who invented his name as in some sense he invented as well as realized himself, reached out for absurdity as devoutly as some men reach for morality. His openness and irony, about himself as well as life, attracted him to Marcel Duchamp in 1915, when they met in New York (literally in New Jersey, but both were within the New York ambiance, Duchamp having exhibited *Nude Descending a Staircase* in the 1913 Armory show, Man Ray just at the beginning of what he intended to be a career in painting). The coupling of their names emphasizes an affinity in their attitudes. They hit it off when they met. Through Duchamp, Man Ray met the Dadaists in Paris. Breton dominated the group and later became the leading theoretician of the surrealist movement. Roland Penrose, who moved in the same circles and knew Man Ray well, says:

With an ardent desire to explore Paris in every sense and every direction and to learn French, Man Ray set out, usually on foot to save his meagre resources. His flair for noticing those things usually passed over by others helped him rapidly to discover the mysteries and to adapt himself to the banalities of the life of a city that at once enchanted him. It was in fact the way of living that interested him, rather than the great monuments.[26]

This was the kind of knowledge of the city that Breton chose for his photographic illustrations. J. H. Matthews says that Breton's "aim in utilizing photographs of certain Paris landmarks is not an impression of greater realism." The photographs are instead related to Breton's words in *Nadja*: "What I regard as the objective, more or less deliberate manifestations of my existence are merely the premises, within the limits of this existence, of an activity whose true extent is quite unknown to me." It is not clear how the photographs are related to these manifestations, even if one is willing to believe that the photographs are not "an impression of greater realism."[27]

Benjamin is less precise, but more accurate, when he chooses Breton's own instrument, metaphor. Benjamin identifies "trashy novels" as old books read by chambermaids; such books characteristically have illustrations keyed to the text. The pristine intensity of Paris's ancient architecture is arrived at by drawing off its banal obviousness (its film, its surface, its appearance) in the photographs. The injection of pristine intensity is achieved in the text; the photographs are the visual banal and

obvious pointers to events described in the text, provided only to differentiate the ordinary appearance of the scene as it occurs in the photograph from the mysterious true meaning as it is disclosed in the text. Such disclosure is, to be sure, only proximate, but it is closer to the real than the impression of the real in the photograph, which is truly an illusion.

In both views, that of Benjamin and that of Matthews, the illustrations are a significant part of the book *Nadja*. A more recent commentator, Wendy Steiner, however, believes that Breton's photographic illustrations are a failure. She quotes Breton to this effect but ignores the ironic tone of his passage:

I have begun by going back to look at several of the places to which this narrative happens to lead; I wanted in fact—with some of the people and some of the objects—to provide a photographic image of them taken at the special angle from which I myself had looked at them. On this occasion, I realized that most of the places more or less resisted my venture, so that, as I see it, the illustrated part of *Nadja* is quite inadequate.

Steiner's excerpt ends there. The passage continues with a colon after "inadequate" instead of a period:

is quite inadequate: Becque surrounded by sinister palings, the management of the Théâtre Moderne on its guard, Porville dead and disillusioning as any French city, the disappearance of almost everything relating to *The Grip of the Octopus* and, above all—for I regarded it as essential, although it has not been otherwise referred to in this book—the impossibility of obtaining permission to photograph an adorable wax-work figure in the Musée Grevin.[28]

In other words, the illustrated part of *Nadja* is inadequate because there are not enough photographs, not because the illustrations are "evidentiary devices whose thesis has ceased to exist, pictures which no longer illustrate."[29] Breton is enumerating a list of illustrations that for various reasons he wanted to include but could not, or is pretending to have such reasons so as to list illustrations not included and possibly nonexistent.

Benjamin is, if not the most convincing critic of the photographs in Breton's *Nadja*, the most inventive. The photographs themselves are annoyingly banal, without any of the virtues ordinarily admired in photographs: clarity, elegant delineation of tone between highlights and blacks, interesting forms, elimination of nonessential details. Above all, the photographs are not allusive. One peers at them intently without discerning

meaning, wit, or purpose. Their meaning is their relation to text. In themselves, they are deliberately dull. Even Man Ray's portraits—of Breton himself, of Paul Eluard, Robert Desnos, and Benjamin Peret—are depressed by bad printing and referral to a text that insists reality is only in the text, whereas in other settings those same portraits shine dramatically in their own light.

Other surrealists used photographs wittily. An illustration in the last issue of *La Révolution surréaliste* is a representation of a nude woman by Magritte labeled "je ne vois pas la [femme] cachée dans la forêt," surrounded by a frame of photographs, each little square a recognizable surrealist with his eyes closed (see illus. 3). This illustration is self-contained. The text, as later in Magritte's "Ceci n'est pas une pipe," comments on the picture and is a part of it. In the first instance it confirms the drawing, though in a far from simple way; and in the second instance it contradicts the drawing in a way that suggests all the complications between text and drawing, words and image. In the use of the photographs for frame, there are no attributions to photographers. Surrealists bent the meaning of photographs to their will, making us see them in a way governed by their texts. In their publications, they paid little attention to the quality of prints but forced the viewer to incorporate whatever was depicted into understanding of the *ideas* expressed.

The last photographer Benjamin mentions in the "Short History" is August Sander. Benjamin praises him for the series of photographs illustrating kinds of work or economic and social class—a generalizing bias greater than can be sustained by the illustrations themselves. Benjamin's admiration for Sander is not based primarily on the photographs but on the idea of compiling the record of professions. According to Benjamin, "the Russian film provided an opportunity to show people in front of the camera who were not being photographed for their own purpose," that is, ordinary people, not actors, were filmed. "And suddenly," he continues, "the human face entered the image with a new, immeasurable significance. But it was no longer a portrait. What was it?" It was a body of work larger than the sum of its parts. "Overnight," Benjamin concludes, "works like those of Sander can grow into unsuspected actuality. . . . One may come from the right or from the left—he will have to get used to being viewed according to where he comes from." A politically and class-divided society is grouped by function (see illus. 4–7). That very

3. René Magritte, *je ne vois pas la [femme] cachée dans la forêt*, from *La Révolution surréaliste* No. 12, 15 Dec. 1929. Surrealists in frame: top row, Maxime Alexandre, Louis Aragon, André Breton, Luis Buñuel, Jean Capuenne; second row, Salvador Dali, Paul Eluard; third row, Max Ernst, Marcel Fournier; fourth row, Camille Goemans, René Magritte; bottom row, Paul Nougé, Georges Sadoul, Yves Tanguy, André Thirion, Albert Valentin.

fact allowed an unselfconscious and stolid, artless presentation which swallowed the individual in the signs of the occupation that gave him identity. Or this is the way Benjamin saw and described the Sander photographs; they are no longer seen exclusively as Benjamin saw them or as Sander meant them to be seen.

Beaumont Newhall speaks of Sander's "utterly nonpolitical stance,"[30] even though he mentions that the Nazis confiscated the first published volume of the projected series. Again the use determines the meaning. Robert Kramer spells out the possible reasons for the 1934 confiscation: Sander's son Erich actively opposed the Nazi regime; Alfred Döblin, of Jewish extraction, had written the introduction; photographs of "Jews, Communists, revolutionaries, Gypsies, and Negroes" were included (no racial purity there). And Kramer points out finally that Sander showed men and women as they worked, without heroicizing. "That Sander was on a collision course with the Nazi myth mechanics was even more inevitable because both were drawing upon an old, compelling intellectual tradition—the concept of physiognomy."[31]

If the concept of physiognomy is no longer compelling, Hippolyte Taine's trope, that "time scores us and furrows us as a pick-axe the soil, and thus exposes our moral geology," is still enthralling. To look at the Sander photographs, ranging as he described his project up from peasants to artists and professionals and then down again to the idiot, is to see clothes, attitudes, backgrounds, and then differences between those depictions and any other experience of country, city, and the stratifications of society. Insofar as these differences exist, the characterizations in the photographs must be called distinctively German. This is the way Sander conceived them.

But this static labeling is an unsatisfactory way of describing a society, although photographers still try to grasp and convey the character of a people by multiplying individuals. Even if we take the Sander photographs at their professed value, illustrating with exactness types of social class, the "types" have to be captioned or we mistake the class. Nothing about the photographed persons is familiar or necessary in other systems of recognition. The Sander revolutionaries might as well be schoolteachers if one relies on visual evidence alone; an industrialist could as well be a banker (but not a laborer—too well dressed); the student could be a dancer—his pose suggests both showmanship and suppleness; the mu-

4. August Sander, *Revolutionaries*, 1929
© 1994 ARS, New York/VG Bild-Kunst, Bonn.

5. August Sander,
Industrialist, 1925

. August Sander,
Gymnasium student, 1926

7. August Sander,
Museum director, 1932

seum director, who represents the scholar, looks remarkably like one of the revolutionaries who could have been mistaken for a schoolteacher. The only firm identities are those of men dressed in work clothes with the tools of their trade evident. The original use of the photographs, to illustrate the range of social classes in Germany, is no longer available to most viewers. The original use can be revivified by means of the captions, perhaps always needed for sure interpretation, but another use must be identified for later interpretation, without abandoning the original use as the declared intention of the maker.

The photographs once had the fascination of the familiar, which may have been one of the reasons they were banned by the Nazis, but they now have the fascination of the strange. They would always have had the fascination of *difference* for some, especially for Americans. *Young farmers on their way to a dance, Westerwald, 1914* (illus. 8) shows three young men dressed up in suits and ties pausing in their walk on a dirt path across a flat field, with three canes in three right hands, hats on heads, faces turned toward the viewer, a cigarette dangling from the mouth of one. Path, fields, and sky form three roughly horizontal divisions. Against the light path the solidly set feet show darkly; against the darkish fields the much darker suits enclose the solid young male bodies; against the pale sky the black hats set off the faces intently turned toward the camera. The figure on the left is the odd man out. He is the one with the cigarette, the one whose glance is arrogant or defiant. His cane shapes an oblique angle to the ground, whereas the other two canes are sedately at a right angle. If all three men had looked as the two on the right look, each a copy of the other, one might have expected them to break into a song and dance, twirling their canes, and the background might have looked like a stage set. Not only does the eccentric position of the third man prevent such a frivolous account; the date of 1914 prevents it, with all that that date implies of the future of young German men.[32]

Post-Benjamin interpretation of Sander has been roughly consistent, from the passing comment by Helmut and Alison Gernsheim that "he gave an unflattering portrait of a cross-section of Germany's social structure"[33] to Robert Kramer's reference: "Sander's genius was to let his subjects appear as they were, to let each face relate its own history. Many of these faces were etched with weariness, hardship, sorrow, reserve, acceptance."[34] Letting subjects appear as they were is probably the same as

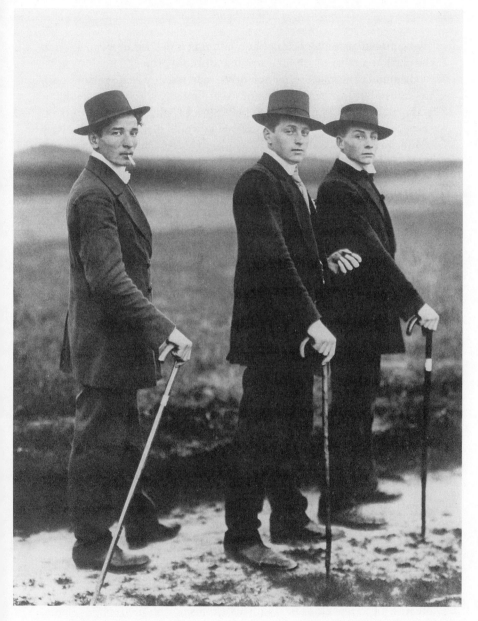

8. August Sander, *Young farmers on their way to a dance, Westerwald*, 1914

giving an unflattering portrait, if unflattering is defined by opposition to the placid banality of studio portrait and studio props.

Benjamin admired Sander not for the individuality of the persons photographed but for the possibility of scientific grouping so accurate that it was predictive: "Overnight, works like those of Sander can grow into unsuspected actuality." Political power shifts would make the social classes significant in ways unforeseen by Sander. This reasoning was offered by Benjamin in 1931 (when the "Short History of Photography" was published) as incentive to continue publication of the Sander photographs after the first volume of 1929, but the Nazi ban (1934) killed those hopes.

The photographs can no longer be described as a scientific contribution either to political or other necessary groupings. They are the unified vision of August Sander, his expression of his world. In that expression he recognized the genius of place and time. Although he has enabled later viewers to share his perception of persons, place, and time, that later understanding, that later perception, operates in ways different from his and from Benjamin's. This is not because later viewers are wiser than either but because a removed and more distant past includes both Sander and Benjamin and includes as well not only the First World War, into which the young farmers must have disappeared, and the Second World War, which occasioned the death of Benjamin and the desolation of Sander, but the continued bitterness of even later wars and what may seem a smaller, meaner, faster-decaying world.

In brief, "A Short History of Photography" is not a history but a review of the books listed in Benjamin's notes: the Bossert and Guttmann collection of 200 photographs (1930), the Heinrich Schwarz book on David Octavius Hill (1931), Karl Blossfeldt's photographs of plants (1930), Atget's photographs (1931), and Sander's photographs (1929). The Bossert and Guttmann volume yielded all the names and work of photographers Benjamin discusses aside from the single-photographer volumes, and of those he uses Blossfeldt only as an example of the "optical unconscious." By this he means that "photography opens up in this material the physiognomic aspects of the world of images, which reside in the smallest details, clear and yet hidden enough to have found shelter in daydreams. . . . Thus Blossfeldt, with his astonishing photographs of plants, brought out the forms of ancient columns in horsetails, the bishop's staff

in a bunch of flowers, totem poles in chestnut and acorn sprouts enlarged ten times, gothic tracery in teasel."[35]

This is all Benjamin says about Blossfeldt or his photographs, but the images are memorable. Although he claims that such photography establishes the difference "between technology and magic," with the camera presumably representing technology, the fact is that the language he uses to describe both process and photographs is magical and tends to distract attention from any literal distinction that he may legitimately be making. It is one thing to perceive with him that enlargement of details through mechanical processes, a fixing of enlarged vision, enables the eye to see the "optical unconscious," that is, the unseen (by the naked eye) made visible, but quite another to describe what that opened eye sees as if it were an imprint of what previously was "hidden enough to have found shelter in daydreams," in other words, as if the optical unconscious were literally a Freudian unconscious. The way Benjamin's mind works is what makes him exciting to read and also what makes him confusing to interpret, or rather what makes everything written on photography after him seem to have been inspired by him.

If I now turn to "The Work of Art in the Age of Mechanical Reproduction" with what may seem in dismaying prospect the same effort of laborious comprehension, that is because no other way of understanding Benjamin occurs to me and also because no better way of understanding photography has occurred to me. One fights with Benjamin (or struggles with his text) not to win an argument but to discover what the argument is.

Once more the concept of aura changes in "The Work of Art in the Age of Mechanical Reproduction."[36] Now it is the perception of man that has altered. The subject has changed rather than the object. Organization of perception, discerned through the actual works of art produced during a period, can also define social organization, according to Benjamin.

To illustrate how this change from object to subject affects the concept of aura, Benjamin introduces in "The Work of Art" a formulation that became familiar in the "Short History"—introduces, in fact, almost the identical passage (224–25): "We define the aura of the latter [natural objects] as the unique phenomenon of a distance, however close it may be.

If, while resting on a summer afternoon, you follow with your eyes a mountain range on the horizon or a branch which casts its shadow over you, you experience the aura of those mountains, of that branch. *This image makes it easy to comprehend the social bases of the contemporary decay of the aura"* (emphasis added). The aura of natural objects is again identified with an atmosphere, and the atmosphere is perceived as distance. If a concomitant of aura is to be distance, then its opposite, closeness, destroys aura. Reproductions bring "reality" closer. Distance and closeness have been invoked to represent the constitution of aura and the decay of aura. Uniqueness and permanence are identified with distance; transitoriness and reproducibility are identified with closeness. Benjamin had established these oppositions and definitions in the "Short History," but here he goes one step further. Reverting first to the notion of the oyster (object) in its shell (aura), he says (225): "To pry an object from its shell, to destroy its aura, is the mark of a perception whose 'sense of the universal equality of things' has increased to such a degree that it extracts it even from a unique object by means of reproduction." So far, the image repeats what Benjamin said earlier. But he goes on to add a new idea: "Thus is manifested in the field of perception what in the theoretical sphere is noticeable in the increasing importance of statistics. The adjustment of reality to the masses and of the masses to reality is a process of unlimited scope, as much for thinking as for perception." Statistics seem to have gotten into the discourse by reducing particular cases, or even multiplied reproductions, to the simplicity of sheer numbers, which conceal as much as they disclose. It is appropriate in the context of "masses" and "reproduction" and "extraction" of aura, "extraction" being the same figure as "sucking the aura from reality." The idea of perception, more important but much vaguer, awaits development before becoming intelligible.

A sweeping statement beginning Section III of "The Work of Art," from which the above quotations are taken, sets the scene. "During long periods of history, the mode of human sense perception changes with humanity's entire mode of existence." The changes have social causes (224). These assertions are obviously true, but whether they have the force and the consequences Benjamin attributes to them is not so obvious, nor is it at all obvious that changes in perception, however caused, are subjective rather than a reflection of what is actually occurring in the objective

world. My inclination, as usual, is to claim that both are true and, not only that, but they are inseparable.

Benjamin's argument shifts ground from time to time, as in the case of good aura and bad aura. A similar shift occurs in his discussion of what constitutes the uniqueness of a work of art. Embedded in tradition, it was originally a cult object "in the service of a ritual—first the magical, then the religious kind" (225). Ritual was "the location of its original use value" (226). Ritual was still the basis of the cult of beauty into which ritual was transformed during the Renaissance. The dramatic turn in the history of art occurred with the invention of photography and the simultaneous rise of socialism, to which, according to Benjamin, art responded with the doctrine of art for art's sake. "This gave rise to what might be called a negative theology in the form of the idea of 'pure' art, which not only denied any social function of art but also any categorizing by subject matter" (226). As a consequence, Benjamin goes on (226), "mechanical reproduction *emancipates* the work of art from its *parasitical* dependence on ritual" (emphasis added). Suddenly the aura of ritual has become unwanted and despised, that from which the work of art is emancipated. Once more aura has become not cloud but fog. In fact, however, the figure has changed so that fog is not the most useful metaphor. Emancipation from parasitical dependence is good, just as stripping the aura (as fog) from reality is good, but in the figures of emancipation and parasitism Benjamin is easing the way to what he thinks of as political consequences of techniques of reproduction.

Benjamin uses the term *reproduction* for photographs of works of art. (Uses of photographic reproduction of other kinds, that is, of persons, places, things, and the dramatic representation of those in movies, are considered separately here but are often referred to by Benjamin as if they were all one.) Such photographs are in theory infinitely reproducible, thereby destroying the notion of authenticity *for the photograph* and vitiating the notion of authenticity for the work of art in that the function of a reproduction can have no connection with the idea of ritual originally attached to the work of art. The function of art then becomes, according to Benjamin, political.

Benjamin's argument is piecemeal. It cuts from century to century, beginning with the primitive religious cult value of the object worshiped and ending with the movies, equated not with dramatic performance, or not

primarily with that, but with their celluloid reproducibility and thus their availability to "the masses," to everyone. This is one political aspect of the new technology. Another is the exhibition value of the work of art rather than its ritual or cult value. In a curious pronouncement indefensible by any resort to facts, Benjamin equates the "superiority" (228) of exhibition value to ritual value by citing Atget's photographs of deserted Paris streets. These photographs have "hidden political significance" (228) because they are empty, because captions can direct attention to significant elements or read significance into the absence of elements. Today, this dimension of Atget's photographs is lost, if it ever existed, as a primary aspect. Of course the photographs are evidence of what Atget saw, and he saw Paris in a particular way at a particular time. Now that time is identified as past, and the photographs are "evidence" in that sense. They record a Paris that no longer exists.

But Benjamin's emphasis quickly shifts from such pronouncements to his real interest, the movies. (I use this term instead of *film*, even though *film* is the term consistently used in the Benjamin translation, partly to demystify the subject and partly to emphasize a crucial distinction between still and moving pictures, even though both are subsumed under "photography.") Benjamin's statements about the movies are wonderfully and imaginatively wrong and intensely interesting and challenging.

Who but he would suggest that it is the right of every man to look forward to being "reproduced" in a movie? "Some of the players whom we meet in Russian films are not actors in our sense but people who portray *themselves*—and primarily in their own work process. In Western Europe the capitalistic exploitation of the film denies consideration to modern man's legitimate claim to being reproduced" (234). Still, it was the urge to be reproduced that made the tintype so popular during the American Civil War, that is obvious today in the number of photographs taken by families, tourists, and other amateurs, and that undoubtedly is sustained by an irrepressible wish for life, however fragilely recorded, beyond death. It is only the extension of that urge, in a perfectly matter-of-fact way, to moving pictures that makes it seem odd and out of place. And even if it seems so in Benjamin's text, the urge has been fulfilled in home movies and private videotapes. But the thrust of Benjamin's contention is not that the actual narcissistic desire to see oneself reproduced is important but that it is important that reproduction be available to all. He

seems to have been impressed by newsreel or documentary Russian films that showed factories operating with real workmen, or women, really working. It is not clear whether Benjamin would have regarded extras in commercial movies, even when they were not actors, as appearing by "right," or whether he might have thought they simply enjoyed their fortuitous lucky "reproduction," or their temporary connection with the professional actors and all the drama (as well as tedium) of production, or even whether he might have thought of the paycheck as payment for work.

Before going on to the changes occasioned by the technology of the movies, I should call attention to a stylistic change in Benjamin's "Short History" and "Work of Art," signaling a substantive change. The passage already quoted (once from each essay) about the aura of natural objects uses the personal pronoun "you," or "the observer," in both cases referring to the individual. ("If, while resting on a summer afternoon, you follow with your eyes a mountain range on the horizon or a branch which casts its shadow over you, you experience the aura of those mountains, of that branch.") The stylistic shift is from the observer to "the masses." The paragraph in "The Work of Art" which begins with the sentence just quoted ends with the sentence, "The adjustment of reality to the masses and of the masses to reality is a process of unlimited scope, as much for thinking as for perception" (225). The difference is that "you" see individually if nature—mountain, branch—is involved. At the movies, you see collectively, in multiple units; "you" become a unit in "the masses." This is the case if "you" are a member of the audience.

If "you" are an actor, the transition from being a performer on stage to being a unit in the film is even more painful and difficult, according to Benjamin and also according to Luigi Pirandello, whom Benjamin quotes on the subject of acting in moving pictures. Their accurate understanding, Pirandello's from experience and Benjamin's from reading and theoretical projection, is that in the film, as Benjamin expresses it, "man [the actor] has to operate with his whole living person, yet forgoing its aura. For aura is tied to his presence; there can be no replica of it" (231). One might speculate that aura and person are reunited in the minds of the audience because film stars, even now when they are not all Hollywood glaze and glitter but are hardworking members of society, are nevertheless politically and personally influential beyond their competence as a result of the

dreams invested in them. Benjamin refuses to grant that this is aura. "The film responds to the shriveling of the aura with an artificial build-up of the 'personality' outside the studio. The cult of the movie star, fostered by the money of the film industry, preserves not the unique aura of the person but the 'spell of the personality,' the phony spell of a commodity" (233). The fallacy in this reasoning has to do not with the passage of time and the dissipation of the star system, with all its publicity, but with the notion that the star system had to be sold to an audience. It was sold, to be sure, but it was also bought—not necessarily, as Benjamin implies, with the eagerness of the born sucker but with the eagerness that Benjamin attributes in another passage to a different value in the movie:

Our taverns and our metropolitan streets, our offices and furnished rooms, our railroad stations and our factories appeared to have us locked up hopelessly. Then came the film and burst this prison-world asunder by the dynamite of the tenth of a second, so that now, in the midst of its far-flung ruins and debris, we calmly and adventurously go traveling. With the close-up, space expands; with slow motion, movement is extended. . . . The camera intervenes with the resources of its lowerings and liftings, its interruptions and isolations, its extensions and accelerations, its enlargements and reductions. The camera introduces us to unconscious optics as does psychoanalysis to unconscious impulses. (238–39)

The beauty of that final statement is that its algebraic form, A is to uB as C is to uD, allows the possibility that A has a good deal in common with C, as well as that unconscious optics has a term in common with unconscious impulses. The further conclusion is that the movies have access to and can give expression to unconscious impulses. Previously, unconscious optics seemed to mean to Benjamin those phenomena invisible to the naked eye but disclosed by means of lenses capable of enlarging details. Here it must mean something different. It means, in effect, point of view—of director, story, and total edited moving picture, a totality for which Benjamin makes the camera stand symbol. "Calmly" in the passage quoted above has only the force of acceptance of the conditions in which the film is seen, the darkness, release from responsibility for what happens on the screen, entrance into an alien narrative with which, if members of the audience cannot precisely identify, there is nevertheless some part that strikes those unconscious impulses and gives them form and substance in the imagination.

Benjamin does not express this directly. The experience of viewing a movie is described differently, as Benjamin reverts to Edgar Allan Poe's account of "shock." Benjamin thinks of the film as a sequence of frames, as if a viewer saw one frame and then the next, whereas the whole point of a moving picture is that the eye cannot pause, or distinguish, between one frame and the next. The illusion of movement is complete. When he compares the canvas of a painting to the screen of the movie, he says: "The painting invites the spectator to contemplation; before it the spectator can abandon himself to his associations. Before the movie frame he cannot do so. No sooner has his eye grasped a scene than it is already changed. It cannot be arrested. . . . This constitutes the shock effect of the film, which, like all shocks, should be cushioned by heightened presence of mind" (240). One element omitted in this account is the pleasure of the experience. The thought of going to see a movie has very little to do with bracing the will and fortifying the mind against the shock of successive frames but a good deal to do with release from the everyday prison of routine. Even the most serious and committed moviegoers would hardly continue if they did not derive some pleasure, not just instruction, conversation, or critical terms, from it. No social conventions require attendance.

Benjamin's contrast between the reception of movies and paintings depends on his identifying the reception of movies by the masses as distraction and the reception of paintings by the individual as absorption. Movies are diversion of attention; painting is the object of concentration. In respect of movement, however, he omits stage drama as comparison at this point because that would invite legitimate notice of similarities, while Benjamin wants to emphasize only differences. When he does use live drama as an example, he proposes that "the poorest provincial staging of *Faust* is superior to a Faust film in that, ideally, it competes with the first performance at Weimar. Before the screen it is unprofitable to remember traditional contents which might come to mind before the stage—for instance, that Goethe's friend Johann Heinrich Merck is hidden in Mephisto, and the like" (245, n. 3). The film may cut off history of performance or may necessitate a critical gap between comparison of stage performance with film performance, but I see no reason why Merck should not be hidden in a film Mephisto as much as in a stage Mephisto,

if indeed the biographical approach is useful at all except to those already familiar with both the approach and with Goethe.

Benjamin makes a more telling comparison than that between a movie and a painting, this time between the reception of movies and the reception of architecture. "Architecture," he says, "has always represented the prototype of a work of art the reception of which is consummated by a collectivity in a state of distraction" (241). People go in and out of public buildings too intent upon their private business to concentrate on the buildings. He goes on:

> Buildings are appropriated in a twofold manner: by use and by perception—or rather, by touch and sight. Such appropriation cannot be understood in terms of the attentive concentration of a tourist before a famous building. On the tactile side there is no counterpart to contemplation on the optical side. . . . For the tasks which face the human apparatus of perception at the turning points of history cannot be solved by optical means, that is, by contemplation, alone. They are mastered gradually by habit, under the guidance of tactile appropriation.

Perhaps tactile appropriation can be thought of as like the orientation of a blind person in the space of enclosures, with that sense of obstacles that comes from the resistance of air currents or the almost imperceptible sound of echoes and presences. Benjamin is determined, however, to equate habit with distraction and to insist that habit and distraction together mean absence of thought. A most improbable line of reasoning follows: "Distraction as provided by art presents a covert control of the extent to which new tasks have become soluble by apperception." If architecture is the art, and apperception is the habitual conscious adjustment of self to space through which we move, then covert control means that the architect can plan his space in such a way that one will be directed to go in certain paths, or even react to the space in certain ways, without realizing that such direction or reaction has been predetermined. This would certainly be a familiar idea to any good architect. How Benjamin gets from there to the film is circuitous and to my mind treacherous. "Since, moreover, individuals are tempted to avoid such tasks, [the "new tasks" in the first sentence quoted], art will tackle the most difficult and most important ones where it is able to mobilize the masses. Today it does so in the film" (242). So arrives the juncture between politics and the film. The shock of the film, whether one assumes the shock alerts and energizes

the mind, or in Benjamin's words "should be cushioned by heightened presence of mind," no longer operates as either alternative, but instead enters the realm of propaganda. As the architect controls the reactions of people who move through a building, a film is able to control the reactions of an audience in such a way as to direct thoughts and presumably actions.

Is this true? The answer must be, not simply true, and not simply false, not every time, not every place, not for every audience, or all in any audience, but how it is true or false, and for whom, are discriminations not easily fixed. In architecture, we see clearly that where the architect builds a wall, he must also cut a door if he wants us to penetrate this wall. The structure of a work of art can be compared to this wall and this door, that is, to the construction of obstacles and pathways to a central meaning, but it requires more sophistication to perceive the equivalent of a wall in fiction than to understand that no one can walk through a solid architectural wall. Even the most generous reading of a text can never include everything imaginable; not just omissions, but prohibitions equivalent to walls exist in texts, and in movies and in all works of art.

Work of art is a confusing term if it implies that all works on film are works of art. My assumption is simply that film is a medium available for works of art, not that all moving pictures are works of art. Art understood as propaganda, or the movies interpreted as propaganda, is the only justification for Benjamin's statement that individuals avoid the "new tasks" that are better performed by "art." Benjamin implies that the "new tasks" are too big and too formidable for the individual, as if a collective decision by, presumably, the "state," or officials, would enable the "artists" to "mobilize the masses" by means of their projections. This formulation might work if the masses would just play their part and obediently be mobilized, as they do and are when the band plays marches and units of the army go off in a choreographed goosestep with the leg-swinging synchronization of the Rockettes, but thought control is not as easy, or as readily achieved, as patriotic action promoted and reinforced by tradition. In commenting on the Eisenstein film *Potemkin*, Benjamin says:

Why bemoan the political deflowering of art now that we have tracked down two thousand years of creative sublimations, Oedipus complexes, libidinal leftovers, and infantile regressions? But this is how the bourgeois theory runs in a period of

decadence: art can venture as much as it likes into the most disreputable back alleys as long as it remains a good girl in politics and does not start dreaming of class warfare.[37]

Benjamin approves of art's coming out fighting for class warfare.

My concern is not with *Potemkin* but with Benjamin's level of abstraction, too remote for exact comprehension, together with his seductively persuasive concrete details used as terms of comparison. One is able to forget that "art" is not a single entity (except in discourse) when it is the subject of such a vivid figure as the venture into back alleys. The Marxist terms—"bourgeois theory," "period of decadence," "class warfare"—are not being argued in the passage quoted but are taken for granted as if their acceptance and intelligibility were a rational consequence of seeing the world clearly. Propagandistic "art" would serve the purpose of inducing others to see thus clearly. Art becomes rhetorical, with its own devices of persuasion.

Benjamin takes seriously the photographs he comments on. He requires attention to the pictures as well as to his descriptions. Pictures and descriptions fit together and enhance each other. The next chapters explore further how imagination, photograph, and description may work together.

4

Untitled

Benjamin is aware of the power of description in the case of the photograph, though he denies it for the painting: "With Atget, photographs become standard evidence for historical occurrences, and acquire a hidden political significance. At the same time picture magazines begin to put up signposts for him, right ones or wrong ones, no matter. For the first time, captions have become obligatory. And it is clear that they have an altogether different character than the title of a painting."[1] Not at all. They have the same character, as Danto makes clear, although they differ in the usefulness of their titles. Just as not all paintings are red rectangles, and if they were, titles would be the more necessary, so many paintings can be understood by the viewer's own supply of information or understanding of how paintings are meant to be viewed, information that takes the place of titles. The fashion among abstract painters to call their works *Untitled* had its origin in a reaction against words as corrupting agents that obscured rather than clarified vision. Indeed, when the content of a painting is not representational, use of conventional description limits the interpretation. A new vocabulary of criticism had to be invented to describe without limiting, one emphasizing sensations, feelings, dreams, and their connection with thickness of paint, color of paint, and its texture on surface—all the physical characteristics that could be described without attributing to their disposition any specific prototype in the world of objects. The use of *Untitled* is a tribute to the power of words.

Descriptions, or descriptive titles, set limits to expectations, direct attention to subject or context, perhaps name the time and place. Many

photographers locate their subjects by using place and date as title. Walker Evans has *Brooklyn Bridge, New York, 1929; Store Window, Brooklyn, ca. 1931; Bedroom Dresser, Newcastle, Maine, ca. 1967.* Edward Weston has *Cypress Root, 1929; Kelp, 1930;* and *Pelican's Wing, 1931.* But Weston also uses *Untitled* for nude females, or parts of nude females, probably because to mention a date, let alone a name, might identify the model and allow associations irrelevant to the formal presentation of design in the photograph. *Untitled* is the equivalent of *Still Life* or *Landscape.* It signifies reticence about going further than what viewers can see for themselves and delicately refrains from nudging them with suggestions. Walker Evans, too, does something of the kind when he uses generic titles for a set of pictures. *Subway Portrait* applies to any one of the series of pictures taken with his concealed camera, in available light, on the New York subway.

Many titles are so conventional as to remain unexpressed. Landscape, still life, street scene, beggar, snapshot of family, birthday party, and new baby are visually explicit motifs without words, but as photographs they gain from specific titles identifying place, date, scene, or in some cases names. If names are omitted, as they often are in the work of professional photographers interested primarily in some aspect of the photograph other than the identity of the subject, the viewer must identify that other aspect. The women with veils photographed by Jacques-Henri Lartigue or Diane Arbus are examples of women not as themselves but as symbols of a condition of being, or an attitude, totally different in the conception of each photographer but alike in representing something other than what their individual names would have suggested—quite other than a portrait.

Visual information can be generalized within various schemata but is particularized in extent and meaning if what is ambiguous in visual context is clarified by words. Magritte's *Ceci n'est pas une pipe* (illus. 9), a representation in which the words play against the literal representation of a pipe, is described by Michel Foucault in *This Is Not a Pipe*: "What misleads us is the inevitability of connecting the text to the drawing (as the demonstrative pronoun, the meaning of the word *pipe*, and the likeness of the image all invite us to do here)—and the impossibility of defining a perspective that would let us say that the assertion is true, false, or contradictory."[2] Misleads? Teases, entertains, and propels us, or, since

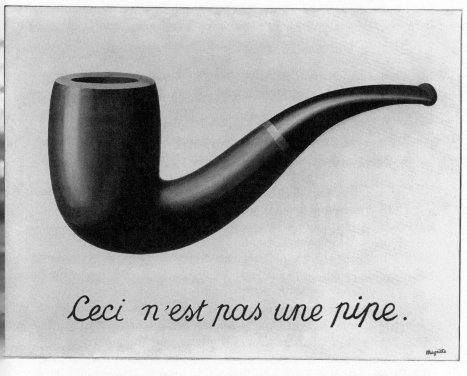

9. René Magritte, *La Trahison des images (Ceci n'est pas une pipe)*. © C. Herscovici

Foucault has obviated the necessity by his explication, might have propelled us into discussion of how to think about this provocative representation of Magritte's.

A scene in the Beatles' movie *Help!* shows Ringo Starr confronted suddenly by a tiger. Just after the animal has padded into the picture frame, the words "A tiger" appear on the screen, invoking a range of associations—silent screen captions, the absurdity of labeling what is obvious, comic strip techniques, cliffhanger moments of tension—but most emphatically undercutting the tiger as threat and danger. As soon as the words appear the audience knows the tiger has been distanced and secured in a frame that no longer permits the tiger to be a threat. To read a

label the reader must be outside. The words appear in the same frame as the approaching tiger. Although any words in the picture frame will suggest silent movie captions, the words are not all performing the same function. Captions for silent movies appeared as white words against a black ground, inserted as a separate frame in the narrative film to clarify the action. "A tiger" in *Help!* is superfluous as explanation. Its function is comic and delimiting.

In Michelangelo Antonioni's *Blow-Up*, a professional photographer takes pictures in a park because he finds the landscape beautiful. When he develops the film, some obscure and barely readable figures in the background suggest that he has inadvertently included the picture of a murder. His passion of curiosity about what is actually on the film and what it means requires that he repeatedly enlarge (blow up) the frames to discern the details. But the enlargements produce their own distortions in graininess and ambiguity of outline. His best technical efforts refuse to disclose an absolute correspondence between what he imagines (the victim of murder, which he imagines whether or not he can clarify it on film) and what is actual, which he can determine only by verifying his imagining. The slippage between the mind's eye and the physical eye, ways of seeing which humans try to make coincide, can never be easily verified. *Blow-Up* illustrates the persistent attempt to rectify that slippage.

To claim the necessity of description for a work of art, I turn to Michael Brenson's description of Alberto Giacometti's *Woman with Her Throat Cut* (1932). Without that title, the interpretation of the sculpture, lying on the floor of a museum, might, it seems to me, as easily have been *The Rape*, *The Praying Mantis Recovering After Ingesting a Large Pod*, *An Insect with Carapace*, *A Headless Female*, or some other title. Restrictions of interpretation are determined by the sculpture, and in the titles imagined there are emphases on different aspects of the sculpture, but none contradicts what can be seen. The actual title, *Woman with Her Throat Cut*, both expands interpretation from what I might have thought I had seen and limits interpretation. The sculpture may still look in a way like a praying mantis, but it is now a sculpture of a woman that has certain aspects of insect—praying mantis, hard carapace—and rape as well as headlessness are applicable so long as the sculpture specifically supports such possible interpretations. Michael Brenson, art critic, saw the sculpture in an exhibit at the Guggenheim Museum and was much struck

by it: "The sculpture, roughly 3 feet long and 9 inches high, is extremely complex. A female figure lies on her back. Her throat is cut." How does he know her throat is cut? That information is provided by the title. Her right arm is thrown across what the title identifies as throat so that once he knows her throat is cut he may properly take this as an ostensive meaningful gesture, but without the title that gesture would not exclude other possibilities, such as the familiar gesture of arm thrown across the eyes to shut out sight of sun or external world. "There are signs of rape and murder. But the figure also seems very much alive. She makes herself sexually available. Her left hand appears ready to lash out."³ This description is very much alive and contributes to the looking and seeing process. Brenson is naming the disturbing elements and recognizing their contradictions at the same time he is celebrating the vitality of the figure. I consider that making herself sexually available contradicts rape; life contradicts murder; the hand that he sees as lashing out seems to me heavy (in shape and comparative size) with the fatigue of excessive, though terminated, activity, whether sexual or violently giving up life, or even resting—a possibility Brenson goes on to suggest—after ingesting the male as a praying mantis would do. Because of the suggestions of insect forms, Brenson also emphasizes the idea of metamorphosis. *Woman with Her Throat Cut* evokes emotions controlled by the title as well as by the sculpture itself.

But what has this to do with photographs? The photograph is not a constructed artifact comparable to a sculpture or a painting, or not comparable in its *constructed* aspect. The sculpture or painting reflects the intention and the handiwork of its maker. Both the intention and the instrumentality are integral to the final work. The eye as well as the hand is instrumental. But in photographing, the hand is virtually absent, and only the intention and the eye govern the result. It is literally impossible to photograph what is not there, although it is entirely possible to distort or arrange subjects and pervert or destroy scale. The intentional use of a camera, with resultant photograph, requires questions that are not asked of other constructed works of visual interest. One legitimate question is, What is it?, meaning, What was in front of the camera? Was it arranged or selected? Is this to be taken simply as literal, or does it have a meaning beyond the elements in it? For a painting or sculpture, What is it? means both what did the maker intend us to see and what *do* we see. It is taken

as given that the painting or sculpture was purposeful, with a meaning beyond its elements, even when the observer cannot instantly tell precisely what that meaning is. The very act of painting or making a sculpture requires intention. The act of seeing it takes time, absorbed attention, and informed awareness of what possibilities display themselves. The production of a photograph requires perhaps more time than is ordinarily credited but does not involve a medium resistant to instantaneous judgment or necessitate taking a long time (whether measured in hours, days, or years) to complete one work. The technical aspects of developing and printing, separated from taking a photograph in most cases even though the camera and its processes are available to everyone, *may* be separated even for the master photographer. This separation of design from execution is not entirely different from the sculpture that must be cast in a foundry, with more or less supervision by the maker. So photography in some ways is like painting or sculpture and in other ways is not. It depends less on the making and more on the seeing. It produces, overall, innumerable trivial examples compared to those that are worth preserving and looking at again and again.

The crucial question is not a technical one, not what constitutes a "good" photograph measured by focus or contrast. The crucial and important question is twofold: What does this photograph convey as information, and what does that information mean? To talk about either aspect, it is necessary to describe the photograph, that is, to name what is seen as fully as possible and then to relate that description to the context, effect, and significance of the visual elements.

Janet Malcolm, whose comments on photography appear in her book *Diana and Nikon*, says that Richard Avedon in the early 1960s was "no longer valiantly tussling with the confines of the medium, using them (as poets use regular rhyme and metre) to plumb his unconscious and shape his invention," but was making people ugly deliberately as a background for models in photographs where

the idea is not to bring the models' beauty into relief but to point up its artificiality and vapid unreality. . . . Avedon has, of course, created them [the background people "of unvarying unattractiveness—fatness or scrawniness, slack-jawed dullness, pitiful agedness"] with his pitilessly scrutinizing strobe lights and mole-into-mountain-making big camera, to whose grim transformations only young children and specially endowed adults, like fashion models and Picasso, are impervious.[4]

Malcolm's savage attack has many targets: weight, intelligence, age, the efficacy of camera equipment, and the intention of the photographer, which according to this passage should be to plumb the unconscious, presumably his own. Alas, the photograph by Avedon that Malcolm is describing gives me a different impression. What seems to Malcolm "slack-jawed dullness" and "pitiful agedness" looks to me like elegant older people laughing at a joke. The joke is embodied in the model, all right, but the joke is not *on* her. She is absurdly fashionable, mocking the pose, and those gathered around her are amused by the difference between a human being and a posed extravaganza of fashion. The photographer sees the joke and perpetuates it in the photograph. Yet either interpretation of the photograph depends on attributing its sense to the photographer. My argument is that such an achievement is the combination of expertise (strobe lights and all) and the imaginative power of the mind. Every image is also subject to the second mind, that of the viewer.

One element contributing a significant part of the history of a hand-made object is the life of the maker so far as it is known. Brenson's account of the Giacometti *Woman with Her Throat Cut*, for example, includes information about Giacometti's life:

There is a good deal of personal history in the work. When he made "Woman With Her Throat Cut," Giacometti was 30 years old. He was a close friend of the writer and anthropologist Michel Leiris and certainly knew of the grisly throat operation that colored his view of life. In the spring of 1932, Giacometti met Donna Madina Gonzaga, a future princess, who visited his studio and triggered in him an ironic but painful statement of shame about his humble quarters. Her long neck fascinated him.

Necks are the common element. The neck of the sculpture is elongated and, again according to Brenson, "resembles the neck of a violin."[5] It is ringed, or fretted. Biographical facts cannot be deduced from the sculpture but must be related to it, read into it, from knowledge having other sources, or at the very least other corroboration. The explanations are relevant to the sculpture because of the artist's emphasis on the conformation of the neck, which is after all where the throat is that is, according to the title, cut. But except for known external factors—geographical location, traveling assignment, or historical information—I can't think of circumstances in which the biographical facts about a photographer can be directly related to the photograph.

Edward Weston, in his *Daybooks*, has written more fully than any other photographer of the circumstances of his life and his photographing so that one might look there for evidence of what goes into a photograph, or what the photographer chooses to put into the photograph, what he takes from the external world of objects and in that separated form preserves; what relation that has to his life and thought. Looking at his photographs, reading his daybooks, it is hard to decide whether the daybooks contribute to seeing the photographs more fully. The daybooks, rather, unfold the character and thoughts of the man in ways that might have been extrapolated from the photographs alone, though with less security of fact.

His love for and devotion to his sons is expressed over and over in the daybooks. He is concerned for their education and wants them to learn from him to think independently as well as to act toward their father with full confidence. He intends to encourage them to develop their talents, whatever those might be. That love, though undoubtedly real, did not prevent literal desertion of his sons. With the exception of his oldest son, Chandler, thirteen, who was taken along, the family was left standing on the dock when he sailed off to Mexico in 1922.

One picture of Neil (the third son, born in 1914) as a child of eight (*Nude, 1922*, illus. 10) shows a large wall paneled with what looks like photographic backdrop paper against which, in the extreme corner, the white-bodied child, looking toward his father the photographer, stands with his arms behind his head, one leg sturdily on the floor, the other relaxed and bent at the knee. The size of the boy compared to the breadth and height of the wall emphasizes the total vulnerability of that child, as do his nakedness, his touseled hair, and his glance toward the camera and his father. One may see in the reduction of the child in scale his vulnerability, his marginality, the exposed fragility; by listening to these descriptive words one might almost insist on seeing a cry for help. This would be seeing incorrectly.

The emphasis of the photograph necessitates observations on the isolation and diminution of the child against the large, flat wall in the space of a studio but precludes the sentimentality of attributing either to child or father, subject or photographer, helplessness or simple acceptance of that state. Elimination of detail and placement of the boy create space in which the only significant object is the figure of the nude child. The figure

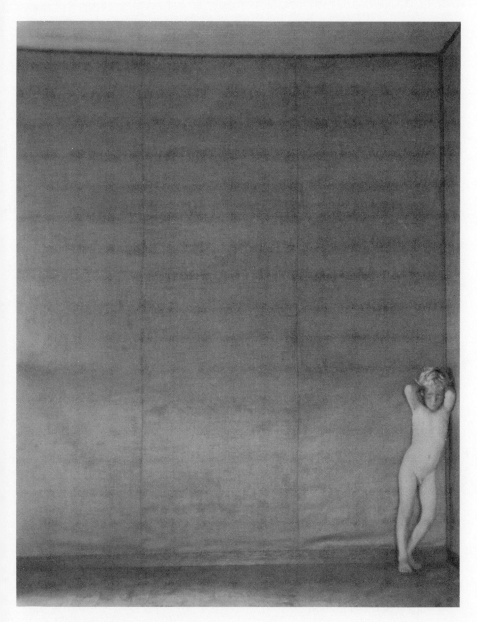

10. Edward Weston, *Nude, 1922*

seems to be surrounded by the grayness of museum space where marble sculptures gleam white with tactile seduction. The lower half of the body pose is one position of the classical Greek nude male figure (see illus. 11).[6] The human body has a limited number of ways of standing still; echoes and associations may combine without having causal connections. That there may not be causal connection precludes direct attribution of intention to the photographer but does not preclude the possibility of such intention. The viewer who makes the association legitimates it by visual reference to the compared figures. The classical nude is visually relevant. The association springs to life without depending on the intention or knowledge of the photographer. The nudity, position of the legs, and isolation of the single figure are elements of classical male Greek sculpture. This child is thus isolated from everything human; the comparison emphasizes the elegance and importance of the figure but prevents viewing it as if it were an individual small child stripped of clothes and made to stand in a corner by an adult male who controlled the organization of the occasion. Yet what we are not allowed to see (the humanly controlled aspect) is what we *are* allowed to say because we know it as part of the biographical data. To some degree the aspect of control between a father and a very young son is normal, indeed necessary. In a biographical context, it would be appropriate to learn what we could about the relationship. Ben Maddow in his biography of Weston remarks of this photograph: "Another strange nude, of Neil as a very small boy, was taken in the studio; again, the composition is strongly asymmetric; the boy stands (and rather sadly, too) off to one side of the print. Three-quarters of the space is occupied by the polished backdrop used over and over again in the studio."[7] The strangeness is an effect of the tension of scale but also the drama, not of boy to space entirely, but of the human figure in an alienated, featureless world poised between hostility and tenderness. The boy recedes into imperfect focus so that his expression is generalized and impossible to interpret in any secure way. He should not be an object of sympathy or pity, love or rejection; he is simply a human figure who happens to be young and undeveloped. Nevertheless, his dignity, assurance, and self are complete and are seen to be so. It is as photographer that the father identifies himself in his respect for his son's person and his admiration for the loveliness of the son's body.

An element of reciprocity between photographer and subject char-

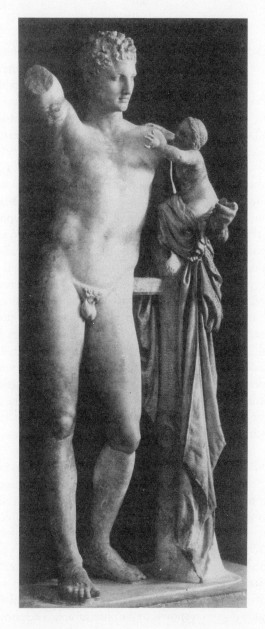

11. Alinari, *Hermes with the Infant Dionysos*, Praxiteles, Olympia, Museum

acterizes this photograph as it does most of those that Weston valued. He
is like Stieglitz in Stieglitz's photographs of Georgia O'Keeffe with respect
to the preservation of a vital connection between photographer and sub-
ject. Weston's female nudes were collaborations in that whether the
woman knew at any given moment that she was being photographed, she
had already given her consent and exposed her willingness. Lest a mis-
understanding arise, let me make clear that this is not at all the same as
treating a woman as an object, any more than Weston was treating his
son as an object. His nude women express a woman's visual value, a
beauty in which both agent and possessor acquiesce. The nude is not
wholly sexual; it is erotic in the sense of disclosing and consenting to a
rich but for the moment dispassionate sensual appreciation of the body.

 Does Benjamin's aura accrue in these cases? I don't see how it can be
avoided or denied. Just as, according to Kenneth Clark, all paintings of
nudes, however chaste, have an implicit suggestion of the erotic, all nudes
have an aura, whether they appear in paintings, sculptures, or photo-
graphs. The most explicit and particular (probably the pornographic)
have the least aura; the most mysterious have the most aura. The force of
"mysterious," or rather, its content, should not be trivialized to mean ro-
mantic, veiled, fuzzy, or moonlit, though any one of these words may ap-
ply in an individual case. Mysterious means that the distance which for
Benjamin defined the quality of aura must be evident in the treatment of
the nude. The distance is that of the observer who "keeps his distance,"
who sees both sensuously and intellectually. This distance is imposed by
the photographer in a degree determined by his intention. The pornog-
rapher intends to evoke a sexual response and is satisfied if he can sell his
pictures, or perhaps use them for blackmail. Not all obscene photographs
are pornographic, that is, not all obscene photographs arouse lust. The
distinction should have operated in the public discussions of Robert
Mapplethorpe's photographs, some of which are obscene by any stan-
dards. The act of one man urinating into another's mouth is disgusting,
but Mapplethorpe's photograph of that act distances the reality, the sub-
ject, by recording what a poet has called, in connection with another
curve in the air, a "piss-elegant" trajectory. Disgust or revulsion at the act
may thoroughly poison response to the photograph. The photograph may
be doubly repulsive because it aestheticizes and exhibits an act which in
our culture is unacceptable. For a photographer to whom the act is not

Untitled 83

only acceptable but in which he finds beauty in classical terms of curve, proportion, and balance, nothing prevents his recording it in a photograph. The arguments over exhibition tended to center on the depiction of forbidden acts, although the arguments were wrapped in concern over public tax money being used to finance the exhibition of such depictions. In the exhibitions that were held, the innocent and unwary were protectively excluded by cunning devices. At the Hartford Wadsworth Atheneum no elevators were in use to reach the exhibition of the Mapplethorpe photographs. Formidable stairs had to be climbed. Those climbing were made aware that they were to see the controversial exhibition. Guards scanned the arrivals at the third floor. Children were not permitted to attend. Admission fees were charged. No morals were endangered, no youth corrupted. Mapplethorpe was a serious practitioner of photography, and those who financed him as well as those who exhibited his photographs were working within responsible criteria. He was perhaps not an ordinarily decent man, to use decency as a term much invoked by his critics, but neither was Caravaggio. Now and in the future all that remains will be the work itself; whether the obscene pictures will continue to be of interest is a matter for speculation. Mapplethorpe's photographs are coldly classical and formally correct; his flowers have little difference in feeling from leather jackets and chains. I myself find it hard to sustain an interest in sheer perfectionism of form.

In the nudes of Stieglitz or Weston the quality of the attention is characterized by the slow delights of vision, in which the eye seizes in a flash the attraction of the nude body and then has the pleasure of lingering over its contours and the tactile appeal of the skin, the contrast with sand on which a Weston nude lies, or the elegance of a woman's hands in a Stieglitz rendering. Instead of the Mapplethorpe distancing through formal arrangements and careful lighting, the Stieglitz and Weston nudes are posed informally, as if spontaneously. Admiration for the work tends to be sympathetic as well as analytic.

The slowness of the delight corresponds to the distance specified by Benjamin, inviting contemplation, meditation, reflection. Visual pleasure lies less in invention, shock value, and trickery (less in Arcimboldo's fruits and vegetables masquerading as heads) than in recognition of the familiar (Arcimboldo's configurations suddenly seen as heads; the human forms in Raphael's representations of mother and child, even when mother and

child are sacred). Recognition of the familiar is one of the chief pleasures of the photograph. When the known elements of an objective world are recognized and at the same time a new aspect of that world is presented, pleasure (as well as shock) can result.

The transcription from space into time and in time from present into past occurs in any photograph, no matter the subject, circumstances, or degree of technical expertise. This past includes all time that has receded from the present—any present time. For many subjects, the transcription from present to past makes no visible difference. It makes no difference to the way of looking at or thinking of Weston's peppers, shells, toilet bowls, or kelp. It makes a difference in the way to think of the nudes or the portraits because they are most present as real persons, subject to the passage of time in ways that are incrementally visible. The most anonymous, idealized, or generalized portrait must nevertheless be single, individual, human in reality. The relation of this fact to the photograph and a confusion of the fact *with* the photograph was the source of Oscar Rejlander's difficulty with criticism of nude models for his *Two Ways of Life* (see p. 89).

What differentiates the generally memorable photographer is visual recognition of meaning in form. This entails the ability to see a three-dimensional objective world in two-dimensional flat form, often in black and white, in instantaneous appreciation of what that segment about to become a separate whole will signify. This is not a portentous, heavily thought-out process, but rather a flash of recognition.[8]

Art and illusion are not restricted to one form of image-making. Making and matching are ways of creating available to all makers. Photographs transcribe some reality, but the photographer has to determine what reality it will be. He makes the photograph by using the convention that it is impossible for him to do anything except transcribe conventional reality and then makes it possible to see in his transcription the new forms that he saw. What the viewer thinks he recognizes as reality is effectively a new reality.

Edward Weston's photographs of peppers and shells are new ways of seeing these objects. Weston resented and scornfully repudiated the suggestion that these photographs had sexual connotations. It is a matter of indifference whether he thought they did or not. Viewers consistently and, I think, rightly interpret the peppers and shells as paradigms of sex-

uality in their crevices, curves, and the eternal ambiguity of interiority defined by formalized containers. The peppers fold over on themselves, clenching, concealing, tantalizing with dark passages. The shells are as perfectly glisteningly beautiful as the toilet bowls in other photographs. At the same time, distance is preserved. The pepper never becomes a crude accidental apparent replica of anything sexual but remains an even more solid pepper than one had ever imagined a pepper to be.

The apparent scale of the objects contributes to the solidity of the impression. Singling out an object, neutralizing the background, and removing all units of comparison obliterates the clues by which to judge sizes and relative positions. In the case of a portrait, this makes no difference because the head is itself a unit of comparison. In a photograph, an Egyptian pyramid and a Mexican pepper can be the same size. A Weston nude sprawled on the sand can appear within the format of a 5″ × 7″ or an 8″ × 10″ print with smaller measurements than the pepper within its rectangle of the same dimensions. When a vegetable whose habitat and familiar surrounds are the garden, the market, and the kitchen is presented abstracted from the ordinary, in black and white, of no determinable size, as an object of curiosity and contemplation, curved and shadowed as if it were a sculpture, we consider both pepper and photography in a new and different way. *Peppers, 1929* (illus. 12), of two peppers lighted as if they were bronze, resembles not a Henry Moore sculpture but a photograph of a Henry Moore sculpture. Correspondences in curve and hollow, one form apparently lying on its back, the other bending over it, either maternally or sexually, but presented as if intentionally, occur in both instances. The correspondences are visual, but they occur only in the photographs, the one presenting the peppers as if they were monuments, the other presenting the monuments of Moore as if they could be reduced to the confines of paper. In either case, since the conventions of the photograph as artifact or illustration are well-known, each is seen in its proper category, and only the unexpected juxtaposition, unintended by either maker, forces resemblances on the attention. But the resemblances remind us that the photographer's imagination is active and provides occasion for discoveries in the world around us.

Richard Wollheim emphasizes the role of the painter as spectator. The photographer is an even more emphatic example of the combination roles of the seer as maker and the seer as spectator because his roles are com-

12. Edward Weston, *Peppers, 1929*

pressed in time to that instant I called the flash of recognition. The flash is most clearly apprehended as instantaneous when the subject is a news photograph taken at a moment of action, but it must also occur in other situations for the photograph to be effective. The role of maker as spectator is even more obvious when the photograph is full of arranged objects or words. Then the final viewer, who comes to the photograph without preconceptions of what will be revealed, is forced to comprehend not the purely visual objects but the intervention of a mind insisting on interpreting those objects. When the mind itself is playful, as Man Ray's was, the viewer can enter into the play without resenting the intrusiveness of opinionated material.

Recession in time is a strong point of interest as long as the connection between an objective world and the photograph is considered direct, revealing, and trustworthy. Even now, when the critical tendency is to dis-

count the trustworthiness of the photograph, there is an equal and opposite tendency to believe what is seen in it. The question is then removed one step to ask not whether what is seen can be trusted but first to name what is seen and then to interpret it. That way of proceeding, that way of talking about the photograph, gives the power of words back to the viewer. When the words complement the photograph, any deception no longer deceives. If photography were a field in which anyone were as good as anyone else, achievement would be accidental and mechanical. It is better to begin with the generous assumption that the photographer transcribes what he sees and that he does so because what he sees is in some way memorable, remarkable, moving, sensational, or typical. To describe and to name is to continue the process of seeing by interpretation. Naming is interpretation, even when the name is *Untitled*.

5

The Things Which Are Seen

◈

Oscar Rejlander, the creator of a famous combination print called *The Two Ways of Life* (1857; illus. 13), was a literal-minded photographer whose claim was that "photography will make painters better artists and more careful draughtsmen." "You may test their figures by photography," he says. "In Titian's *Venus and Adonis*, Venus has her head turned in a manner that no female could turn it and at the same time show so much of her back. Her right leg also is too long. I have proved the correctness of this opinion by photography with variously-shaped models. In *Peace and War*, by Rubens, the back of the female with the basket is painted from a male, as proved by the same test." *Test* and *I have proved* are terms useful in scientific discourse. As criticism of Titian and Rubens such comments are hopelessly limited, but one must also catch the tone of excitement, closer to the excitement of scientific discovery than the relish of critical description. Rejlander understood photography as a way of testing draughtsmanship, as if representation had measurable accuracy. Charles Darwin used some of Rejlander's photographs of individual faces to illustrate *The Expression of Emotions* (1872), suggesting that Rejlander's interest conformed to exploratory and scientific habits of contemporary nineteenth-century thought.

The Two Ways of Life is a mosaic of thirty negatives combined so that the finished print is a high Victorian tableau with many figures. The model for the balanced disposition of figures, the central arch, and the idea of an architectural setting is Raphael's *School of Athens*. The Rejlander work is relentlessly schematic. Two young men dressed in thin

flowing costumes suggesting Grecian drapery choose between, on the viewer's right hand, the sober life of virtue and, on the left hand, the exciting pleasures of vice. This is surely not what is meant by the photograph expressing reality directly, but still, certain things can be observed in the print. The shallow stagelike background displays, on the left, espaliered vines, no doubt yielding the inebriating grape; on the right, chaste classical column and niche. A man and woman working at homely tasks on the right are balanced on the left by men throwing dice. On the right side, where virtue is depicted, the ornamental lion on a pedestal is male and, on the left side, in which the youth gleefully contemplates naked women disporting before him, the ornamental lion is female. All these planted signs are instantly transparent. The great number of female nudes is appropriate to Victorian classicizing. Moral purpose is served by the severity of the lesson conveyed. On the side of virtue one, presumably a penitent, kneels before a Madonna-like woman, fully and perhaps even excessively clothed. It is not easy to understand why the penitent has let her clothes drop to her waist as if for a medical examination. To be sure, her back is turned as she kneels so we do not get the full frontal exposure. A group of women in the central foreground as well as several explicitly tempting the young man on the left are bare from the waist up and show their breasts or backs. Pudenda are concealed, buttocks are not shown, and in the case of the most frontally presented nude, the head is swathed in a gauzy pale scarf that conceals her face, which is turned modestly away. Rejlander was accused of making indecent pictures. It was not only the fact of nudity that constituted the objection but also the conviction of contemporary identity conveyed by the photograph. Rejlander took an interesting view of the objectors: "They have no right to ask the names or profession or religion of models, still less to use vile epithets in speaking of them. . . . There are many female models whose good name is as dear to them as to any other woman."[1] In short, to paint nude models was a transforming, generalizing process, but to photograph was construed by moralists as exposure of particular persons.

The combination print was not a dead end for photography, although its aim changed from imitation of paintings to exploitation of such combinations as a legitimate instrument of creative work. Serious practitioners of an art or craft inevitably include experimenters. Rejlander's experiment, *Two Ways of Life*, was bought by Queen Victoria and must

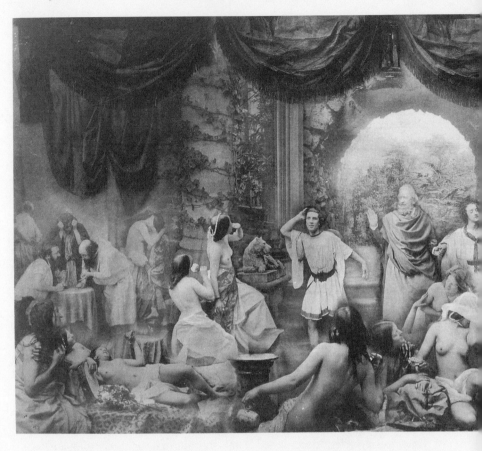

therefore have been an accurate rendition of officially approved senti-
ments. Rejlander did not make another such elaborate construction but
experimented in ways more productive as techniques, although not as
money-makers. He made deliberate double exposures and also created
photomontages (pasting prints together). A masturbatory fantasy enti-
tled *The Dream* might have been envied by Man Ray, who later broke a
good many barriers of decorum but made no photograph quite so sugges-
tive as *The Dream*. Rejlander made his money by selling portraits and
supplying artists with photographs. Lewis Carroll studied photography
with him. After Rejlander, Henry Peach Robinson became the photog-
rapher known for combination prints, but even though Prince Albert had

13. Oscar Rejlander, *The Two Ways of Life*

a standing order for Robinson's prints, other photographers did not follow the technique. The English photographers who succeeded Robinson in public view, Peter Henry Emerson in the Norfolk Broads and Frank Sutcliffe at Whitby, practiced, in their separate places and ways, a more straightforward approach, intentionally reflecting nature.

The Two Ways of Life could, perhaps with difficulty, look back at a modern viewer, but only if that viewer were determined to engage that look, if, that is, the interest of the viewer found some use for this photograph. The use would no longer be recognition of the planted signs for good and evil; it might be as resource for the cultural historian, who would describe the photograph in less dismissive terms than I have used.

Rejlander's comments are interesting only in the emphasis he places on the uses of photography, that is, for correction of drawing and for transcribing situations but not individuals, nude models not nude women.

Walter Benjamin, as ever essential for this discussion, has a different power of description, far more intellectually engaging. Benjamin's famous passage on long exposure is memorably poetic prose, but it bears, like many brilliant insights, an oblique perception of the problem:

Many images by [David Octavius] Hill were taken at the Edinburgh cemetery of Greyfriars. Nothing is more representative of this early period [of photography]: it is as if the models were at home in this cemetery. And the cemetery, according to one picture that Hill made, is itself like an interior, a delineated, constricted space where gravestones lean on dividing walls and rise out of grass floor—gravestones hollowed out like fireplaces showing in their hearts the strokes of letters instead of tongues of flame. The procedure itself caused the models to live, not *out of* the instant, but *into* it; during the long exposure they grew, as it were, into the image.[2]

This account of what happens during a long exposure (although long in this case was only what David Bunce called "the very long exposure of a minute and more"[3]) has reinforced and dramatized the process of transcription characteristic of photography but has made it seem to depend on the length of time the model was required to remain still rather than on the process itself. This insistence on length of time in posing as a factor in the photographic process ignores the hours a model for painting is required to pose and seems to invest the time spent posing with significance beyond its merit. The explosive energies compressed in a photograph, encouraging the viewer to puzzle out its literal and conceptual contents, are like the unconscious energies Freud describes as emerging in a joke or a dream. The release achieved by comprehension of joke, dream, or metaphor is satisfying: in the Freudian joke because repressed ideas, which have gathered strength from their repression, are discharged with laughter; in the Freudian dream because repressed ideas are discharged or realigned with revelation of meaning. The very closure of a photographic frame compresses energies. The capturing of surface and the closure are magical, not the time involved. Nevertheless, Benjamin's words convey a truth that alludes to the anomaly of temporal dislocation. Growing into instead of out of the instant suggests that the image will become the reality. When the exposure is finished, that instant, whether seconds or min-

utes, has gone by, is dead, but it lives, that very moment of time, in the photograph.

Benjamin is also condensing images. The cemetery becomes an enclosed domestic scene; the gravestones are "hollowed out like fireplaces"; the "procedure," that is, placement of the men and women in front of a cemetery stone, as if the stone's letters were a fire to warm them, and emphatic mention of the length of the exposure, as if they were lounging at home, creates an impression of the models' belonging to this setting rather than being transposed momentarily into it. The cemetery background becomes the defining ambiance and death the easeful companion.

This wide significance is created by Benjamin's language of description, which in turn constructs the language of interpretation. Walter Benjamin denied aura to the photograph, yet gradually, through familiarity, affection, and his own critical imaginative comments, the aura he denied is accruing about the idea of the photograph. The aura accruing about the idea of the photograph is, however, secular, not sacred. Benjamin quotes Baudelaire with total sympathy: "Photography should be free to stake out a claim for ephemeral things, those that have a right 'to a place in the archives of our memory,' as long as it stops short of the 'region of the intangible, imaginative': that of art in which only that is allotted a place 'on which man has bestowed the imprint of his soul.'"[4] Unfortunately for this thesis, photography could not be so restricted. The distinction Benjamin intends is similar to that made by Paul (2 Cor. 4:18): "While we look not at the things which are seen, but at the things which are not seen; for the things which are seen are temporal; but the things which are not seen are eternal." Benjamin is valuing art for its intangible and imaginative "things not seen" and devaluing photography as a catalog of things in the "archives of our memory." The things not seen form the sacred aura. Photography's aura is secular.

A description of another photograph by Benjamin (Bossert, plate 128) creates the story of Karl Dauthendey. The Dauthendey description is wonderful because it is so personal to Benjamin, so splendidly imagined, so wrong, so provocative:

The picture of Dauthendey—the photographer and father of the poet—from around the time of his wedding, seen with the wife whom one day shortly after the birth of their sixth child he found in the bedroom of his Moscow house with arteries slashed. She is seen beside him here, he holds her; her glance, however,

goes past him, directed into an unhealthy distance. If one concentrated long enough on this picture one would recognize how sharply the opposites touch here. This most exact technique can give the presentation a magical value that a painted picture can never again possess for us. All the artistic preparations of the photograph and all the design in the positioning of his model to the contrary, the viewer feels an irresistible compulsion to seek the tiny spark of accident, the here and now.[5]

Without the knowledge that Benjamin gives of the future of this couple, the photograph would be dead. What makes it magical is what Benjamin associates with it, the story of time stopped at a point in the couple's lives when their union had not yielded six children and a suicide. One sees the photograph through Benjamin's eyes and with awareness of how he has expressed his interest. The opposites he speaks about are those of the authenticity, the actuality, of the figures in the photograph, recognition of the pure evidence, the "here and now," as opposed to the light of knowledge and imagination, perhaps also memory, that endows the figures with portent. His way of describing the future of this couple suggests by its formulation that Benjamin is directing our attention to the "unhealthy" aspects of their conjugal ties, however fixed the actual photograph is to a present which by the time he writes is long past.

The first hint of "unhealthy distance" is in the selection of the time of birth of the sixth child to fix the date of the suicide. The brutality of the description mirrors the brutality of the act, though one wonders, at this still later date, whether the brutal act was the suicide or the abandonment of the infant to the father's care. "In the bedroom of his Moscow house" suggests she has defiled the husband's possession, his house. It might more intimately be her bedroom, if she set her death scene there. Nevertheless, whatever the facts, it is Benjamin's description that has made the scene alive, given it a story. It is his magic, not the photographer's, that has made the "tiny spark of accident" illuminate the photograph. Within the "here and now," which is all we can see in the photograph without his telling us the story of the people in the picture, the future is blank. "Her glance . . . goes past him, directed into an unhealthy distance." The distance is the future. Its unhealthiness was visible only to the bride (and to Benjamin) who was to "commit" the deeds so deplorably sensational and so contrary to what the protective bridegroom might wish.

Benjamin says that the "presentation" has "a magical value that a

painted picture can never again possess for us." But why not? A painted picture of a couple, even one whose future was so ominous, might attempt that insight and inspire us to wonder at the place the future has in an encapsulated present. But the point of Benjamin's remark is that the photographed couple is untouched by the circumstances of the photograph; the two are uninterpreted even where interpreted by the photographer so that they exist purely and solely as their own beings unmediated by another's thoughts or arrangements. Benjamin is the source of what we now might see in the photograph, the bride whose glance escapes the intended meaning of a new and auspicious marriage.

The story is implicit in the couple, not in the photograph. Benjamin's point can be applied to other photographs: the authenticity of the real is one aspect of the photograph, the other is the story implicit in the condition of every man, with its individual variations so limited in invention, so acute in experience. The story is the magic because it is unstated, not withheld but not expressed, and because it requires language to complete the photograph's expression. The evidence and authentication are in what is shown; the magic is in the language, which any abstraction and any degree of abstraction requires, which any story requires.

The photograph without the story is undistinguished in itself and unreadable in anything like the dimensions of its narrative implications. Benjamin's account of the picture can invoke prophecy only after the prophecy is fulfilled. If the story of the couple is implicit in themselves, it is implicit only because it is made explicit by Benjamin. The story as Benjamin tells it (created or invented or imagined by him) determines the way to look at the photograph. In fact, more than determining the way to look at the photograph, it is a substitute for the photograph. The Dauthendey photograph has no intrinsic poetic interest, is not to my knowledge reproduced anywhere but in Bossert, certainly not frequently, and is not memorable when one does see it. Benjamin's account of it is full where the picture is empty. If the photograph has interest it is because of Benjamin's investment in his story. It looks back at him, if not at us, and by his treatment of the photograph he has enabled us to see it in some degree with his eyes and thus to expect its reciprocal glance.

Roland Barthes gives a similar though more intensely self-conscious response to a photograph:

In 1865, young Lewis Payne [sic] tried to assassinate Secretary of State W. H. Seward. Alexander Gardner photographed him in his cell, where he was waiting to be hanged. The photograph is handsome, as is the boy: that is the *studium*. The *punctum* is: *he is going to die.* I read at the same time: *This will be and this has been*; I observe with horror an anterior future of which death is the state. . . . I shudder . . . *over a catastrophe which has already occurred.* Whether or not the subject is already dead, every photograph is this catastrophe.[6]

Gardner's photograph catches the starkness, pain, even resolution in Lewis Paine (illus. 14). At a time when men were clothed in high collars and long coats and presented themselves as stiff, upright, solemn pillars (even the seated Abraham Lincoln looks like a folded pillar), Paine, against his coarse-textured background and with hands cuffed with metal and separated by a rigid bar, is almost at ease. His bare neck is broad, sturdy, columnar, monumental. His fate is complete. It is the acceptance of that completion, the knowledge that the image he acquiesces in will be his legacy, that contributes to the power in the photograph. He is alive then but will be hanged. Barthes says that "nothing can be refused or transformed" in the photograph. Yet the completion of that photograph is the historical knowledge of who Lewis Paine was and what he had done, as well as the death sentence that had been passed and that shortly thereafter was executed. That state of being past now includes everyone who was then alive.

Dauthendey and his bride were taken by a conventional studio photographer. All the photograph might have meant or conveyed would have been lost without Benjamin's description. Alexander Gardner's photograph of Lewis Paine has intrinsic merit and interest so that Barthes's gloss is less necessary, even though it is interesting as analysis and poignant as response. The photographer controlled the terms of the response because of his own conception of what the picture should convey.

The first descriptive passage in this chapter, after Rejlander's comments on the uses of photography, was Walter Benjamin's on the Greyfriars cemetery photograph by David Octavius Hill and Robert Adamson. The photograph is worthy of the description. The second of Benjamin's descriptions was that of the wholly undistinguished photograph of Dauthendey. The description is worth a thousand such photographs, to invert the epigram. Turning from Benjamin to Roland Barthes is to turn from one master of description to another, and Gardner's portrait of Lewis Paine in the execution cell is equal to Barthes's description.

14. Alexander Gardner, *Portrait of Lewis Paine*, 1865

The next example is of a great photographer, Julia Margaret Cameron, for whom a great descriptive writer has not been found. There are describers and explicators, however, among whom recently is the English critic Mike Weaver.

Nadar, the great nineteenth-century French photographer, emphasized the rapidity of the photographer's grasp of the visual emphases he wanted and the comparative instantaneity of the transcription of idea to realization. His emphasis was on the idea in the mind of the photographer

rather than on the object photographed. Julie Margaret Cameron's photographs illustrate the contention that idea is an essential part of photographing because some of her ideas were considerably better than others.

Mike Weaver has documented the influence on Cameron of Anna Jameson's *Sacred and Legendary Art*, with its emphasis on Christian typology and the English poets, but Weaver cannot make the case that Cameron's photographs were the better for this. Nor were they better for the well-known influence on her compositions of the ideas of the painter G. F. Watts.

Cameron was a strong-minded woman. The traditions of a ruling class did not so much give her confidence as allow her to assume without thought that confidence was right and her actions were for the good of herself and those around her. Her great virtue as a photographer was separate from the fact that she was of her time and class, a Victorian with Victorian values. Her visual sense and her highly developed conviction that people and events only required management for good results combined to allow principled exploitation of family, household, neighbors, and friends as models. Her photographs of famous men are remarkable, but her photographs of ordinary women are equally remarkable. It is not the accomplishments of the subjects that give the photographs their luminous intensity but Cameron's eye for visual distinction and her keen sensuous pleasure in the way light creates volume and diffused daylight models a face with tenderness.

In her dullest pictures, Christian typology and idealized English poets furnished systems of apprehending the world from which she chose the most sentimental. Saints tend in her typological representations to be wooden, stagey rather than dramatic; picturesque at best, leaden at worst. Madonnas are beautiful if their representation coincides with the reality of a young woman touched with virginal radiance. The women who modeled (with the exception of Ellen Terry) were not professional and thus able neither to efface themselves entirely in a character nor to lend themselves pliantly to the photographer's pose. The sentimentality of conception is all too evident, created by the costuming designed to fit some indefinite period of "history" and a droopiness of contour designed to be morally uplifting. Loose, amorphous, flowing garments pass for biblical or medieval, signifying mainly a distant past and removal from

everyday life. Only when her modeling instrument is light does the fall of
the cloth folds accentuate figure and attitude and further the design. Her
best photographs are those of heads alone, the unsmiling faces appearing
from darkness with the interest of strangers and the mystery of intimacy
without disclosure. In the realm of high moral or sacred invention, she
betrays her medium.

The best of her portraits, whether of the famous men or the women
of her household, are intensely singular, isolated from the commonplace
world. But the removal into the idea works only when it coincides with
her sensitive use of light and when the elements of story and allegory can
be subdued into formal elements rather than intruded into the viewer's
consciousness by pedagogical intentions. Such intentions are overem-
phasized by Mike Weaver's insistence on relating particular pictures to
quotations from Anna Jameson to the detriment of the simpler, less ag-
gressive identifications of the actual models.

One instance among many may be cited. A Cameron photograph of
her grandchild shows the little boy asleep, head turned toward us (illus.
15). He lies on his stomach with an arm and leg drawn up and his middle
covered by a cloth. He wears no diaper for the occasion, but the cloth
covers any possibility of exposure of genitals, and his rounded little but-
tocks curve gently into shadow. Leaning over him so that her upper body
is almost parallel is his "mother." As Helmut Gernsheim points out, the
woman is actually Mary Hillier, often the model for Cameron's Madon-
nas, and the final picture is a combination print of two separate photo-
graphs, one of the two-year-old and one of Mary Hillier.[7] Cameron's title
for the picture is *My Grandchild*, but the inclusion of the maternal figure,
given Cameron's propensity for dressing her meaning in a received story,
allows the firm reading of Madonna and child. But Mike Weaver inserts
quotations from Jameson to beat the meaning home: "A beautiful version
of the Mater Amabilis is the *Madre Pia*, where the Virgin in her divine
Infant acknowledges and adores the Godhead," and another quotation
to characterize the Mater Amabilis: "The Virgin is not here the dispenser
of mercy; she is simply the mother of the Redeemer. She is occupied only
by her divine Son. She caresses him, or she gazes on him fondly."[8] What
the quotations lack is any decent reticence. It is as if she had said that the
Virgin smothered Him in kisses. The language identifies the type or story
Cameron invokes, but it adds a dimension of Victorian excrescence rather

15. Julia Margaret Cameron, *My Grandchild*, Aug. 1865

like the Albert Memorial that does an injustice to Cameron's photo-
graphs. They have their own excesses, the soft focus, the sometimes ri-
diculous poses and costumes, that lend themselves to descriptive excesses
of language, but to combine Cameron and Jameson does both the *Leg-
ends* of Jameson and the photographs of Cameron an injustice, empha-
sizing in both what is most repellent to modern taste and what is most
factitious in both mediums.

Actually looking at a number of the typological pictures can result in a disturbing dilution of the pleasure that has been taught by Cameron's best and most frequently reproduced photographs. Her dependence on idealistic notions transcribed into visual dimensions may mean that her visual ideas were strong and that she used this envelope because it seemed appropriate and congenial. We know that she was moved by English poets and literature. Tennyson was a friend. He lived next door to her in the Isle of Wight. Her portrait photographs of him and of other notable men are powerful and fit our ideas of how great men look. But her idealization of poets and literature does not explain why her pictures of women, few of whom would be known to us except for these photographs, are also powerful. She had an eye for beautiful girls and women, and then, like any painter, she placed them and observed them closely. But her ideas of beauty were not insipid; strength was an element in the sense that the women all seem to exist firmly in their own right, in their own bodies, as it were. This is, for both men and women, a result not only of the length of time required to hold the pose but of the self-possession and self-confidence needed to fit into the pose and to take it seriously. The confidence of the men, stiffened by fame, is understandable, but the women, too, accept themselves, present themselves for scrutiny with some latent acquiescence in this form of extended life. Many of them are not looking at the camera, giving the impression of removal and an existence separate from the posing. Those looking at the camera are equally sober, removed, and intent. The sense of their concentration on something other than themselves, other than the pose and the camera, is always present. Cameron's attitude toward her sitters was compounded of admiration, bullying, and perhaps a subliminal wish on the part of both photographer and models for fame, an unexpressed if coincident ambition.

Weaver makes a connection between a painting of Rembrandt that Cameron might have taken as a model and one of her most self-conscious pictures, *Whisper of the Muse* (illus. 16).[9] Rembrandt's painting is *The Evangelist Matthew Inspired by the Angel* (1661; illus. 17).[10] The comparison is of the kind that Focillon rightly most abhorred. The resemblance is superficial—in both cases a young person's mouth is close to the ear of an elderly, bearded man. Svetlana Alpers makes clear the essential difference between this depiction of an action, which she points out is related to an assumed text, and the Italianate representation of a scene,

16. Julia Margaret Cameron, *Whisper of the Muse*, 1865

17. Rembrandt van Rijn, *The Evangelist Matthew Inspired by the Angel*, 1661

which is related to an established compendium of gestures whose mean-
ing is transparent. "The use of expressive figure types, but more basically
the very notion of the expression of invisible feelings, does not obtain in
the north," according to Alpers.[11] This is a useful formulation in looking
at Rembrandt's *Evangelist Matthew*. Somewhere there is a text, if the title
of the painting is not enough. Its interest as an example of painting, how-
ever, is no longer in the text but in the two faces as portraits. The face of
the whispering angel is that of Titus, Rembrandt's son. The old model is
not identified. Rembrandt, however, never lost sight of the tough, irre-
ducible surfaces of things, the skin, bones, contours, and wrinkles that
make the heads formidably present to the eyes. If this represents the Evan-
gelist Matthew and his angel, it also unmistakably uses living models who
are present in all details. That he does it by means of paint is a miraculous
combination of hand and eye. It is entirely possible to see the painting
without the text.

It is also possible to see Cameron's *Whisper of the Muse* without text,
but in this case, with or without text (or title), the viewer is diverted from
the idea, which is high-toned idealization at best and sentimental banality
at worst, to the actual transcription of a man with a beard holding a
stringed instrument in an unplayable position, his head bent to listen to
a little girl seen in profile, apparently smelling his eyebrow, accompanied
by another little girl on the left just laying her head on the man's sleeve so
that even if he were otherwise positioned to play the instrument he would
not be able to move his arm. Charitably, one might assume he had paused
to listen to the "muse." Her mouth, however, is closed. She has finished
or has not begun. If there is charm in the picture, and it is so irritatingly
conceived that one has to rid oneself of a shudder in looking at it, that
charm is in the glance of the little girl on the left, who is having nothing
to do with the pretenses going on above her but is looking directly at us.
She seems real, resigned, and alive, but she is small and not in any obvious
way integral to the composition. She cannot redeem the whole.

What, then, can be the comparison between Rembrandt's painting
and Cameron's photograph? The comparison teaches us that idea governs
photograph as well as painting, and it allows us to contrast the ideas even
more sharply than the means. In this particular comparison, one must re-
member that the original painting (now in the Louvre), in its coloring and
scale and immediacy of paint, is the unique object. Only its reproduction

in black and white can be compared with Cameron's photograph, thus reducing the sense of literal difference of means and concentrating on the similarities, which are increased by the perilously misleading resemblances on the page of a book.

Rembrandt's two heads, those of Titus and the old man, are, without text, a contrast between youth and age in close relation. The angel's mouth is closed, like the little girl's in the photograph, but its position is by the old man's ear. The man's expression is of one internally absorbed, a glance directed inward, with his left hand touching his beard in a gesture of contemplative acceptance, while his right hand holds a pen over the paper of the book. The light falls on the man's face, his forehead, nose, and cheek, and on the angel's nose. It is less bright on the angel's hair and face and on the old man's beard and hands, but bright again on the book. The old man's inward gaze is like that of the Madonna of any pictorial Annunciation, and the angel's look is that of consummation, closure, message delivered. It is also possible that the communication is wordless, angel to mind of man directly. We seek textual reasons for this angel's mouth being closed but quite different reasons for the closed mouth of the child angel in the photograph. Such reasons would be the length of time a child can hold a pose; the dubious possibility of a child's looking angelic with an open mouth; the intrusion into a photograph of knowledge that interprets pose as pose, angel as real child. Titus was the actual son of the painter, aged about twenty when he was the model for Rembrandt's angel, and there is a certain pleasure in knowing of his existence, name, and role, of recognizing his features in the painting. He is in that way more real than the Cameron angel child. But this knowledge is of a different order from the knowledge that Cameron's child was real. Titus as angel need not have been recognized as Titus but would still have been, with the title, wholly recognized as angel. The Cameron child was wholly recognizable as a child model without title, and it is difficult to accept, in fact impossible to accept seriously, the identity of the child as angel even with title. The best we can say is that we can see what was meant, with the help of the title. The "muse" of Cameron's photograph is here interpreted as equivalent to angel in her adopted pictorial convention. If indeed Cameron had seen Rembrandt's evangelist and angel, she turned its gold into lead.

The description above of Cameron's *Whisper of the Muse* is couched

in terms of distaste, even scorn, with only one word of appreciation for
the little girl looking directly at us in the lower left corner. Other terms
may be possible. The curve of the "muse's" neck is a delicate continuation
of the soft profile of the child and is connected with the sensuous opening
of the man's jacket by her hand. The diagonal composition is reinforced
by the line of the musical instrument. The little girl on the left stops the
movement. The child's features are soft, her expression the noncommittal
withdrawal of personal engagement that is short of hostility but far from
enjoyment. She is, however, unmistakably real in the sense of being lit-
erally transcribed, believably present, not invented or modified in any
way except for enforced stillness and the veil of soft focus. The central
man (posed by G. F. Watts) is also real in this sense, though the bend of
his head toward the "muse" and the position of his hands on the instru-
ment portray a more sophisticated acquiescence in the instructed pose.
The interest of the photograph lies in those lines of the man's two outer
garments, particularly the jacket, over which an overcoat is worn. The
jacket is pale and bound around the edges with a darker material so that
its edges are conspicuous. The material drapes like a fairly heavy wool
which is nevertheless loosely woven. The jacket is unbuttoned. It opens
like a vase under the beard, with large curves, almost closes as the ma-
terial comes together, and opens again at the beginning of the bottom of
an hourglass shape. Over that the very dark overcoat, bound on the edges
with a slightly lighter material (or a material that takes light in a different
way from the dark wool) bends in the large curve of his shoulder on the
left but on the right ripples almost frivolously between the instrument and
the child's hand. The question is, Are we observing the fashion in men's
clothing of a certain date, or are we seeing what the eye of the photog-
rapher is directing us toward, the interplay of curves and light that com-
pose the picture? Given Cameron's fascination with costume, we are safer
with the latter possibility, though nothing is excluded, and those inter-
ested in dress would no doubt be able to identify its period.

 A similar comparison might be made between Cameron's *King Ar-
thur* (illus. 18) and Rembrandt's *Man with the Golden Helmet* (illus.
19).[12] Weaver does not suggest this comparison, presumably because he
has a better one at hand in lines directly from Cameron's own copy of
Tennyson's *Idylls of the King* which she underlined herself. Unfortu-

nately, the underlining no more defines the photograph than the whole passage:

> *And even then he turn'd; and more*
> The moony vapour rolling round the King,
> *Who seem'd the phantom of a Giant in it,*
> Enwound him fold by fold, and made him gray
> And grayer, till himself became a mist
> Before her, moving ghost-like to his doom.[13]

Lack of focus does not serve here to emphasize tonality and an air of mystery. Lack of focus for a military man suggests incompetence. The leap of imagination that would be required to believe in Cameron's King Arthur is insistently hampered by his accoutrements. Rembrandt's helmet seems golden, Cameron's gray cardboard. Just as one can hold simultaneously in mind the glass of windows and the gold of sunset reflected in them, so one can hold in mind the difference between the actual material of the gilt helmet and the gold of its painting. It is impossible to do the same for Arthur's helmet, and its spurious quality extends to the pseudo-heroicism of the posed man.

The distinction does not depend on the authenticity of either helmet. Rembrandt and painters in his studio were as likely to dress up their models as was Cameron, but they did so in the service of different ideas, Rembrandt in a reliance for truth on the audacious reality of surface, Cameron in the conviction that conventional visual poeticizing would reveal the idea. Arthur's gaze may be turned to fit the lines of the poem, but the quality of the further lines is not conveyed by a literal transcription of "phantom," "gray / And grayer," "mist," and "ghost-like." The sharply focused attention-catching detail in this photograph is the man's ear, turned toward us in its exact curves and convolutions, with suggestions of interiority.

If most of Cameron's photographs illustrating or derived from texts should be considered peripheral, her genius becomes evident in the compelling portrait photographs. The only modern picture I have found to compare with hers is a newspaper photograph. The resemblance is fortuitous, but it offers a way of getting at the idea of beauty that so inspired Cameron.

On Wednesday, September 17, 1986, a photograph by Stephanie Gay,

18. Julia Margaret Cameron, *King Arthur*

staff photographer for the *New Haven Register*, appeared with the following caption: "Silent Moment. Steve Laskevitch and Linda Richmond, both of New Haven, listen to a prayer service on the city's Green marking the United Nations International Year of Peace and the 40th anniversary of the United Nations Children's Fund" (illus. 20). Youthful idealism here takes the form of peacefully attending a prayer service. The language of

19. Rembrandt van Rijn, *The Man with the Golden Helmet*

the newspaper caption has a nineteenth-century echo seductive in its
rhythm as well as its meaning. The young man with wide-open eyes faces
the viewer directly, only his chin obscured by the head of the young girl
encircled by his arms. The expressions are inwardly absorbed, wholly in-
attentive to the camera, perhaps even unaware of it. They are not posing,
they are listening, or praying, enraptured by a spiritual solemnity and

20. Stephanie Gay, *At a prayer service on the New Haven Green*

comforted by their closeness. The figures in the Gay photograph are in focus, but the dark background and the particular lightness of the faces, together with the beauty of the heads and the apparent unselfconscious-ness of the pose, are reminiscent of Cameron. The assembly is like hers also in its isolation from the clutter of background detail.

Stephanie Gay's two figures appear in natural juxtaposition, coher-ently linear in the overall outline of two bodies and within the outline as

each figure is seen separately. They have an apparent relationship origi-
nally with some ongoing event—they look out and away from them-
selves—then later, as the picture is removed (transcribed onto film), they
seem not so much to be looking at the viewers of the photograph as to be
looking still inwardly. The viewers, compelled to bridge the gap between
themselves and the figures in the photograph, if only by the act of looking,
find that the figures remain self-contained and complete. Their eyes do
not return a viewer's glance. If returning the glance means that the whole
picture is invested with significance beyond its subject, however, then the
whole picture *does* return one's glance, just as the Cameron portraits do
and just as Benjamin said that a work of art does.

The subject of Gay's photograph was unimaginable to Cameron. The
photographers have in common, however, a visible interest in the way
long hair frames a face or falls over a forehead in a tantalizing stray lock.
Almost all of Cameron's portraits of women make use of the way hair
flows, outlines, weighs, caresses, swirls, cascades, and is confined or re-
leased like water dammed or spilled. In portraits of men hair plays an
equally important part but has a different function. Wild, white, unruly
locks (i.e., *Charles Hay Cameron, 1869,* and *Sir John Herschel, 1867*)
emphasize the carelessness of appearance that marks genius of intellect.
Great intellect for men and great beauty for women formed Cameron's
rationale for choosing and photographing subjects for portraits.

One of the most beautiful women was Cameron's niece Mrs. Herbert
Duckworth, who later became Mrs. Leslie Stephen, mother of Virginia
and Vanessa (afterward, Virginia Woolf and Vanessa Bell). The three
1867 portraits of her reproduced in Helmut Gernsheim's monograph
(Plates 89, 99, and 149) illustrate her beauty. All have a dark background
out of which head and neck emerge in emphatic presence. Julia Duck-
worth's neck rivals the long necks of D. G. Rossetti's models, Elizabeth
Siddal and Janey Morris.

Plate 89 is a frontal view of Duckworth's head framed in a barely vis-
ible white cap, the neck rising from a narrow white pleated ruche (illus.
21). Hair is visible, but it is absorbed into a background of indefinite un-
focused leaves, which take the burden of luxuriance as they stray over the
primly tucked-away hair. The large, deep-set eyes are wide apart, the nose
straight, the mouth wide, a classical face. Although Virginia Woolf did
not describe her mother directly in *To the Lighthouse,* she wrote of the

21. Julia Margaret Cameron,
Mrs. Herbert Duckworth, 1867

22. Julia Margaret Cameron,
Mrs. Herbert Duckworth, 1867

23. (*oval*) Julia Margaret Cameron,
Mrs. Herbert Duckworth, 1867

fictional Mrs. Ramsay that "she felt herself very beautiful" as Mr. Ramsay watched her while he thought, "You are more beautiful than ever."

Plate 99 (illus. 22) is a profile of Duckworth, not the best and most famous but so similar in pose to the best, Plate 149 (illus. 23), that they can be compared. Overall the figure of Plate 99 is without blacks or whites but is entirely modulated grays against black. Light falls on the outline of the profile, but although the nose is sharper and more pointed than could have been imagined from the front view, the shadow in the eye hollows and below the cheekbones models the face in the expected classical mold. The neck is exposed. The hair is straight on top and gathered into a profusion of tangles at the neck, then disappears into the dark background. The shock of the difference between Plates 99 and 149 is like looking from a P. H. Emerson, with its watery, silvery tones, to a stark black-and-white Bill Brandt. The shadows are much deeper, the whites purer, the modeling simplified and strengthened, the hair smoother, the lips especially modeled in detail. Above all, the shadow beneath the chin and on the neck cuts the flesh into shapes strange as interrupted sunlight on a column.

If the figures in the Stephanie Gay photograph form a subject as alien to Cameron as Cameron's floating-haired and filmy-costumed figures would be to Gay, and yet Gay's work bears a resemblance to Cameron's, the resemblance must be ascribed to the essentially common attitudes toward faces and a common feeling that close-ups best convey identity. Both achieve their effect by dark background, close approach, and attention to subjects whose faces receive light in certain conformations, or, an alternative way of attributing to the photographer what properly belongs to her, attention to subjects whose faces can be perceived as capable of receiving light so that conformations appear which might ordinarily, without the direction of the photographer, be missed.

This is different from, and distinguishable from, other kinds of portrait photography. Richard Avedon's subjects have chosen a character, which they are encouraged to portray in front of a white backdrop. Avedon, however, though meticulously polite about letting his subjects think themselves into their characters, authenticates that character by choosing when to record the portrayal. He seeks or recognizes identity and unemphatically but decisively excludes all other possible moments. This in turn confirms the subject's idea of self. Avedon too recognizes the essential ap-

pearance most nearly coinciding with his internal private imagining of appearance. He sees the wrinkles, or the carelessness of stance, or the forthright yet subtle glance of the eye, which for the first time becomes visible evidence of age, or uneasy purpose, or sensitivity. What has been thought or wrought in the body becomes visible to the eye.

The congruence of photographic eye and judgment with the subject-spectator's judgment is not in this case surprising. Avedon claims sympathetic vision. Naming the characteristics in the portrait by stranger-spectators is more difficult. Wrinkles, carelessness of stance, or glance of the eye are legitimate predicates; wrinkles may mean age; but uneasy purpose or sensitivity are dependent on either invisible determinants—thought, actions not depicted—or a sequence of movements we imagine and might thus interpret as uneasy or sensitive, without necessarily even then being precisely sure, but only allowing them among the possible interpretations and looking for confirmation in context, or biography, history, and other relevant factual supplementary information.

The next instance of describing a photograph is by the modern scholar Carol Armstrong, who characterizes Paul Valéry's description of an Edgar Degas photograph as "a convenient laundry list of its contents." Armstrong's purpose is to describe it differently, as Degas's self-portrait. The "laundry list," however, is not so free of valuation as the term suggests: "Near a large mirror we see Mallarmé leaning against the wall, and Renoir seated on a sofa facing us. In the mirror, in the state of phantoms, Degas and his apparatus, Mme and Mlle Mallarmé can be made out."[14] Naming each figure creates a list. But the principal emphases are relative position of figures in front of or seen within the mirror and the assumption that outside the photograph are "we"—the viewers—who "see"—that is, see clearly—or "make out"—that is, see unclearly, with difficulty—certain parts of the photograph. When the thought of immateriality (phantoms) occurs, it must either be rejected or accommodated. Any mirror image encourages, by virtue of being a reflection, its construal as other, as double, as uncanny. Armstrong's description relies on the matter-of-factness of "laundry list" to play down or even ignore such extensions of the meaning of "phantom," which in her text suggests only the more limited meaning of that which is incompletely visible.

Since the function of Armstrong's description is to establish the primacy of the mirror image as "a kind of self-portrait presented and named

as a portrait of others," it is understandable why "phantom" is a part of the list not singled out for comment, as if phantom were an ordinary descriptive "laundry list" term. Valéry may have been using the word *phantom* to describe what could be seen as a slightly absurd "self-portrait" of Degas. The "portrait" mirror reflection is virtually headless. In place of the head is a white burst of light. The women are hardly discernible as individuals, but rather appear as outlines of light and shadow, placed so as to be indistinct presences distant from the surface of the mirror and partially obscured by Renoir's head in front of the mirror. The photograph (of which the Metropolitan Museum of Art has a print), is entitled *Portrait of Renoir and Mallarmé*, ca. 1890. The photographer, Degas, works in front of the large mirror, his reflection behind it; the two women are present, but without some other record no one would know their identity. Renoir and Mallarmé are thoroughly present and the most solid objects in the picture.

Armstrong's description rightly makes certain that the viewer sees the mirror images as significant, but that the significance must be Degas's self-portrait is not an interpretation that can be established as necessary. Feminists might see the dim figures of women in the mirror as illustrating their peripheral role. The exaltation of the mirror functioning as enclosure of Degas with the other two artists and at the same time his operation of the instrument that registers the enclosure give him conceptual but not visual primacy.

Language is a system in which words refer to objects or to each other in complicated but ruled relationships. The world of visible objects, the world that can be photographed, has no such structure. It is transcribed only as surface. Surface will transcribe structure (everything that can be seen has a name), but it will be a structure belonging to a system other than the photograph. The photograph itself has physical properties and is made with technical, physical, and chemical resources, but these, though unique to the photograph, are not what is meant when someone describes what he sees in the photograph: this is a person, this is Jane Doe, this looks like Jane Doe at her wedding. In this ostensive use of language, "This is my cat" has the same meaning as "This is a picture of my cat." The comment, "This is [a photograph of] Jane, but it doesn't look like her," illustrates the problem of matching surface, or "reality," to experience, or mental picture. "It doesn't look like her" expresses a belief, an

attitude, a stance toward the photograph vis-à-vis the actual person indicating a slippage between the two images. "It doesn't look like her" conveys in addition to the slippage a clear premise that the true right image is not the photograph but the experience or memory of the person herself. Every photograph is in this way a test for the viewer's imagination.

Some aspect of the real is transcribed, like it or not. The question is not whether, not even how, this occurs, but how the viewer is to think and imagine a description and interpretation that will make sense and that will correspond to what can be seen and named in the photograph.

The next chapter turns to a consistent term of metaphor in the description of photographs, the term *mask*, to illustrate varying emphases on what is concealed and on the nature of any concealing element in the photograph.

6

Mask as Descriptive Concept

In photography, proficiency of execution may also be interpreted as mask or disguise, concealment of the warts and disfigurements, or, alternately, concealment of natural goodness; we who prepare a face to meet the faces that we meet may be convinced that only surprise will catch a glimpse of truth, or only the amateurism of youthful innocence, or only lack of pose. Barthes calls the photographer who took the Winter Garden picture of his mother "the mediator of a truth," the truth being his recognition of her unique being in the photograph. But Barthes rightly does not reproduce this most important photograph in his book. "I cannot reproduce the Winter Garden Photograph," he says. "It exists only for me. For you, it would be nothing but an indifferent picture, one of the thousand manifestations of the 'ordinary'; it cannot in any way constitute the visible object of a science; it cannot establish an objectivity, in the positive sense of the term; at most it would interest your *studium*: period, clothes, photogeny; but in it, for you, no wound."[1] This is certainly true. But what Barthes and other writers have done is to bring within the range of possibility an acknowledgment on the part of the rest of us that what they have discovered and named must exist for us too. They cannot name our precise wound; they can only name their own; but we may now with tentative assurance begin to understand what their use of their photographs was. They have invested photographs with meaning; their language directs us to the idea of unseen truth in the photograph.

Awareness of metaphor in the use of mask, even the most literal, is almost irrepressible in the case of the photograph as opposed to painting. The reason for the difference in our regard lies in the notion of the pho-

tograph as a transcription of the real, the photograph thus becoming itself the mask concealing what is behind it and thwarting confrontation with the real. What in the work of the eighteenth-century Venetian painter Pietro Longhi we can accept as a conceit inherent in the situation, the ball with its beautiful women enhancing their mystery and appeal by the Venetian convention of the domino, in photographs may be resented as a contrivance to cheat. Conversely, in some of Diane Arbus's photographs the viewer may be grateful for masks covering certain helplessly vacuous faces. Both resentment and gratitude originate in the frustrated expectations of the real. In these cases the mask is literal, even with its metaphoric overtones.

Barthes uses other photographs and another formulation involving mask:

Since every photograph is contingent (and thereby outside of meaning), Photography cannot signify (aim at a generality) except by assuming a mask. It is this word which Calvino correctly uses to designate what makes a face into the product of a society and of its history. As in the portrait of William Casby, photographed by Avedon: the essence of slavery is here laid bare: the mask is the meaning, insofar as it is absolutely pure (as it was in the ancient theater). This is why the great portrait photographers are great mythologists: Nadar (the French bourgeoisie), Sander (the Germans of pre-Nazi Germany), Avedon (New York's "upper crust").[2]

Let me make clear first how much I admire and enjoy the dazzling authority Barthes conveys before I venture, with respect, to look at the actual photographs he is summoning as evidence. The photograph entitled *William Casby, Born a Slave, 1963* is reproduced in *Camera Lucida* with a legend from Barthes's text: "The mask is meaning, insofar as it is absolutely pure."[3] The mask of "the ancient theater" is Greek. Masks were worn by actors to identify performers with the characters assumed. Their purity lies, for the modern metaphor, in their being unmistakable identification, both because they were conventionally known and because they were unvarying in the agreed-upon identifying characteristics. The mask shares some characteristics with the double, the shadow, the image in the mirror, the realm of ambiguous identity and loss of identity entered by Diane Arbus. But looking specifically at the photograph of William Casby occasions uneasiness with Barthes's "the essence of slavery is here laid bare: the mask is the meaning."

This photograph suggests a mask because it looks like one. Not the slightest veering from a placement parallel to the picture plane can be detected. The position vis-à-vis the viewer is as if the head were pinned on a bare wall at eye level. The mask is the "essence" of slavery because, according to Barthes, it is "the product of a society and of its history." In less exalted prose, the more appropriate word might have been "typical," and Casby's photographed face-mask might have represented the type, slave.

A similar presentation of a portrait occurs in the photograph of Dwight Eisenhower, also by Avedon, also looking like a mask.[4] So much is known about Eisenhower that the question becomes, What knowledge is applicable to the photograph? Yet "essence" suggests itself from the bareness of the head and the utter lack of signifying properties. The face and head are deliberately isolated from insignia of power, from uniforms and medals, from the Oval Office with its flag in the background, from every identifying extraneous signal, leaving a man whose being remains to gaze through his eyes. This might be called the essence of the private man who is known to us only through his public life. The caption names him, gives his office, the date, and place: *Dwight David Eisenhower, President of the United States, Palm Springs, California 1.31.64.* The caption gives information necessary for thinking about the portrait, not just necessary as identification.

Both portraits are taken as if the nose is pressed against the camera's ground glass. The heads are isolated, very close, slightly distorted in the way a round globe surface flattened is distorted. Seen frontally that way, and close, with only the setting in neck and shoulders to make them substantial, it is no wonder the heads look larger and more significant than themselves. The background is blank. The photograph of Eisenhower has more space around the head than the Casby; the body appears conventionally dressed in a dark suit, dotted tie, and white shirt. Knowing he is (was at the time of the photograph) the president of the United States demands a wholly different interpretation from that of the photograph of William Casby, former slave. The clothes and the condition of the skin in the two instances indicate differences in economic and social status. I doubt that ignorance could do more without the accompanying identifying descriptions. If mask is apt in one case, it is apt in the other.

Suppose, then, that both photographs do present their subjects as if

the face were a mask. Looking at the photographs together allows this visible likeness of presentation while at the same time distinguishing real differences between the faces, of color, direction of eyes, and centering of head. What unequivocal information do these masks provide?

As long as the names are given, speculation (critical explication) is both limited and loosed. Barthes extrapolates generously, brilliantly, imaginatively, on the Casby photograph, beginning with the comment: "Since every photograph is contingent (and thereby outside of meaning), Photography cannot signify (aim at a generality) except by assuming a mask." The photograph is dependent (contingent) upon reality and contingent also because it replicates a random (contingent, not meaningful) reality. It is not constructed, therefore it cannot generalize or abstract. If construction is involved, it is construction out of elements of the real and visible that can be arranged or directed but not created solely by imagination. In paraphrasing Barthes's argument (less argument than statement), I want to make it sound reasonable by spelling out the reasoning rather than accepting the wit and aphoristic force at face value. He offers as test the mask of the ancient Greek theater, in which the signifying identity was the virtue. So the spelling out would go like this: unless the photograph identifies both by name and by classification (e.g., slave, soldier, melancholic), thus providing both individual and "character" represented by the individual (as Casby is *William Casby, Born a Slave*, and signifies "the essence of slavery"), it is *only* contingent, without general interest, unable to engage the viewer except as it inspires inventive interpretations. If it is not a mask and has therefore none of the meaning Barthes invests in it, it is open to any interpretation that is willing to be limited by the actual visual elements. That is often very limited indeed.

Barthes is using "mask" in the large sense of that disguise inherent in the process of making a photograph. The removal of what we might well go back to Lucretius to name, the film or skin of appearance, creates a mask by the act of removal. The photograph is the film or skin of appearance. At the very least it calls attention to the fact of being a mask (transcribed from reality) by removal. In addition, the removal of the mask not only certifies its existential "maskness" but because it looks exactly as real objects look, or as we have learned to see them, the mask is taken as true depiction of those objects. Once again, the reason we take it as true depiction is that the photograph bears a strict and necessary re-

lationship to its source in the visible world. This way of using mask is very like the use of the word *veil* before photography was invented. It is an acknowledgment that perception is imperfect, lack of epistemological certainty is the norm; we *always* envision as we see. The emphasis is on the impenetrability of the particular, or individual. With a shift of emphasis, the individual can represent a type (for example, in the photographs by August Sander or Sir Benjamin Stone).

The other, literal, use of "mask" is the particular face-covering that conceals what is behind it when it is attached to the face by ties behind the head or hooks over the ears or when it is more substantially made to fit over the entire head and sit on the shoulders. By metaphoric extension it is the literal covering that conceals anything. The Greek mask is this literal covering. Barthes has invested mask with both the literal and the extended metaphoric meanings.

Mask is a concept often used about photography and photographs; one meaning may be dominant, but all possible meanings are implicit unless the definition is expressly limited. Walker Evans photographed persons in the New York subway cars by riding the trains with a concealed camera. James Agee says of those subjects:

The simplest or the strongest of these beings has been so designed upon by his experience that he has a wound and nakedness to conceal, and guards and disguises by which he conceals it. Scarcely ever, in the whole of his living, are these guards down. Before every other human being, in no matter what intimate trust, in no matter what apathy, *something of the mask is there*; before every mirror it is hard at work, saving the creature who cringes behind it from the sight which might destroy it. Only in sleep (and not fully there), or only in certain waking moments of suspension, of quiet, of solitude, are these guards down; and these moments are only rarely to be seen by the person himself, or by any other human being. (Emphasis added.)[5]

Here the outer appearance is taken as mask of the true inner being, a mask wrought by the will of the person who displays it but a mask penetrated by the photographer, or, as Agee suggests, dropped by the subject. Photographer Evans maintained his mask of unawareness, concealing his intention, while at the same time pointing his hidden camera.

The photograph has removed and preserved the "film," which is the photograph. In Barthes's discourse it was thought of as the removed

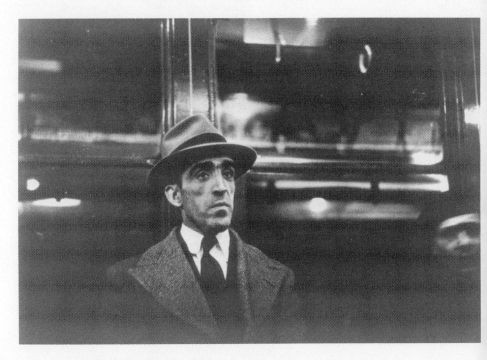

24. Walker Evans, *Subway Portrait*

mask. In Evans's subway photographs, however, the suggestion is that Evans has been able to surprise the subjects without their usual masks, without their conscious presentation of self (see illus. 24 and 25). The precise distinction of the photographs is that the subjects lack masks. They are stripped of properties, personal context, and private setting. They have no names, past, or future. Their exposure without masks reveals macabre isolated individuals looking at nothing. Yet if they have no pose (are unaware of the camera), they have stubborn individuality. They have identity as city people, small people (not individually distinguished except for survival), but they must not be thought of as vacuous because they are not important. As Agee says, "Each carries in the postures of his body, in his hands, in his face, in the eyes, the signatures of a time and a place in the world." *Many Are Called*, the title of the book in which the subway portraits are published, inevitably suggests "but few are chosen." Evans

25. Walker Evans, *Subway Portrait*

and Agee had a bedrock conviction that something about the many required attention.

A contemporary photographer, Yousuf Karsh, says about his own portraits, "All I know is that within every man and woman a secret is hidden. . . . The revelation, if it comes at all, will come in a small fraction of a second with an unconscious gesture, a gleam of the eye, a brief lifting of the *masks that all humans wear* to conceal their innermost selves from the world" (emphasis added).[6] Karsh's photographs should ideally, according to this profession, reveal that secret, make that revelation, surprise that lifting of the mask. What he demonstrates in fact, however, is a cultural reverence for power, purpose, and achievement, expressed in the very choice (or assignment) of subjects, enhanced by solemnity of treatment. The subjects may be caught briefly without their own masks, but they are then covered with the photographer's inadvertent mask of

sheer admiration not for the subjects' uncovered disclosed selves, though he has recognized them, but for his subjects' importance in the world. Looking at his photographs of famous people, one sees that he has not allowed the private moment of revelation to remain private but has turned it into a public moment. Contrasting his photographs of famous people with photographs of famous people taken by Man Ray, André Kertèsz, or Richard Avedon illustrates how deeply Karsh's mask of admiration obscures the revelation of a private person.

Karsh thus understands the necessity of looking beneath a public mask, but he does not understand that he has contributed another mask. His Marian Anderson, so wholly and straightforwardly admirable, looks, or could be thought to look, ever so slightly bored (illus. 26). It is a close-up portrait of head and shoulders, clothing showing only as texture and darkness, even though the textures are velvet and fur. A handsome ornament hangs from a thin chain about the neck. Both eyebrows are made up in shapely crescents, but some trick of light has made the eye makeup below the eye on the left seem incongruously darker. If this were not so beautiful and dignified a woman, the solemnity might seem portentous. In truth, she was humming to herself. Karsh says, "This is the portrait of a harmonious soul revealing itself unconsciously in song." But as an example of "the invisible target," the secret that can be surprised under the mask, it is too bland. That look of abstraction is characteristic not only of a harmonious soul but of a woman who has just begun to wonder whether she turned the stove off before leaving home. The portrait is beautiful, but Karsh has not made it reveal the unconscious soul.

Literal masks occur frequently in Diane Arbus's work. Her photographs suggest masks even when there are not literal masks, just as Avedon's frontally posed and isolated heads suggest masks. In a series of pictures by Arbus identified as *Untitled (1)–(7) 1970–71*, three include masked figures. Two others emphasize abnormally dull-witted faces, while the remaining two depict grotesquely playful bodies. Another kind of mask occurs in an Arbus photograph called *A house on a hill, Hollywood, Cal. 1963*, in which a pure facade, visibly supported behind by a strutwork of scaffolding, is silhouetted against a mackerel sky lit by a setting sun. The sky is light, the solid elements below the horizon are dark, with details of windows and fire escapes still darker, and the grasses slightly paler. The facade is a mask with nothing behind it. It is a Hol-

26. Yousuf Karsh, *Marian Anderson*

lywood structure made to give the illusion of a house, but the photograph, by including the supports in the rear, deliberately exposes the elements of the illusion, destroying one effect to create another.

As in many of the other Arbus photographs, the space behind, in this case the sky spectacularly clouded and sunlit, opens the scene to wide and distant natural spaces which contrast with the locally foregrounded objects of attention. The spaces are both natural and unknowable, nameable but mysterious. Arbus succeeds in making the natural as ominously vast as her subjects are often particularly monstrous. The complicity of

abnormal subjects (dwarfs, giants, the retarded) in other Arbus photographs may be a sign of their courage or their acceptance of fate. Arbus says, "Most people go through life dreading they'll have a traumatic experience. Freaks were born with their trauma. They've already passed their test in life. They're aristocrats."[7] Arbus's total acceptance of the wounds both inflicted and endured by humans is illustrated in photographs that display the wounds as if they were the norm, creating a disbalance between mask-photograph and reality-wound. But is nature also complicitous? One seems to be asked to lie in wait with Arbus until the veil is rent for a second and the trauma both of nature and of person is exposed. The visual effect, however, is not of complicity but of indifference on the part of nature. The extent and distance of the backgrounds out of doors seem exaggerated. There is no vanishing point. The background is a backdrop. Nature is both removed and awesome and yet can be made to stand still for a picture in which it will suggest the impersonality of the natural world.

Nature is not all that Arbus uses as backdrop. *Xmas tree in a living room in Levittown, L.I. 1963* suggests restriction rather than amplitude. Although the focus of the photograph is the Christmas tree decorated with tinsel and bulwarked by packages at its base, other properties of the scene modify and subvert any ordinary meaning of Christmas celebration. The clock surrounded with irregular metal spikes on the bare wall resembles drawings of the star of Bethlehem, but it registers a quarter to one in the afternoon. A visual trip around the room discloses banal, commercially standardized furnishings. The emphasis is on the vacancy at the center of the boxlike room.

The name Levittown evokes the acres of identical little box houses built after the Second World War to ease the housing shortage. Arbus emphasizes the neatness, emptiness, and intellectual poverty of a house defined by department-store norms. We long for some sign of individuality that would make this house, or the people whose house this is, identifiable, and there is nothing. That is what the absence of certain properties signifies, that in a house like every other house in Levittown live people like all other people in Levittown. The signs of difference are suppressed. At best one might think of tidiness, conformity (represented by gift packages), responsibility (clocks keep one on schedule), and observance of society's rituals (Christmas). Arbus is not discounting the value of what she

shows, but she is showing as well the vast emptiness at the center which the photograph both masks by singling it out as subject and exposes.

Again, Arbus seems to be asserting that emptiness and absence are telling us something, even when the emptiness and absence are represented by clutter. In *A widow in her bedroom, N.Y.C. 1963*, myriad objects appear in a corner of a room. The widow of the title sits amid her possessions. Under an ornately carved desk covered with Oriental religious figures are a radiator grill and two wastebaskets, an electric wire, and the bottom of a curtain gathered into one of the wastebaskets. On the left wall, in front of the enormous Oriental vase with huge glossy flowers sticking up out of the mouth, is a small table with drawer open, crystal knobs alight, coffee cup and saucer with spoon on top, plastic-rimmed spectacles atop a small radio or television set, and, on the stool beneath, a small patch of quilted material. It's a jungle. Disorder is also emptiness.

At the same time, Arbus celebrates the simple irreducible fact of being alive, the vigor and thrust of being. Sometimes she singles out specifically sexual aspects of life. The figures may be transvestites or a sword swallower used to create a symbolic sexual displacement. One woman looks sexually provocative but is perversely labeled housewife. Yet each one is assertive of self. The self they present does not necessarily coincide with the one that is perceived, and this, rather than any moral implication, occasions discomfort. Even if the subjects are unpleasantly marginal, they compel, even command, attention by their force of being.

Woman with a Veil on Fifth Avenue, N.Y.C. 1968, is a close-up of a woman's head framed in fur and chiffon. The fat, dimpled face is covered by a wide-meshed black veil. Whatever can be said about the tacky fulsome costume, and I haven't even mentioned the huge pearl earrings that bob at either side of the head, the apparel is complete, consistent, purposeful, and a source of pride. It is this very purposefulness that Arbus has pictured. A discrepancy occurs, however, between a dispassionate judgment of the woman in the photograph and her judgment of herself. Her vitality actually stresses her tastelessness. Judgment by the viewer is divided between attraction and repulsion. The oblique suggestion in all of the Arbus photographs is that they are both revelation and concealment. The notion of mask is always present.

Jacques-Henri Lartigue is sensitive in an entirely different way from Arbus's to the adornment of the female body, and the high-spiritedness is

27. Jacques-Henri Lartigue, *Mardi-Gras with Bouboutte, Louis, Robert and his brother Zissou, Paris, 1903*

evident in his use of masks.[8] Three boys and a girl wearing comic masks face the camera in a row (illus. 27). They stand on a gravel path in front of a stone wall against which a dark hedge and espaliered vines grow under strict control. No straggling vine shoots interfere with the pattern of the arches visible within the stone wall. The severity of the background, with its evidence of care in the original laying of the stone, in the contained growth of vines allowed just so much encroachment and no more, in the neat edging of the grass verge below the wall, sets off the ridiculous and inventive masks on the four children below. The fun of the picture lies in the contrasts between formal background and burlesque posing;

between the rigidity of design of wall and shrubbery and the splendid abandon of the masks; between the controlling patterns into which these children will grow and their immediate playfulness.

Arbus's masks set would-be playfulness against a bitter reality. Lartigue's masks hide laughter. Arbus's photograph of the veiled woman's face asks us to notice the subject's vacancy of mind but couples that with an aggressive forward-thrusting composition of costume and attitude. When Lartigue's women wear veils, the effect is totally different.

One such photograph by Lartigue is called *Avenue des Acacias, 1911* (illus. 28).[9] The white elegantly figured veil, drawn tightly around the head and fastened securely to the brim of the draped and domed hat, entirely obscures the face of the woman and by obscuring calls attention to it. The pattern on the veil follows the contours of the nose and jaw like a tattoo. In the case of neither the veil nor the tattoo can the cover be mistaken for an instrument of modesty or comfort. It is a mask as instrument of public presentation, continued in the fashionable cut of the coat out of which the jabot flies like a sail, reinforced by the trim cuff and the glove with its three black stripes down the back like a sign of military rank, and the lorgnette. High fashion is often preposterous when it is isolated for the purpose of showing a contradiction between its perfection and the human beings who buy and wear it. Still, clothes are the outward and most visible sign of a stance toward society. This stance is comprehensible both in the Arbus and in the Lartigue photographs.

The Race Course at Nice, 1912 (illus. 29)[10] shows another veiled woman. The crown of the hat is lower, the vertical feather higher, the brim turned up, but the veil is still anchored to the brim and fastened about the neck. An overall pattern of squares in the wide hexagonal mesh dances over the young and beautiful face. The veil is no longer a tattoo, it is Piet Mondrian's *Broadway Boogie-Woogie.* The woman's uplifted hand, from which the fingers of the long glove have been removed and tucked into the cuff, and the slight upward curve of the mouth under the veil, both suggest that this is a moment of tense watching, presumably of the race. Lartigue conveys his enjoyment of these two women's appearance by catching each of them in apparent concentration, the first in midstride, the second in a moment of suspense about the outcome of a race. They are not looking at the camera. They are going about their business. But their business includes the beautifully outrageous exterior surfaces

28. Jacques-Henri Lartigue, *Avenue des Acacias, 1911*

they have composed. In contrast, Arbus does not single out a woman of fashion, only a woman wearing cheap clothes presented as if she were a woman of fashion.

The existence and nature of objective reality are not in question, not because there is no question but because only the assumption that what

29. Jacques-Henri Lartigue, *The Race Course at Nice, 1912*

is visible is in some sense real will allow photographs to be taken and then requires to be read into photographs the information that we think we see there and that we think is derived from the external world. Heinrich Böll says: "The great deceit of photography lies in the prior deceit of 'objective reality.' It is not the lens which makes the decision, but the photographer's eye." He admits the connection between photograph and objective reality, one concrete and one abstract, and calls both deceitful, though the photograph depends for its deceit on the deceit of the reality. The deceit is not at issue here, only the connection.

It is indeed a photographer's eye (mind, intention) that chooses what and when to photograph, sees a pattern in chaos, and bends the indifferent reality into meaning. Harold Rosenberg comments: "In our century it has become customary to believe that if appearances are deceitful, reality is no less so. The need for masks is no longer felt—faces are enigmatic enough." Rosenberg is referring to Richard Avedon's portraits, but what he says about faces ought to apply equally to Walker Evans's New York subway portraits of unidentified subjects, and yet his view contradicts Agee's. According to Agee, the subway riders have exposed themselves without protection (without masks) on these occasions of routine non-observation, losing themselves in the crowd or in the city transportation system without fear of their "wound and nakedness" being discovered. Rosenberg, for whom the face is the mask, describes the faces differently so that we see them differently. In both instances the outside (the face) is imagined as separate from the inside (the self as conscious being).

Taine's metaphor, "Time scores us and furrows us as a pickaxe the soil, and thus exposes our moral geology," mentioned earlier, is not much use to the photographer or the viewer of photographs, persuasive as it is in expression. Taine's "moral geology" is a determining force from inside the body, as time is from the outside, and the inside, behind the face, appears externally when the erosion of time exposes the contours of character. But the words permitted to describe both character and face do not describe a photographed face. Such words as *kind, cruel, brave, cheerful, mean, humble*—words describing ways of acting—are not clearly coded to visual counterparts. Recognition of this fact, though unacknowledged, may lie behind the persistent use of the mask as metaphor for the face (whether as prepared expression covering "wound," or naked expression indicating the usual mask has been dropped, or condition of face corresponding so exactly to the deceit of the mask that the face is the mask).

John Berger contrasts the wish (or intention) of a subject being painted with some modern wish that would presumably apply to the one being photographed. "The satisfaction," he says, "of having one's portrait painted was the satisfaction of being personally recognized and *confirmed in one's position*: it had nothing to do with the modern lonely desire to be recognized 'for what one really is.' " Reality is being described differently in the latter case. Book dust jacket photographs are entirely for being "confirmed in one's position" as author, as human being, as such

and such a person, often very skillfully projected by the poser rather than entirely by the professional photographer. What "one really is" is more nearly one's own invention now, rather than being determined by the external signs of class, wealth (or lack of it), and talent. This creates a problem of its own, which Richard Avedon has confronted. "I often feel," he says, "that people come to me to be photographed as they would go to a doctor or a fortune-teller—to find out how they are."[11] Richard Avedon and his models tend to know *who* they are. *How* they are is the modern question. Photographs are less an answer than a reflection of the questions, a way of arresting the flux of time so as to contemplate the questions. None of the questions can be eliminated. The categories of photographs—portrait, landscape, fashion, snapshot, news, police, license, and other identifying functions, to name a few—are based on intended use, but intended use need not be the only use. Other uses may go beyond the limit of intention.

The aura itself may be regarded as a mask. For an object to return one's gaze, the gaze must be directed toward the object, and the gazer must be willing to see what is there to be seen, rather than investing the object with significance beyond its ability to sustain additional weight. As the account of Proust's use of photograph as metaphor will show, Marcel's sight of his grandmother without the aura of "intelligent and pious tenderness," as if he were seeing a photograph, was bare, harsh, and strange. The surface was unmodified by filial regard. Marcel hastened to clothe her again. There is no aspect here that can be called reality. It would be wrong to suggest that the vulgar old woman he sees was the reality to the exclusion of the grandmother. Both are constituent, as are other aspects here irrelevant to a fictional character (atomic composition, medical history, the mind and memory of the grandmother herself before Marcel existed, for example), in the complex existence of one person. We assume, because all of us fictionalize our lives and the lives of others who have a part in our story, that to surround a grandmother with an aura of intelligent and pious tenderness is good, better than to see her plain. Marcel, in the image of his grandmother seen as if photographed, is reducing a beloved figure to purely physical appearance. That state is intolerable. The investment of tenderness must begin again.

7

Metaphor

❦

The strength of a metaphor depends on its aptness, usefulness, and de-scriptive power. Benjamin's aura is a strong metaphor, already intro-duced. Aura is developed further by Benjamin and will appear again, am-plified. Another strong metaphor in the context of photography is a com-parison of some aspect of photography with some aspect of language. William M. Ivins, Jr., provides an excellent example:

The great importance of the half-tone [i.e., the middle tones between black and white achieved by photoengraving] lay in its syntactical difference from the older handmade processes of printing pictures in printer's ink. In the old processes, the report started by a syntactical analysis of the thing seen, which was followed by its symbolic statement in the language of drawn lines. This translation was then translated into the very different analysis and syntax of the process.

The passage ends with the statement that the half-tone "represents one of the most amazing discoveries that man has ever made—a cheap and easy means of symbolic communication without syntax."[1]

Ivins, in his brilliant explanation and interpretation of what he called visual communication, commented that "our verbal definitions are only good so long as we do not have to think just what they mean."[2] Verbal definitions construct operative fictions dependent on use. His distinction between visual and verbal statements is that visual statements have no syntax for reading their meaning, thus introducing an implicit compar-ison, because statement, syntax, and reading are terms primarily appli-cable to language.

Before photography, according to Ivins, the syntactical analysis of a

picture preceded the handmade reproduction, which became a symbolic representation of its original. References for reproduction are the woodcut, etching, or lithograph that reproduce a work of art. But the reproduction of the work of art by means of photography becomes equivalent to the reproduction of the syntaxless world of real objects in any photograph.

A picture is seen first as a whole and then analyzed in any order of parts, unlike the sentence in which each word has a place, in which the order of words may have meaning, and in which every part is related to a whole statement unintelligible until the sentence is completed. Verbal statements, Ivins reminds us, can be exactly repeated, but until the invention of photography visual statements could not. His use of the grammatical term *syntax* is a metaphor for the ordering of parts.

The grammatical model for analysis of visual statements is useful when it is clearly acknowledged as one term of a metaphor; a visual "statement" is like a sentence (whatever unit is chosen for comparison) in this or that respect, with due care for accuracy and appropriateness. The comparison between photography and language then makes a powerful metaphor.

A contemporary critic uses the same metaphor: "When it comes to organizing the world into a picture, the photographer has little to go on. . . . Prose is the closest analogy to still photography, but *photography is a language without syntax*. A photographer's only constraining form is his frame. Inside those four edges there are no structural traditions, only space" (emphasis added).[3] Such structural traditions as exist in the mind of the photographer are derived from representational systems that assume the verticality of the person, with feet on the ground, and that assume stable interest in the doubling of a person, place, or thing by means of a depiction. E. H. Gombrich has distinguished other constraining forms of cultural convention. Ivins refers to "the kinds of things our minds permit our eyes to tell us."[4] Sophisticated and creative visualizers take these conventions as the rules of the game and play against them, as Man Ray does with his Rayographs or Marcel Duchamp with his ready-made objects. In the passage quoted above, "language" is one term of a metaphor, and to say "photography is a language without syntax" is inviting a comparison of the structure of language, which operates through grammatical rules, with the lack of structure imagined in arbitrary fram-

ing of anything and everything in the world that casts a shadow. It is like saying photography is a language composed entirely of nouns.

The point to emphasize is that photography as language is either a metaphor (a comparison) or it is nonsense. It is a relief to find Wittgenstein saying, "It is *primarily* the apparatus of our ordinary language, of our word-language, that we call language; and then other things by analogy or comparability with this."[5] He draws attention to the obvious in a way that has been made necessary by the confusion of the metaphoric with the literal. For example, in the following passage "language" and "linguistic," "communicate" and "codes" lend a false air of exactitude to an unclear thesis:

Another contemporary movement, conceptual art, has influenced present-day photographic realism by laying the base for what in some cases has become the empty repetition of formulas. Conceptual art is often primarily intellectually oriented, and thus risks becoming a sectarian avant-garde movement. It has nevertheless managed to clear up many *linguistic misunderstandings*; by demonstrating that we can *communicate* without using well-established *codes*, it has helped to further the analysis of *the language used by artists and photographers.* . . . Developing new *linguistic solutions* through technical manipulations, and the resulting new ways of seeing, can combine to form a massive direct attack against the mass media which hold sway over the consent or dissent of mass society today. (Emphasis added.)[6]

The author of this passage shifts from metaphor to literal meaning, with the result that he substitutes consistency of jargon for clarity of thought. Once language becomes a term of metaphor, the next user may slip into a literal confusion, as if claiming codification of signs were enough to make codification self-evident.

John Berger, another critic of photography, also uses language as a term of comparison. He evokes the image of a bulletin board with all sorts of personal papers pinned to it, pictures, newspaper cuttings, photographs, drawings, and says, "On each board *all the images belong to the same language* and all are more or less equal within it, because they have been chosen in a highly personal way to match and express the experience of the room's inhabitant" (emphasis added).[7] I would suggest that the passage means "all the images belong to the same experience." The reference to language is unnecessary and confusing.

Berger also evokes the metaphoric extremes of silence (paintings) and

noise (photographs as information): "Original paintings are silent and still in a sense that information never is." Silence and stillness "permeate the actual material, the paint, in which one follows the traces of the painter's immediate gestures." The viewer presumably receives the actual impulses that generated the brush strokes, relives that experience, establishes himself in the position of the working painter, and imagines himself painting as he looks at the picture, thus completing an arc of communication between painter and viewer through the medium of the painting. "This has the effect of closing the distance in time between the painting of the picture and one's own act of looking at it. In this special sense all paintings are contemporary."[8] The viewer creates the picture while looking at it, reproducing the process by which it was originally created. This may happen, but it is not all that happens in looking at a painting. A painting viewed in this way involves a close, sympathetic scanning of the surface for the individual strokes of the brush, an experience available only in front of the original painting, not in front of a reproduction. Photographs do not have brush strokes (they are never *characterized* by brush strokes). They are more or less informative. Except for the daguerreotype (and Polaroid), they are not unique. But the painting may also be informative. The contrast between paint as silent and still and information as, by implication, noisy, cannot be extended usefully. To say that all paintings are contemporary in the sense that looking at a painting and recreating it by close observation closes the distance in time between the act of creating and the act of looking is just true enough to be disarming, indeed winning, but neglects the fact that much is learned from and about paintings from reproductions. In the contrast Berger wishes to emphasize, the reproduction becomes information and only information. It cannot convey that original experience of directness as well as texture or paint and total presence of the artist in the work of art.

Berger's point is not trivial and not to be ignored, but at the same time certain aspects of reproduction should be acknowledged as useful. Photographic reproductions of paintings have recognizable criteria. Excellence is judged by correspondence to the original in color, form, clarity, and size. Reproduction never equals and rarely matches successfully. Often reductions in size and weight, though markedly different from the original, are the chief values of the reproduction. Posters accommodate large-size reproductions (sometimes an enlarged detail); postcards are a

standard comparatively small size; book reproductions are determined by the size of the book or by decisions about placement. All good reproductions acknowledge that the painting is the primary fact. The reproduction has a weak existence as a good reproduction of the painting. The reproduction constitutes a fact different from the painting as fact. The terms of discussion can be muddled or confused, but not the facts of the matter.

Another source of confusion in the concept of reproduction is the variety of reproductions possible. Obviously, photographs register what is in front of the camera; therefore, their registry is far from limited to reproduction of paintings. They record any part of the visible world that comes within their purview. They "reproduce" the visible world. One class of photographs registers paintings and is called reproduction of paintings; another, larger class reproduces a framed conformation of the external world; and a third class, excluded from this discussion, is moving pictures made for the film or television screen.

Some metaphors now applied to photography existed long before its invention. The first reflecting surface was water. In Ovid's version of the Narcissus myth, Narcissus died of love for his own image in the water. The metaphor provided by that story has never lost its energy. It may be used to illuminate self-deception and self-love or to make the point that in the pursuit of beauty life is well lost. Narcissus was, after all, found again as the flower.

Lucretius's explication of the image in water or in the mirror provides a different metaphor. Lucretius believed that because many sensations are created by invisible causes (odor, heat, movements of air), they must be created by the surface-films of objects, thus

the reflections that we see in mirrors or in water or any polished surface have the same appearance as actual objects. They must therefore be composed of films given off by those objects. There exist therefore flimsy but accurate replicas of objects, individually invisible but such that, when flung back in a rapid succession of recoils from the flat surface of mirrors, they produce a visible image. That is the only conceivable way in which these films can be preserved so as to reproduce such a perfect likeness of each object.

Such films pass through glass, but a mirror they

cannot penetrate. . . . That is why such surfaces reflect images that are visible to us. No matter how suddenly or at what time you set any object in front of a mir-

ror, an image appears. . . . Just as a great many particles of light must be emitted in a brief space of time by the sun to keep the world continually filled with it, so objects in general must correspondingly send off a great many images in a great many ways from every surface and in all directions instantaneously. Turn the mirror which way we will, objects are reproduced in it with corresponding shape and colour.[9]

The passage might have inspired the mirror scene in the Marx Brothers's *Duck Soup*. "Turn the mirror which way we will" is the rhythm of the quick dodges, the sallies to surprise, of Groucho and Chico, dressed identically, on opposite sides of a door frame which Groucho mistakes for a mirror while Chico attempts to sustain Groucho's illusion by mimicking a mirror image of his movements. The comic success of the scene depends on the audience's knowing, with Chico, that the double doorway space is not a mirror, while the tension is provided by Groucho, who doesn't know whether it is a mirror or not and suspects it is not. Groucho tests and retests, darting forth to watch the inevitable image if the space holds a mirror, suspiciously thrusting movements out to spy the possible falsehood of the image, though Chico with apparently unfailing accuracy continues to reflect, almost to anticipate, Groucho's gestures. The two men become so intent on what has turned into a totally absorbing game that both become caught. Each in his anxiety to outwit the other forgets the reality of the situation, whatever that reality may be, and each crosses over into the other's territory. They literally change places. The intent to deceive on Chico's part and the intent to penetrate deception on Groucho's part are lost when the movements become more important than their purpose. At the instant of interchanged positions the original intention to deceive no longer operates. One game is over and has been superseded by another. Instead of each trying to deceive the other, both are caught up in an illusion in which their common actions become an end in themselves. Mischievous Chico and sardonic, skeptical Groucho have both passed through into the illusion.

Balzac, without Lucretius's scientific interest, came nevertheless to Lucretius's conclusion. The photographer Nadar, the novelist's friend, mockingly records Balzac's belief that

all physical bodies are made up entirely of layers of ghostlike images, an infinite number of leaflike skins laid one on top of the other. Since Balzac believed man was incapable of making something material from an apparition, from something

impalpable—that is, creating something from nothing—he concluded that every time someone had his photograph taken, one of the spectral layers was removed from the body and transferred to the photograph.

Nadar jokes that "Balzac had only to gain from his loss, his ample proportions allowing him to squander his layers without a thought."[10] Nadar reminds us also that the belief, however sincerely it was held, did not prevent Balzac's sitting for at least the one daguerreotype that exists of him.

The fragile skin shed by the object and captured in a photograph (or mirror) is another metaphor with energy. Oliver Wendell Holmes cites Lucretius's belief and then uses it to extend the metaphor:

There is only one Colosseum or Pantheon; but how many millions of potential negatives have they shed—representatives of billions of pictures—since they were erected! Matter in large masses must always be fixed and dear; form is cheap and transportable. We have got the fruit of creation now, and need not trouble ourselves with the core. Every conceivable object of Nature and Art will soon scale off its surface for us. Men will hunt all curious, beautiful, grand objects, as they hunt the cattle in South America, for their *skins*, and leave the carcasses as of little worth.[11]

This is a curious passage. It repeats the figure of the skin that can be scaled off the surface of objects or which the objects themselves shed. The billions of pictures Holmes refers to have indeed been taken without perceptible diminution in Colosseum or Pantheon. But the suggested depreciation of the monuments, those originals in which the photographs representing the "skins," or "films," originals which Holmes suggested would be abandoned like the carcasses of animals once the skins were taken as trophies, has not occurred. Far from it. Although travel is faster and more available now than when Holmes wrote, it is not only speed and access that make a difference in how modern contemporaries see, photograph, and imagine the monuments and at the same time know the difference between the photograph and the monument. The space these monuments occupy is altogether foreign to, almost in another plane than, the space ordinary people inhabit. To insert oneself into such space (as Woody Allen does more systematically in *Zelig*) is a way of authenticating a visit to the monuments, an assertion of the power to subdue their strangeness or otherness. At the same time, to be photographed with the monument lays a claim for coexistence with the monuments of civiliza-

tion and allows the person photographed to imagine that for a brief moment his space touched the space of history. Roland Barthes evokes a more delicate image of emanation when he refers to "any *eidolon* emitted by the object."[12]

Oliver Wendell Holmes called the daguerreotype the "mirror with a memory," and that figure of speech has endured to suggest how the multiple aspects of chaos and flux are intercepted (an impression taken) without being themselves halted or affected. When Prince Genji went into exile from the court in the tenth-century Japanese novel *A Tale of Genji*, he stood with his love, the Princess Murasaki, before a mirror and told her, because she was not to accompany him, to hold that image while he was away. The imagined retention of an image, that is, the memory enacted, preceded the possibility of securing an actual image.

Just as you cannot step in the same river twice, so you cannot take the same photograph twice, and for the same reason. That which may seem the same is different precisely, even if not only, in being literally different in time. Benjamin calls this recording of objects "the perpetual readiness of volitional, discursive memory," which, "encouraged by the technique of mechanical reproduction, reduces the scope for the play of the imagination." Volitional memory, as Benjamin uses the term, is conscious memory. But it is not only that which we wish to remember; it is our identity as well as our past; it is the extent of experience and learning and the limit of self-knowledge. When a record of a particular state of affairs, say a photograph, is accepted as evidence that such was the state of affairs, flexibility is reduced or corrected, and there is little play of memory as invention, fancy, or even recovery.

Memory plays an important part in Benjamin's metaphor of aura, as the passages quoted in the chapter on Benjamin show. Benjamin's ostensible purpose in elaborating the metaphor of aura is to reinvest original works of art with aura and to strip aura from the upstart photography. I now wish to claim boldly that aura is a concept applicable, despite Benjamin, to photography. *Despite* Benjamin is only partial truth; although Benjamin denies aura to the photograph, the language of his description of actual photographs tends to supply it. The aura of photography consists in more than a century and a half of recognition, familiarity, and incorporation into culture; articles of clothing have as much as that. The aura of photography becomes manifest in figures of speech in which two

aspects are assumed. One is the existence of the external world which is registered by means of the camera and film. The other is the puzzle, mystery, and magic of such registry.

As we have seen, aura for Benjamin first meant associations or clusters of images gathered about an object of reverence; second, it meant an atmosphere, or nimbus, obscuring an object. That atmosphere could be dispelled, destroying the aura. Destruction of aura might, in some instances, reveal what was previously masked by aura. Now Benjamin amplifies his concept: "Looking at someone carries the implicit expectation that our look will be returned by the object of our gaze. Where this expectation is met (which in the case of thought processes, can apply equally to the look of the eye of the mind and to a glance pure and simple), there is an experience of the same aura to the fullest extent." The camera, he says, is deadly because it takes our likeness without returning our gaze. We look at it, but the looking is not completed by a look in return. Only when such a glance is completed is a connection made. In the case of a work of art, connections are shaped and recovered for art. It is, however, not easy to understand what Benjamin intends to convey by an *object*'s returning such a glance. "Experience of the aura," he says, "rests on the transposition of a response common in human relationships to the relationship between the inanimate or natural object and man. The person we look at, or who feels he is being looked at, looks at us in turn. To perceive the aura of an object we look at, means to invest it with the ability to look at us in return."[13] He quotes Valéry on the work of art: "No idea it inspired in us, no mode of behavior that it suggests . . . could exhaust it or dispose of it. . . . And no recollection, no thought, no mode of behavior can obliterate its effect or release us from the hold it has on us."[14] One can follow this while at the same time withdrawing slightly from the image that at first added an invisible layer to the object, then took away an invisible layer from the object, and now allows the object to reach out and hold us by its gaze.

To imagine that an object returns a look is to activate the memory of what has been forgotten and distant from consciousness, so that, according to Benjamin, the volitional memory is not the whole of memory. The reciprocity of the relation between object and conscious (volitional) or unconscious memory can be expressed in various ways, but Benjamin is intensifying the connection between object and response by insisting

that the investment of the object is first an act by the responder and then by virtue of that investment, which creates aura, exists as an entity capable of returning the glance. The metaphor is complex; in this expression of it, the object invested with aura need have no intrinsic value, or no reference to systems of value outside the intensity and expansive power of personal response. It need not be a work of art. One such object is the *madeleine* that released Proust's memory. Its aura, peculiar to Proust's experience, led to the creation of the novel.

An object that *is* a work of art also has an aura. This time, instead of being the activator to an individual memory, it is the historical tradition, the cultural memory, in which all can participate. "Monuments and pictures present themselves only beneath the delicate veil which centuries of love and reverence on the part of so many admirers have woven about them."[15] The object evokes and demands a response both loosened and governed by a community of like responses. Such an object is "endowed by the poet," and one might shift the first image, of objects "beneath the delicate veil," to objects clothed ("endowed") by the poet. The idea of investment is continued through all the uses of aura. Furthermore, in Benjamin's continuing explanation, not only objects but words have an aura, which neatly moves the argument back to the question of language:

This endowment is a wellspring of poetry. Wherever a human being, an animal, or an inanimate object thus endowed by the poet lifts up its eyes, it draws him into the distance. The gaze of nature thus awakened dreams and pulls the poet after its dream. Words, too, can have an aura of their own. This is how Karl Kraus described it: "The closer the look one takes at a word, the greater the distance from which it looks back."[16]

The return of the gaze is not here invested by the gazer but endowed by the poet. The aura cannot be made precise because here are not only distance but dreams: " 'To say, "Here I see such and such an object" does not establish an equation between me and the object. . . . In dreams, however, there is an equation. The things I see, see me just as much as I see them.' "[17] The mind of the dreamer includes all the actors on the stage of the dream, one as much as another, the "I" of the person no more expressive of identity than the "it" or the "other." All the elements of a dream are equally the dreamer's.

Benjamin's conclusion is that "if the distinctive feature of the images

that rise from the *mémoire involontaire* is seen in their aura, then pho-
tography is decisively implicated in the phenomenon of the 'decline of the
aura.'"[18] The photograph has no aura itself; it can have no tradition, no
place of being, no associative thickness, and individually it can have no
history in Benjamin's view. The fact of reproducibility, understood as vi-
tiating or even entirely dissipating the aura, means there is no unique ob-
ject for the accumulation of associations. The photograph has contrib-
uted, according to Benjamin, to the decline of that great nebula of asso-
ciation, inheritance, investment, or endowment, emanating from object
and word, the aura.

Two examples of aura, chosen almost at random from the many pos-
sible, may suffice to illustrate its powers. The first choice might be Wells
Cathedral. Stone steps leading to the Lady Chapel are worn into curves
by worshipers mounting on their knees. Frederick Evans, who photo-
graphed those steps in 1903, saw that "the beautiful curve of the steps on
the right is for all the world like the surge of a great wave that will pres-
ently break and subside into smaller ones like those at the top of the pic-
ture."[19] Evans has achieved in this photograph both transparency and os-
tensive meaning (see illus. 30). Where he points one sees as he saw, and
in Wells Cathedral itself one is enabled to see that what he saw is what is
there. A tradition of faith shows its fullness of aura. No personal religious
faith is required to understand this aura.

A second example is the case of the sculptures from the Parthenon now
called the Elgin Marbles, transported in the nineteenth century from
Greece to England by Lord Elgin, currently displayed in a room especially
designed for them in the British Museum in London. Melina Mercouri,
as Greek minister of culture, pleaded for their return to Greece because
the marbles are a part of the Greek cultural heritage which the Greek
people are entitled to see, to have. Greek feelings of awe and reverence,
in this view, lack the precise objects that could give those feelings both
focus and boundary. If this is so, it is so because the origins and original
placement of the sculptures are known to be included by right in Greek
history. The sculptures can be pictured and described—this, after all, is
how much of the world learns to know the marbles—but that is not suf-
ficient for the very people whose ancestors made them for the Parthenon.
Consideration of these circumstances does not constitute an argument
either for the return of the marbles or for their retention in the British

30. Frederick H. Evans, *The Sea of Steps, Wells Cathedral, 1903*

Museum, but only illustrates the powerful existence of awe and reverence even when the feelings have no immediate objective correlative. Such an objective correlative is nonetheless known to exist in this case and may exert the more powerful attraction to strengthen the notion of modern Greeks' descent from Periclean forebears. The aura of the Parthenon marbles exists in their absence from the Parthenon as well as in their physical presence in the British Museum.

Benjamin establishes a definition of aura and then discusses its disintegration with the mechanized intervention of camera and sound recorders, the "important achievements of a society in which practice is in decline." Practice means "traces of the practiced hand." The aura is perceived about objects made with the hand, honored as sign as well as instrument of the maker. This ancient tradition is broken by photography. Benjamin calls attention to the fact that Baudelaire recorded in *Les Fleurs du mal* the disintegration of the aura, and he cites Baudelaire's recurrent use of the unreturned glance as a symbol in his poems—"the expectation roused by the look of the human eye is not fulfilled."[20] People don't look back when they are looked at, a modern failure. The absence of reciprocal glances indicates that society is breaking down into fragments; relationships are no longer securely defined; expectations are no longer reliable. The figure of the broken glance between one person and another, the glance directed like a beam but received nowhere, is, for Benjamin, a figure of man's disconnectedness, illustrating the social alienation he believes characteristic of modern society.

In a passage from Proust, a surprising reversal occurs in the metaphor of interaction between object and viewer: "Some people who are fond of secrets flatter themselves that objects retain something of the gaze that has rested on them."[21] Instead of an object's losing an invisible layer, it gains an invisible layer, again the accretion of memory, history, and tradition that Benjamin calls aura. Benjamin goes on to distinguish photography from painting using the same figure of reciprocity:

The painting we look at reflects back at us that of which our eyes will never have their fill. What it contains that fulfills the original desire would be the very same stuff on which the desire continuously feeds. . . . What distinguishes photography from painting is therefore clear, and why there can be no encompassing principle of "creation" applicable to both: to the eyes that will never have their fill of a painting, photography is rather like food for the hungry or drink for the thirsty.

It is like food for the hungry and drink for the thirsty in that discrimination diminishes with the demands of appetite. Needs of the body belong to a dimension of life which can be satisfied literally but not metaphorically. It does not belong to that aspect of life to which painting belongs, "on which the desire continually feeds." Painting provides an inexhaustible food for the imagination; the more it satisfies, the more it provokes desire. Further, "what prevents our delight in the beautiful from ever being satisfied is the image of the past, which Baudelaire regards as veiled by the tears of nostalgia."[22] The image of the past must be imperfectly understood, ambiguous, and indeterminate in order to sustain its constant renewal; the photograph, depicting some aspect of the past which is both evidenced and determined by the existence of the photograph, falsifies it in fixing it because such fixing is partial and limiting. The frame excludes more than it includes.

Even yet the figure of the aura is not exhausted. Baudelaire, Benjamin says, "indicated the price for which the sensation of the modern age may be had: the disintegration of the aura in the experiences of shock."[23] Baudelaire effects a discontinuity between object and gaze. He breaks the aura, or makes it disintegrate—again that metaphor sustaining the interpretation of aura as the surround of an object. That discontinuity, in the form of rupture or fragmentation, is a shock. The individual consciousness is additionally shocked by stimuli from sharply increased and energized sources as society is multiplied in number and complicated in space (the city, the crowd, the assembly line, not to speak of the later revelations on both macrocosmic and microcosmic scales). Benjamin cites the defense against such shocks as consciousness itself, in the Freudian sense that what is available to the consciousness can be articulated, categorized, and assimilated. If the shock is so severe as to be traumatic, the experience of shock may be relegated to the unconscious, repressed to the depth of nonremembrance, from which it may again be triggered into consciousness by the involuntary memory.

The aura is thus opposed to the shock. The aura is significant, valuable, and above all shared; is valuable *because* it is shared and forms a communal experience enriched by the past and bathed in present radiance. The drama of the aura is most fragile when it is most literal and most convincing when it is metaphoric, penumbral, and associative.

The shock is individual, wounding, and isolating; man is no longer

able to assimilate the world around him. The world changes so rapidly, and crowds man so closely, buffets him with so much information, that it constantly distracts him from that wholeness achieved in an earlier age when objects had auras. Newspapers, Benjamin says, offer evidence that man is "increasingly unable to assimilate the data of the world around him by way of experience."[24] This is a familiar complaint. Even before the data had so piled up, all the time knowledge was proliferating, man was peering at the world with the same old eyes and processing information in the same old brain. Man's eye and brain never comprehended the whole of the world. So the emphatic word is "increasingly." What there is to be known has grown so great in range and so specific in detail that we seem to know less simply because what there is to be known has increased so much.

Invention of the several parts of the photographic process was participant in the disastrous proliferation of those inconsequential bits of information. The camera records an instant, a fragment of time. The camera is a factor isolating, perpetuating, and conveying a moment of shock, according to Benjamin. He even says that "the camera gave the moment a posthumous shock, as it were."[25] "Posthumous" because a moment gone is a moment unrecoverable, in one sense unrepeatable, so, as it were, dead.[26] Against the world's increase in speed Benjamin wished to oppose and praise the slowness of tradition, the stillness of revered objects, the quiet of expectations daily fulfilled. Shock, although atomic and confusing, was energizing in a way, but in a way of which Benjamin could not approve, as if shock were an electrical impulse that galvanized the body. Expectation of shock resulted in nervous watchfulness and constant readiness for reaction to the unknown. These reactions typify one aspect of the new mechanized, speeded-up world.

The repeated mechanical actions performed on an assembly line were another aspect. In these assembly lines the individual became master of machinelike movements. The mechanism of gesture is invoked by Benjamin when he cites a short story of Poe's called "The Man of the Crowd." Poe says of Londoners that "if jostled they bowed profoundly to the jostlers." Poe's selection of this detail as telling in the choreography of the crowd anticipates what Charlie Chaplin perfected in *Modern Times*, the exaggeration of expected movements (of body, of assembly lines, of the set pieces of ordinary life) so that their absurdity becomes

visible. The jostled who bows to the jostler, when one might expect impersonal jostling in return, whether challenge or withdrawal, is an example of the inability to adapt routine polite motion, the bow, to motions necessary for survival in a crowd. Chaplin mechanized such movements so that his assembly-line worker in *Modern Times* repeats a rotating motion with his wrench so often, with such intentness on the necessity of performing his job properly, that on release from the assembly line the movement continues, ending in the scene with the tightening of buttons, placed on the dress over a woman's nipples, as if they were metal nuts. Suddenly the woman's breasts, with their natural aura of sexuality, nourishment, and sanctity, are figuratively displaced and mechanized. The disintegration of their aura is complete.

Yet that aura, while it is dramatized, exploded as if it were a myth, burst as if with laughter, is not only disintegrated. Disintegration exists at the same time that the aura remains intact and constituted just as it was before; only now, after the effect of disintegration, the disintegrating image overlays the image of the aura. The image is now like a double exposure on film, rather than either totally changed or totally destroyed. Illusions coexist with the facts that deny them.

Benjamin turns the word *aura* in his writing as if he were turning a crystal ball, intent on the image forming within the center but speaking from various points of view in turn, none of which excludes the others, each of which in turn, and finally simultaneously, illuminates the center that holds them all at once.

The next chapter will begin with Benjamin's constant reference in identifying the work of art, that is, Proust.

8

Proust, Lowell, Barthes, Musil

Benjamin's touchstone is Proust, the first great imaginative writer to make extensive use of the wonder and the magic of photography. On the real and imagined Albertine, Proust catches an overlaying of images corresponding to the simultaneous recognition of aura and disintegration of aura:

And then, since memory begins at once to record photographs independent of one another, eliminates every link, any kind of sequence between the scenes portrayed in the collection which it exposes to our view, the most recent does not necessarily destroy or cancel those that came before. Confronted with the commonplace and touching Albertine to whom I had spoken that afternoon, I still saw the other mysterious Albertine outlined against the sea.[1]

The words "mysterious Albertine outlined against the sea" form the intact aura; the words "commonplace and touching Albertine" cause the aura to disintegrate; the two effects, as if each were a photograph, exist at once.

Proust's most significant passage in the context of photography is the transformation of Marcel's beloved grandmother into any ordinary red-faced old woman, but that transformation is so complex and intricately structured that a simpler and more immediately intelligible example of metaphoric transformation may be instructive first. Marcel has been visiting the military camp where his friend Saint-Loup is stationed. As Marcel looked out his window at the square where the regiment was forming up, he "saw Captain de Borodino go majestically by, putting his horse

into a trot, and seemingly under the illusion that he was taking part in the Battle of Austerlitz. . . . Erect on his charger, his face rather plump, his cheeks of an Imperial fullness, his eye clear-sighted, the prince must have been the victim of some hallucination" (2: 141). Military choreography is always very precise, most meticulous when it is most ceremonial. The comic enters when the captain becomes so immersed in purely formal movements, in the rules of the game he is playing, that he projects himself into the role of Napoleon at war, seduced by the rules of pretense into acting as if the pretense were the reality, pomp turned into pomposity. The complacent self-delusion, enacted on a stage of public performance, amuses the intensely observant Marcel. Marcel's next occasion for observing self-delusion is deadly serious. The delusion is his own.

The experience of talking on the telephone for the first time when that invention was new is recreated as Marcel talks to his grandmother while he is in Doncières and she is in Paris. As his grandmother's disembodied voice on the telephone forces recognition of her separateness, Marcel imagines her as a "phantom, hitherto unsuspected and suddenly called into being by her voice, a grandmother really separated from me, resigned, having (something I never yet thought of her as having) a definite age, who had just received a letter from me in the empty house." The passage continues with an account of the actual reunion with his grandmother in the Paris house:

Alas, it was this phantom that I saw when, entering the drawing-room before my grandmother had been told of my return, I found her there reading. . . . She was absorbed in thoughts which she had never allowed to be seen by me. Of myself . . . there was present only the witness, the observer . . . the stranger who does not belong to the house, the photographer who has called to take a photograph of places which one will never see again.

The obliteration of all the feeling that might have been conventionally expressed is the first notice of transformation. Marcel is witness, observer, stranger, photographer. Conspicuously absent are grandson, brilliant student, obedient child of the house, all the roles he abandons in the cold stance of witness. The passage continues:

The process that automatically occurred in my eyes when I caught sight of my grandmother was indeed a photograph. We never see the people who are dear to us save in the animated system, the perpetual motion of our incessant love for

them, which, before allowing the images that their faces present to reach us, seizes them in its vortex and flings them back upon the idea that we have always had of them, makes them adhere to it, coincide with it.

"The idea that we have always had of them" has more nonvisual than visual elements, even more to do with self than with the other that is to be invented as well as apprehended. And the self too has to be invented, constructed, developed. Toward the end of the passage it becomes clear that to be witness, observer, stranger, and photographer is to stand still and alone, an unmoved mover. It cannot be done for long.

How, since into the forehead and the cheeks of my grandmother I had been accustomed to read all the most delicate, the most permanent qualities of her mind, how, since every habitual glance is an act of necromancy, each face that we love a mirror of the past, how could I have failed to overlook what had become dulled and changed in her, seeing that in the most trivial spectacles of our daily life, our eyes, charged with thought, neglect, as would a classical tragedy, every image that does not contribute to the action of the play and retain only those that may help to make its purpose intelligible.

Our eyes neglect because they are charged with thought. They form the idea of the other both by constitution and by omission. They literally do not see that which does not add to or conform to the idea that controls sight. The very invocation of classical tragedy suggests that the controlling idea is a valuable instrument of the imagination, not a means of falsifying the external world but a means of giving it a comprehensible shape. Undeniably, falsification may occur, but the difference suggested is not between truth and falsehood but between fiction and falsehood.

But if, instead of our eyes, it should happen to be a purely physical object, a photographic plate, that has watched the action, then what we see, in the courtyard of the Institute, for example, instead of the dignified emergence of an Academician who is trying to hail a cab, will be his tottering steps, his precautions to avoid falling on his back, the parabola of his fall, as though he were drunk or the ground covered in ice.

Suddenly is disclosed, not the one photographed plate that has recorded an action, but a moving picture of Chaplinesque comedy. The convention of the Academy requires us to see dignity, accomplishment, solemnity, and a whole cluster of admirable qualities embodied in the figure of an Academician, the very qualities most easily tipped into absurdity the mo-

ment they are exaggerated or fantasized, as they were in Captain de Borodino's parade-ground illusion of grandeur. It is not required of an Academician or a military man that he be able to laugh at himself. For that, Marcel is sufficient. Suppose that the veneration with which one may regard the Academician constitutes the aura. The aura is then torn like a veil when he can be ridiculed or when he is in a position to be laughed at. The accidental fall is comparable to, but not the same as, the "cruel trick of chance" that strips the aura from a beloved person. The exposure is exposure in both cases, but the Academician is revealing that which is kept in reserve all the time as part of every judgment, that the human being, dressed in veneration as he may be, nevertheless is subject to frailty, fault, and reversal of fortune. In the case of the grandmother's exposure, Marcel pictures what he knew abstractly, the ugliness of aging flesh, the ordinariness of the human body. In the first instance, the Academician fell for a moment from his position of dignity so that what he has in common with the rest of mankind was emphasized to the exclusion, or in dramatic contrast with, the high position and office he holds. However sharp the laughter, the revelation is good for the witnesses and presumptively good for him. The revelation of the grandmother's physical state and otherness is a different matter. It takes place entirely in the imagination. It is the result of a momentary maladjustment between the object and the aura so that without the aura the object is seen as if it were a strange thing. It is not something that happens *to* the grandmother. The happening is solely in the eyes and mind of the witness.

So it is when some cruel trick of chance prevents our intelligent and pious tenderness from coming forward in time to hide from our eyes what they ought never to behold, when it is forestalled by our eyes, and they, arriving first in the field and having it to themselves, set to work mechanically, like films, and show us, in place of the beloved person who has long ago ceased to exist but whose death our tenderness has always hitherto kept concealed from us, the new person whom a hundred times daily it has clothed with a loving and mendacious likeness.

The layers of existence are expressed in both time and space. A beloved person is made up of the accretions of daily feelings of "intelligent and pious tenderness," the aura of love and familiar acceptance of love. Time destroys the reality but not the aura. The aura surrounds and encloses that time-encroached being with the image of love which the eyes see instead of seeing the time-altered reality of physical being. If there is a time lag

between the actual sight of the beloved and the swinging into position of the feelings that ordinarily clothe it with "intelligent and pious tenderness," then that detachment of the imagination from sight, briefly allowing the eyes to see the imperfect physical being only, leaving imagination to catch up, reclothe, and reconstitute the "loving and mendacious likeness," identifies a phenomenon of great interest in explaining an idea of what happens to the photographic plate or film. The lack of attached feelings is interpreted as if their absence created the reality of the external world. The conclusion in the text follows:

> And—like a sick man who, not having looked at his own reflexion for a long time, and regularly composing the features which he never sees in accordance with the ideal image of himself that he carries in his mind, recoils on catching sight in the glass, in the middle of an arid desert of a face, of the sloping pink protuberance of a nose as huge as one of the pyramids of Egypt—I, for whom my grandmother was still myself, I who had never seen her save in my own soul, always in the same place in the past, through the transparency of contiguous and overlapping memories, suddenly, in our drawing-room which formed part of a new world, that of time, that which is inhabited by the strangers of whom we say "He's begun to age a good deal," for the first time and for a moment only, since she vanished very quickly, I saw, sitting on the sofa beneath the lamp, red-faced, heavy and vulgar, sick, vacant, letting her slightly crazed eyes wander over a book, a dejected old woman whom I did not know. (2: 141–43)[2]

When the "intelligent and pious tenderness" fails to close sight to the ravages of time, although before that moment the ravages were invisible, the sight can be tolerated only for an instant before the feelings rush in to clothe the figure again.

Proust's metaphor suggests that the photograph is a record only of surfaces and has no power to hold memory. It subtracts the entire emotional affect of a person because it cannot help limiting itself to literal phenomena of physical surfaces. The eye of the camera is the eye of the stranger. It subtracts emotional context, leaving in this case the withdrawn, indifferent bones of age. The photograph is not, here, a repository of memory. The photograph is treated as if, in the new world of time, the mechanical nature of the camera matched the imagined poverty of vision unmediated by "pious and intelligent tenderness." Thus is the holy icon, the beloved image, torn from its setting and looked at in the cruel, harsh light of day, where its wood is seen to be cracked and its colors faded and dusty. And thus, hastily, is the image restored to its darkness and famil-

iarity in surroundings designed to obliterate its real faults and to nourish again its aura.

Marcel says, "I . . . had never seen her save in my own soul, always in the same place in the past, through the transparency of contiguous and overlapping memories." This is the "I" who says "I, for whom my grandmother was still myself," so that the metaphor of the photograph is also a metaphor of separation of the grandmother from the contextual complexity of Marcel's identification of her with himself. Instead of Marcel's grandmother she becomes, by his metaphoric photograph, any old woman, "heavy and vulgar."

The grandmother is shortly to die. She herself knows how ill she is but does her best to conceal her weakness so as to foster the obliviousness of Marcel and his mother, her daughter; she does it for the sake of their illusions and their comfort, their denial of the possibility of her death, not for any illusions of her own. An earlier account of a photograph in the novel tells us something of the way she wished to be remembered.

When, some days after our dinner with the Blochs, my grandmother told me with a joyful air that Saint-Loup had just asked her whether she would like him to take a photograph of her before he left Balbec, and when I saw that she had put on her nicest dress for the purpose and was hesitating between various hats, I felt a little annoyed at this childishness, which surprised me on her part. I even wondered whether she was as unconcerned about her person as I had always supposed, whether she was entirely innocent of the weakness which I had always thought most alien to her, namely vanity. (1: 843)

Marcel judged her even then.

To Saint-Loup, taking the picture of the grandmother might be supposed to be a compliment to Marcel, his friend. The text itself allows us to believe that Marcel's faulty perception, self-centered as always, is at its distorting work again. Proust catches here, by means of one fictively imaginary and one fictively actual photograph, both the use and the sadness of self-deception and the use and the sadness of whatever is called reality.

Proust uses the photograph as a metaphoric instrument of vision when Marcel becomes witness and observer of his grandmother's ordinary appearance as if seen by a stranger. That use of photograph as the metaphor for bare fact becomes more complicated when Marcel much later, after his grandmother's death, is struck by the sight of the actual,

not the imagined, photograph of his grandmother taken by Saint-Loup. The little scene occurs while Marcel is waiting for Albertine. "I kept my eyes fixed," Marcel says, "as on a drawing which one ceases to see by dint of staring at it, upon the photograph that Saint-Loup had taken, and all of a sudden I thought once again: 'It's grandmother, I am her grandson,' as a man who has lost his memory remembers his name, as a sick man changes his personality" (2: 803). The click of attention, the shift of focus so that what was lost is found, or what was forgotten is remembered, is familiar.

Françoise then enters the room to announce Albertine's arrival and remarks of the photograph, "Poor Madame, it's the very image of her" (2: 803), and reminisces about its taking. Gradually, in the apparently desultory bits of information Françoise keeps adding, it is disclosed that the grandmother had had the photograph of herself taken to have the memento to leave Marcel upon her death, a death she expected but did not want to burden Marcel with knowledge of; that she had chosen the big hat Marcel had contemptuously dismissed as a sign of vanity to conceal the signs of disease in her face; that her every thought, in other words, had been for Marcel, not for herself. The use of photograph as metaphor is a literary device, to be sure, a means of deepening understanding of character. It also illustrates that use of the photograph which will teach us its meaning.

We can even find in Proust a prototype of Barthes's recognition of a significant photograph and the difference between that photograph and any other that might be imagined. Marcel is conversing with Brichot, professor at the Sorbonne. Brichot praises Mme Verdurin's earlier salon, and Marcel muses: "But if that salon seemed to him superior to the present one, it was perhaps because one's mind is an old Proteus who cannot remain the slave of any one shape and, even in the social world, suddenly transfers its allegiance from a salon which has slowly and arduously climbed to a pitch of perfection to another that is less brilliant," and here begins the epic simile—

just as the "touched-up" photographs which Odette had taken at Otto's, in which she queened it in a "princess" gown, her hair waved by Lenthéric, appealed less to Swann than a little snapshot taken at Nice, in which, in a plain cloth cape, her loosely dressed hair protruding beneath a straw hat trimmed with pansies and a black velvet bow, she looked, though a woman of fashion twenty years younger

(for the earlier a photograph the older a woman looks in it), like a little maidservant twenty years older. (3: 202)

Time past, the age of the woman in the photograph, its deceptive or unexpected disclosure of meaning, the contradiction between the formal photograph, in which the woman presents herself, and the informal, unprepared appearance of the, if not more real, woman, the more private, the more securely perceived and valued as the viewer's own, these elements are the same in Proust's simile and in Barthes's discovery of his mother. Barthes is deeply aware of his coincidences with Proust, as he says. Here is Barthes's full comment after he had identified the photograph of his mother at the age of five as the one filled for him with her gentleness, kindness, and innocence:

For once, photography gave me a sentiment as certain as remembrance, just as Proust experienced it one day when, leaning over to take off his boots, there suddenly came to him his grandmother's true face, "whose living reality I was experiencing for the first time, in an involuntary and complete memory." The unknown photographer [who took the picture of his mother as a child] of Chennevières-sur-Marne had been the mediator of a truth, as much as Nadar making of his mother (or of his wife—no one knows for certain) one of the loveliest photographs in the world; he had produced a supererogatory photograph which contained more than what the technical being of photography can reasonably offer. Or again (for I am trying to express this truth) this Winter Garden Photograph was for me like the last music Schumann wrote before collapsing, that first *Gesang der Frühe* which accords with both my mother's being and my grief at her death; I could not express this accord except by an infinite series of adjectives, which I omit, convinced however that this photograph collected all the possible predicates from which my mother's being was constituted and whose suppression or partial alteration, conversely, had sent me back to these photographs of her which had left me so unsatisfied. These same photographs, which phenomenology would call "ordinary objects," were merely analogical, provoking only her identity, not her truth; but the Winter Garden Photograph was indeed essential, it achieved for me, utopically, the impossible science of the unique being.[3]

Craft and technical proficiency are necessary in practice but may be irrelevant in theory. Lack of technical proficiency is made in these passages the equivalent of the approach to truth.

An unexpected reinforcement of Proust's view of the photograph as stripping a figure bare of asssociations is expressed in a poem by Robert Lowell:

Those blessed structures, plot and rhyme—
why are they no help to me now
I want to make
something imagined, not recalled?
I hear the noise of my own voice:
The painter's vision is not a lens,
it trembles to caress the light.
But sometimes everything I write
with the threadbare art of my eye
seems a snapshot,
lurid, rapid, garish, grouped,
heightened from life,
yet paralyzed by fact.
All's misalliance.
Yet why not say what happened?
Pray for the grace of accuracy
Vermeer gave to the sun's illumination
stealing like the tide across a map
to his girl solid with yearning.
We are poor passing facts,
warned by that to give
each figure in the photograph
his living name.[4]

"Something imagined" by the poet is equated with "the painter's vision," something "recalled" with the photograph. Yet there is a puzzle, because something "recalled" has been shaped by "those blessed structures, plot and rhyme," which are no use, or are not available ("no help to me now" could be either) when he wants "to make something imagined." One could almost think that in the italicized lines, the very voice of the poet, the painter's vision is encompassing the object that returns his gaze: the vision "trembles to caress the light." The snapshot has never been more brilliantly characterized than in the lines

lurid, rapid, garish, grouped,
heightened from life,
yet paralyzed by fact.

The poem turns about-face on the line "Yet why not say what happened?" There is a "grace of accuracy." The photograph does no less than reify our status as "poor passing facts," but the very existence of this blind accu-

racy enjoins differentiation by the "living name." Only the poet gives the living name. And accuracy's grace is precision. *Grace* of accuracy, like Vermeer's illumination, can be achieved by the poet. The living name confirms identity and makes the connection between photograph and person. The act of naming, either newly as when Adam named the animals or with proper names as when parents name babies, is intensely significant in establishing identity. But for the purpose of argument about the meaning of a photograph, one would have to give equal weight to the "poor passing facts," that is, the impression in the photograph of physical appearance of objects and persons. Otherwise there would be nothing to name. Lowell also lets slip that he considers the snapshot "heightened from life," not quite what we are used to attributing to the photograph. But of course he is right. The grouping is a consideration of form, an arrangement, whether posed or conveying informality and lack of pose. Its rapidity (snapshot) does not negate that effect.

> heightened from life,
> yet paralyzed by fact.
> All's misalliance.

Two disparate ideas yoked make the misalliance. Imagination is not the same as memory, though they are indissolubly yoked; a painter's vision is not a lens; form contradicts fact. "Fact" in that sense would mean the hard solid rock, the world out there that cannot be altered by taking thought, the sun that sets, that rises, the given form of the human body, the wind and the rain. It means physical fact. Form, then, is shaping, grouping, framing, composing, according to principles imparting meaning beyond the physical facts themselves. How, in that case, a misalliance? Form, rather than following function, creates its own function, which is to make an idea visible. This stubborn, consistently contradictory but real and permanent opposition of fact and idea is what makes the possibility of visually uniting them interesting, moving, sometimes great. The methods of union are different in the various visual representations, including photography, but the union of that misallied pair in daring coincidence of plane is the necessary intention. Idea, in this very large sense, includes feeling. Lowell's final four lines do not overcome the difficulties or reconcile the differences but control them, allowing proper weight to each term: the naming, the poor passing fact.

There is a similar disparity between idea and facts, if one may now so describe the elusive notion, in the Proustian overlay of Marcel's thoughts about Albertine: "In the infinite series of imaginary Albertines who followed one after the other in my fancy hour by hour, the real Albertine, glimpsed on the beach, figured only at the head, just as the actress who 'creates' a role, the star, appears, out of a long series of performances, in the few first alone" (1:917). Or, again, "Confronted with the commonplace and touching Albertine to whom I had spoken that afternoon, I still saw the other mysterious Albertine outlined against the sea" (1:936). The writer has created both terms, the commonplace, factual Albertine and the mysterious Albertine, but if the possibility of the two conceptions held at once did not find a corresponding acceptance in the reader—if the whole notion of two held at once were questioned—Proust's formulation would seem stranger than it does. Within the text, the notion is made wholly familiar.

One more example of Proust's playing with the metaphor of the photograph is wonderfully comic. Charlus is speaking:

He told us about a house that had belonged to his family . . . which now belonged to the Israels. . . . "Naturally I wish to know no more of this house that has disgraced itself, any more than of my cousin Clara de Chimay who has left her husband. But I keep a photograph of the house, taken when it was still unspoiled, just as I keep one of the Princess before her large eyes had learned to gaze on anyone but my cousin. A photograph acquires something of the dignity which it ordinarily lacks when it ceases to be a reproduction of reality and shows us things that no longer exist." (1:820)

Charlus does not suggest that the house has been literally changed in any detail since it has been sold to people he disdains, but for him the photograph he keeps to remember the house by has ceased to be "a reproduction of reality" and now shows "things that no longer exist," that is, in this case, it is no longer a house owned by his family. The house stands as it was, but because it is degraded by its new owners, the house as it was and as it looks in the photograph is the picture of something that is only a memory. How this means that it has also acquired dignity is not immediately evident. The comparable photographic preservation of cousin Clara de Chimay in her previous state of fidelity gives the Baron's outrageous complacency its comic turn. The dignity is achieved, apparently,

through insistence on stopping the truth in its tracks before indignities have to be acknowledged.

Thus Charlus identifies his own photographs as authentic by denying authenticity to the parts of his story that do not conform to his fiction. His fiction is that the later, betraying aspects of his depicted object or person, former house or former cousin (former in the sense that they are cast out of the family and of the possibility of existence in Charlus's life once they betray its standards), are not real. He does not deny that they exist. The house stands; the cousin lives. He claims by means of the authenticating power of the photograph that their existence as *his* house and *his* cousin ended with their transgressions. He constructs and identifies a fiction and uses the photograph to verify the fiction as the real. This is part of the comic effect of the passage. If the claim was made that the photographs did not look different from the one circumstance to the other, Charlus would insist that the fact of the difference and the chronological accuracy of his photographs (before the fall, in each case) created and represented a principle, and that is the impossibility of depicting in an original state that which is known to have been subjected to a debasing circumstance. He sees, in this case, what he knows, rather than strictly what he sees.

The opposite process took place when Marcel returned to his grandmother in Paris and for the first time saw her, as if in a photograph, separated from himself, existing in her age and infirmities as if her chief function in life were not to be his grandmother but to exist and even to perish apart from him.

Roland Barthes's account of his mother's posing for her picture can be compared with the account of Proust's grandmother having her picture taken by Saint-Loup:

Yet in these photographs of my mother there was always a place set apart, reserved and preserved: the brightness of her eyes. For the moment it was a quite physical luminosity, the photographic trace of a color, the blue-green of her pupils. But this light was already a kind of mediation which led me toward an essential identity, the genius of the beloved face. And then, however imperfect, each of these photographs manifested the very feeling she must have experienced each time she "let" herself be photographed: my mother "lent" herself to the photograph, fearing that refusal would turn to "attitude"; she triumphed over this ordeal . . . *with discretion* (but without a touch of the tense theatricalism of humility or sulki-

ness); for she was always able to replace a moral value with a higher one—a civil value. She did not struggle with her image, as I do with mine: she did not *suppose* herself.[5]

Marcel's grandmother, in the Proust passage, is deliberately creating an image of herself that will do, she hopes, as a true picture of herself to remain with her grandson after her death. She not only dresses well but conceals the traces of illness by wearing a hat that will shadow her face. (One learns this detail later, when Françoise harshly discloses to Marcel the full explanation of the circumstances of taking that photograph.) She is controlling the image of herself that will appear on the photograph. Neither woman, Marcel's grandmother or Barthes's mother, is posing in the self-conscious way that Barthes claims for himself. The pose, or posing, is exactly what he is so proud of his mother's not doing, although he cannot help doing it himself.

Proust imagines his scene at the moment when Marcel jealously regarded the grandmother's preparations for a picture to be taken by someone else. It is only some time after the grandmother's death that we learn of her noble intention to force herself to endure the dressing, endure the thought of the future when she would be gone, and embrace the onerous task of representing herself, all for Marcel's benefit. And at that later time Marcel is able to comprehend better the thought and love she gave so unstintingly to him.

The time of the photograph stretches from the moment of its taking to the moment when Marcel discovers the grandmother's true purpose in having her picture taken and from that moment back to modify the earlier memory of its being taken.

Barthes too is working between time past and time present. Although his book is not presented as fiction, and although Barthes is dealing directly with photography, as Proust is not, certain similarities occur. In both accounts, a beloved female figure, in Proust's case the grandmother of Marcel, the narrator of the novel, and in Barthes's case his own mother, is centrally involved. After years of closeness, the beloved woman dies. A photograph of her remains. How shall it be regarded by the survivor? What remains for Barthes is not in fact one photograph but many because he is not writing fiction, and part of his search for any photograph which he can regard as truly depicting the mother is in discarding or discounting the myriad everyday ordinary and undescribed photographs that do not

satisfy him. He seeks "the truth of the face I had loved." He found it in a photograph of his mother when she was five years old. Barthes makes the comparison with Proust himself. "For once," Barthes writes, "photography gave me a sentiment as certain as remembrance, just as Proust experienced it one day when, leaning over to take off his boots, there suddenly came to him his grandmother's true face, 'whose living reality I was experiencing for the first time, in an involuntary and complete memory.'" But what Barthes seized from Proust's text was the possibility of equating that living reality of the involuntary and complete memory with the photograph of his mother at the age of five. He clothed that photograph with the future and with his feelings of love as surely as Proust altered his grandmother's image after seeing her first as he assumed the role of witness and stranger and then as he resumed his "intelligent and pious tenderness." The peculiar fact that Barthes recognized the aura of that love in a picture of the mother when she was five, that is, of his mother before he was born and long before she assumed the form he must first have seen, is a measure of the fictional possibilities in vision.

Photography is neither mirror with a memory nor window[6] but a picture of that which is about to become a memory, a capturing of what, in the present which is about to become the past, is to be remembered. This is not to confuse picture with memory itself because memory is internal, private, and kinaesthetic, like dreams.

It is all very well to say that the external world is caught, if fragmentarily, in a photograph. The question is, What does the resultant picture mean? The texture of meaning is illustrated by the complexity of the passages quoted. For Proust, it was the external world in the literal person of his grandmother stripped of the veils of illusion with which any beloved person is enveloped that he imagined as a photograph. In this view, the photograph reveals the plainest surface unaffected by feelings. Surface is foregrounded. Volume exists in space, person exists in flesh, flesh is transitory, and the old lady is everywoman, anywoman. The act of imagination described relies for its effectiveness as much on the transformation of the photograph as on the transformation of the grandmother. The photograph is one term of an analogy, as misleading in its way as the picture of the grandmother. Proust is using an "as if" formulation: the grandmother seen without affection or predisposition is as ordinary as a photograph might represent her to someone who did not know her. The sit-

uation is as if a photograph could not convey anything but a woman "sitting on the sofa beneath the lamp, red-faced, heavy and vulgar, sick, vacant, letting her slightly crazed eyes wander over a book, a dejected old woman whom I did not know." Yet many of these attributes are precisely those a photograph could not convey. "Heavy and vulgar, sick, vacant," are descriptive notes entirely of feeling, not at all exclusively, if in any degree, visual. In fact, how vacant? One might think of the eyes being vacant, at least that is a familiar description of some recognizable state, but it cannot here be vacant eyes because the eyes are "slightly crazed" and furthermore are presumably cast down because they are wandering over a book. Yet Proust is convincing that this is what the camera records, what would be recorded in a photograph. One believes him utterly. And this very belief allows construal of what the photograph means. It means the decomposition of a gestalt into elements purely isolate, optically neutral, even though they are as painterly a set of facts as one could wish: "sofa beneath the lamp," or chiaroscuro; "red-faced," a color; "sick, vacant," not the alert woman who read the letters of Mme de Sévigné; "letting her slightly crazed eyes wander over a book," the very antithesis of the critical act of reading as Marcel read or as he knew his grandmother read; but as a final and conclusive blow, "a dejected old woman whom I did not know."

He said he saw this "for a moment only, since she vanished very quickly," and it is this element of fleeting time that is emblematic of his vision. The photograph is that which records a glimpse of the real world that one would be ungenerous to tolerate for more than an instant, but which for an instant seems to reveal a truth. The brevity of the operation is consonant with the ideas of instantaneity and the ephemeral, both represented by the idea of the photograph.

Roland Barthes speaks of "an essential identity, the genius of the beloved face," his mother's, as he searches for the right photograph after her death. He never has Proust's strange moment of revelation, of being witness and stranger. His feelings toward his mother are always characterized by Proust's "intelligent and pious tenderness." The beholder who recognizes identity is the possessor of that identity by virtue of the act of naming. In some mysterious way, Barthes depends upon absence in the photograph he chooses, or finds, as much as upon the characterization he recognizes in the mother, who in the photograph of her aged five is not

mother; the son is unborn. To this moment he can be witness, though he never allows the notion of stranger to enter. He does not prevent, and thus one may assume he allows, another actual photograph, the frontispiece of his book, to suggest additional meaning modifying the text. The text contains no reference to that photograph. The photograph is simply there, an adjunct to the text, without caption and without extension. The photograph is in color, but only one color, blue-green, with the shadows black and the rents in the curtain white as the light shines through. The photograph shows a pair of blue-green, loosely woven curtains through which daylight shines except for heavy vertical doublings of the material in black, opaque folds. Where the curtains overlap in the center, one is slightly pushed aside by a fat sofa thrust between them. On top of the sofa, which comes in diagonally from the lower right corner of the photograph to end just through the gap in the curtains, is a big puffy pillow. The lower third of the photograph is heavily weighted by darkness. One glimpses nothing beyond the curtain but light, no color but blue-green. All is suggestion, mystery, and a tantalizing absence of specific properties or human relevance. Its credit line, printed as if it were the caption, reads "Daniel Boudinet. Polaroid. 1979." For Barthes, absence, a quality perceived and named, seems to occupy the same place in his imagination as the "beholder" occupies for Michael Fried, the art historian whose imagination was fired by Diderot's description of imagining himself taking a place within the painting he was looking at. What Barthes found was his own absence. The color blue-green is suggestive. Barthes says, "In these photographs of my mother there was always a place set apart, reserved and preserved: the brightness of her eyes. For the moment it was a quite physical luminosity, the photographic trace of a color, the blue-green of her pupils." *Camera Lucida* was published after the death of his mother, and the frontispiece may delicately evoke both her presence and her absence.

The concepts of absence, negative space, and the idling machine are all telling metaphors for an aspect of seeing. In the vocabulary of sight as well as in the vocabulary of literary criticism, the concept of "negative" is significant. Artists use the term *negative space* to mean the space between things where nothing is, between solid volumes, a space like the memory gap that holds a sufficiently precise outline so that none but the missing word will fill the gap. Only the exact shape of absence can be remarked. The boundaries of solids not only define the solids but define the

space the solids exist in. If clouds in the sky are foregrounded in attention, the space visible between clouds is negative. One can learn to see negative space as shape.

The phrase "negative capability" was invented by Keats to mean a state "when man is capable of being in uncertainties. Mysteries, doubts, without any irritable reaching after fact & reason." It is better, according to Keats, to reach for the "fine isolated verisimilitude caught from the Penetralium of mystery"[7] than let that go in order to construct the whole, which in any case remains mysterious and unknowable. The "irritable reaching after fact & reason" is that necessity for completion, connection, and generalization or abstraction that cannot be absolutely reconciled with the uncertainties and mystery of the individual and particular. The uncertainties of reality contrast with models constructed to correspond to reality. Models inevitably simplify. Keats is saying let the uncertainties, mysteries, and doubts remain.

In Roland Barthes's peculiar search for the photograph that would recall his mother to him after her death, he rejected all of the apparently realistic photographs left from his knowledge of her lifetime. He chose, as the use he required of the picture taught him the meaning, that picture of his mother when she was five years old. This act of choice recalls Wittgenstein's metaphor of a machine "idling" as a paradigm of potential movement for which the impulse or lever to start has not been activated. Barthes's search is an instance of the engine idling until the one picture activates the full flood of feeling and memory. Barthes recognized the shape, the negative space, of absence, and sought the image to fill the space. It is a sign of our times that Barthes looked for a photograph. Beyond the fact that many photographs of his mother existed, he sought the verification of her being that only a photograph could give him. He wanted something beyond "simple resemblance," something only he could provide and the existence or effect of which he could never prove. The evidence was the authentication of her existence. For Barthes the point was of crucial importance. The something beyond "simple resemblance" was the aura without its object. The activation of the idling picture within his own startled attention could not be foreseen. He did not know for what he was looking, until one among the photographs he examined could give it to him.

Proust was born in 1871 and died in 1922. The comparably great Austrian novelist, less well-known in English than Proust, Robert Musil, was born in 1880 and died in 1942. His novel, *The Man without Qualities*, was never finished, a state comparable to the circularity of Proust's novel, achieving an open-endedness that demonstrates the genius of being incomplete. My concern is not, however, with his whole work or his lack of closure but with the way he conceives the photograph to exist and have meaning.

One must grasp first that Musil was forever pondering on the existence of the One and the Other and often represented the problem by means of what he called the picture. Sometimes his hero, Ulrich, the man without qualities, was inside the picture, sometimes outside looking at the picture, sometimes outside imagining himself to be inside. " 'In their basic relation to themselves,' " Ulrich says,

'most people are narrators. . . . What they like is the orderly sequence of facts, because it has the look of a necessity, and by means of the impression that their life has a "course" they manage to feel somehow sheltered in the midst of chaos.' And now Ulrich observed that he seemed to have lost this elementary narrative element to which private life still holds fast, although in public life everything has now become non-narrative, no longer following a "thread," but spreading out as an infinitely interwoven surface.[8]

The title, *Man Without Qualities*, characterizes rather the man with all qualities, none of which can be distinguished, than a man lacking in qualities. Or if quality should mean, as it can in English, a dominant characteristic, like Ben Jonson's characters, each typical of one humor, that would be the quality, or range of qualities, Ulrich would be without. He is a man without qualities as white light is without color: in appearance, although white light is actually composed of all colors. He is a man without obsessive direction, without the single-mindedness required to be called politician, statesman, mathematician, all professions in any one of which he might excel if only the others could be excluded. We no longer have Renaissance men, those who excel in everything, who, in the metaphor of the composition of light might be thought of as the spectrum, a rainbow of excellences. Instead, we have Ulrich, who resembles a Hamlet with a sardonic sense of humor. An example that serves to illustrate both Musil's and Ulrich's visual acuity occurs in a passage about clothes:

Clothes, if they are lifted out of the fluidity of the present and regarded, in their monstrous existence on a human figure, as forms *per se*, are strange tubes and excrescences, worthy of the company of such facial decorations as a ring through the nose or a disc extending the lip. But how enchanting they become when they are seen in combination with the qualities they bestow on their wearer! What happens then is nothing less than when some tangle of lines drawn on a piece of paper is suddenly infused with the meaning of some great word. Let us imagine that the invisible goodness and elect nature of a human being were suddenly to loom up behind his head as a halo floating golden as the yolk of an egg and big as the full moon (as one sees in pious old paintings), while he was taking his walk in the park or was just putting a sandwich on his plate at a tea-party: without a doubt it would be one of the most tremendous and shattering experiences possible.

The image of "halo floating golden as the yolk of an egg and big as the full moon" suddenly appearing to mark the saintly man is comic, to be sure, but Musil does not yet insist. He goes on:

And such a power of making the invisible, and even, indeed, the non-existent, visible is what a well-made dress or coat demonstrates every day! . . . All of them ["convictions, prejudices, theories, hopes, belief in anything, thoughts"], by endowing us with the properties that we lend them, serve the purpose of placing the world in a light that emanates from us. . . . By exercising great and manifold skill we manage to produce a dazzling deception by the aid of which we are capable of living alongside the most uncanny things and remaining perfectly calm about it, because we recognize these frozen grimaces of the universe as a table or a chair, a shout or an outstretched arm, a speed or a roast chicken. . . . And in fact the most important intellectual devices produced by mankind serve the preservation of a constant state of mind, and all the emotions, all the passions in the world are a mere nothing compared to the vast but utterly unconscious effort that mankind makes in order to maintain its exalted peace of mind. It seems to be hardly worth while to speak of it, so perfectly does it function. But if one looks into it more closely one sees that it is nevertheless an extremely artificial state of mind that enables man to walk upright between the circling constellations and permits him, in the midst of the almost infinite terra incognita of the world around him, to place his hand with dignity between the second and third buttons of his coat. (2: 275–76)

He develops the figure of the obliviousness with which the ordinary business of life is carried on—"the task for which everyone has his own special system"—to cosmic proportions before pricking the bubble of that vanity which permits man "to place his hand with dignity between the second and third buttons of his coat." The punch lines, the graphic de-

tails, are purely visual, the halo and then the Napoleonic position of the hand.

Remarkably enough, he provides still another passage about a man and his mother. The description of Ulrich's response to the photograph of himself as a child begins with the sentence, "Wide streets and squares opened out obscurely before him," and to get the sense of the scene, both of interior mind and exterior setting, a preceding passage is relevant:

Ulrich went home on foot. The night was fine, but dark. The houses, standing tall and compact, formed that strange confined space,⁹ open at the top, which is called street, and high above it, in the air, there was something going on—wind, or clouds, in greater darkness. . . . In such a night as this it was possible to feel the significance of events as in a theatre. One felt that one was an apparition in this world, something that created the effect of being larger than it really was, something that rang and echoed and, when it passed across an illuminated background, had its shadow walking with it like some huge, jerking clown, now rising to his full height and at the next instant once more creeping humbly at the walker's heels.

Here Ulrich is "an apparition" feeling larger than life, with a sense familiar to any walker in the streets at night of strangeness of scale and unfamiliarity of shadow. Walter Arnheim, a character whose name is invoked in what follows, is friend and rival, associated with Ulrich both actually and in his imagination: "Ulrich suddenly imagined with how much complacency and inner 'stage-management' Arnheim would have walked along here in his place. And at that he lost all pleasure in his shadow. . . . He now seemed to himself to be nothing more than some phantom wandering through the gallery of life, aghast at being unable to find the frame it should slip into" (2: 432–33). No stage management for Ulrich. He struggles constantly to clear his mind of deception and as constantly accuses himself of entering states of deception. How he seems to himself is a crucial question of identity. From "apparition" he becomes "phantom," without a location or "frame" that would isolate meaning. The frame he then finds is located by means of the transition from the dramatic image of streets forming "that strange confined space" through which he walks in the night to the ordinary streets of the following passage:

Wide streets and squares opened out obscurely before him, and the buildings were ordinary buildings, serenely spangled with storey upon storey of lighted win-

dows, but devoid of any bewitching element. Coming out into the open, he caught
the feeling of this tranquility, and, without rightly knowing why, remembered
some childhood pictures he had been looking at a short while earlier, photographs
of him and his mother, who had died young, and he recalled the sense of strange-
ness with which he had gazed at that little boy so happily smiled upon by a beau-
tiful woman dressed in the style of a bygone era. There was the extremely intense
idea of a good, affectionate, bright, little boy, which had been everyone's picture
of him; there were the hopes for him that were as yet outside his own ken; there
were vague expectations of a distinguished and brilliant future. . . . And although
all this had been invisible in those early days, decades later it was there on the old
photographs, plain and distinct for him to behold; and from the midst of that vis-
ible invisibility, which might so easily have become reality, he saw gazing out at
him his own childish face, still babyishly soft and blank, with the slightly cramped
expression due to having to stand quite still. Looking at these photographs, he
had felt no trace of affection for that little boy, and even if he did contemplate his
beautiful mother with some pride, the main feeling the whole thing left him with
was that of having escaped some frightful danger by the skin of his teeth.

Anyone who has undergone this experience, having encountered his own gaze
and seen himself, mantled in some bygone instant of complacency, looking out at
him from old photographs, and the whole thing so odd that it seems some sort of
a glue must have dried up and fallen out of the relationship, will know what Ulrich
felt like. (2: 433–34)

Neither Proust's (Marcel's) nor Barthes's accounts of persons represented
as looking at or imagining photographs, especially of a beloved female
figure, has been like this. This is more like Proust's imagining a photo-
graph than like Barthes's real photograph in the sense of disillusionment,
but it is more like Barthes's in its removal from a present time. This pho-
tograph of mother and child is not enveloped in "intelligent and pious ten-
derness." The description is of a relationship from which the glue has
dried up. The pieces no longer hold together. Ulrich's mother "died
young," and presumably she had died when Ulrich was also young, so she
was not someone he had known, grown up with and to, loved without
thought, been enmeshed with without hope of disentanglement as in the
case of Proust and his grandmother except for his one moment of clear-
sighted disenchantment; or as in the case of Barthes and his lifelong en-
chantment with his mother.

There is a resonance in the Musil passage which is absent from the
others. What frightful danger has Ulrich escaped? Perhaps the danger of
affection for a complacent self, even though the self he contemplated in

the photograph was a child. Perhaps the expectations of a "distinguished and brilliant future," reasonable and conventional hopes for a bright little boy, were seen at this later time as the stranglehold of familial direction, though Ulrich's father did his best, to be sure, to maintain that stranglehold. Ulrich had written as a schoolboy a composition that seemed to his elders to be either blasphemous or to defame the fatherland. "His father's wrath being aroused at the shame brought upon himself by this almost unrecognisable chip of [sic] the old block, he was packed off abroad. . . . There Ulrich learned to extend his contempt for the ideals of others to international dimensions" (1: 15).

It seems that if at the later time of looking at an earlier photograph one dissociates oneself deliberately, or even involuntarily, from intimate feelings about it, or if one disavows such feelings, it might be the same as looking at the picture of a stranger. After all, if one had not already had a familiarity with such a photograph and with what the younger self had looked like, one might well not recognize it. Or one might be in the position of being one of a family with resemblances sufficiently close so that one could no longer tell which baby was which. This is not the case with Ulrich. He not only recognizes his mother and himself in the photograph, but he identifies a feeling of danger to himself, so strong that he prefers its strength to that of admitting affection for himself as a child or affection for the mother who left him, who died. Yet it is into this frame that he looks when he has traversed ordinary streets, felt a tranquility of spirit, only violently to reject both. He wants no theater, either when he walks through streets or when he looks upon the little framed stage of the photograph. Tranquility may be deception. Theater may be deception. Ulrich is looking for the very opposite of "intelligent and pious tenderness." He is looking for intelligent lack of piety; he has no tenderness. Finally, he is revolted by the complacency of the photograph. His wish to insert himself into a frame is after all not the right way to find identity.

Three instances of writers finding meaning in a photograph of a self with a mother figure might suggest that some psychological interpretation is necessary. This is not my interest. For my purposes, the significant aspect is the choice of *photograph* to educe meaning.

The instances are comparable, or susceptible of generalized meaning, by having common elements expressed in subtle and trustworthy ways. In spite of these common elements and perhaps because of the trustwor-

thiness of style, the photograph does not have the same meaning in each case. Proust's example of Marcel as stranger-witness to the stripping away of illusion is like a stripping away of aura, like the rending of a veil, as if the resulting exposure of photograph were the hidden reality. Barthes's photograph of his mother, real but unseen by his readers, fills a gap in his imagination. It is the more real to him because it is so private, so distant in time, so invested and endowed by him with significance. Musil gives the character of Ulrich less range of interpretation. Ulrich seems closer in this respect to the ordinary viewer of photographs, that is, the response is dependent more on attitudes toward family, childhood, self, or the past than on visual acuity.

My emphasis on literary imaginations is a deliberate choice of approach. An earlier chapter mentioned that many interpretations of photographs are couched in the vocabularies of the writers' professions, whether art history, sociology, political history, or literary theory. The literary approach without theory allows the acknowledgment of these interpretations but avoids the special vocabularies and indeed bypasses the special expertise to confront the photograph not abstractly, as "photography," but particularly, in its individual intimacy. A kind of discomfort for some readers may ensue from the lack of a theoretical structure. This too is deliberate—for the sake of the freedom to see a photograph without aura. Only if inspired by the photograph itself to speculation and description does one invest that photograph with aura. What is said about a photograph depends on what is perceived by the viewer, who must, according to the use intended for the photograph, resolve, explicate, or ignore the significant tension between "heightened by life" and "paralyzed by fact."

9

The End, Secular Aura

❧

Each of the metaphors used, whether the term is *aura*, *mask*, or *language*, illuminates the idea of the photograph. Walter Benjamin's concept of aura might have been the key to photograph as metaphor except that it is only by extension of Benjamin's own descriptions that the claim can be made that photographs *have* aura. Using language as one term of a metaphor is less useful but more prevalent than aura. Mask as a descriptive term could as well have been mask as metaphor. Benjamin, Proust, Musil, and Barthes, as well as Keats with his negative capability, are all saying, in individual poetic and imaginative modes of expression rather than philosophic (aesthetic or logical) modes, that certain perceptions are originally oblique and private; they retain a penumbra of mystery and are conveyed to others in the languages of the imagination.

The varied uses of mask as metaphor can, in effect, be cross-referenced. Proust has split the reaction which Agee confines to the individual, who "cringes" from the wounded self, into two: the momentarily self-absorbed individual (the grandmother) and the perceiving individual (Marcel), but the understanding of figurative concealment or revelation is the same for Agee and Proust. In Agee's construal the individual conceals from himself by protective inattention his "wound and nakedness." Proust dramatizes that inattention by calling it a "veil of intelligent and pious tenderness" but then illustrates how the veil can be withdrawn for a moment, as if the gaze could penetrate a mask, as if the stance of the witness could become for an instant that of the stranger-photographer whose gaze briefly sees an alternate truth when the veil of

"intelligent and pious tenderness" does not intervene. Marcel says of his first glimpse of the grandmother, as he arrives unannounced from Doncières, that "she was absorbed in thoughts which she had never allowed to be seen by me." She has, in Agee's sense, dropped her mask. Marcel's reclothing her shocking appearance in the veil of "intelligent and pious tenderness" is a confirmation of Keats's insistence on retaining the mystery. Musil's emphasis for discernment of what is under the mask is different: "All the passions in the world are a mere nothing compared to the vast but utterly unconscious effort that mankind makes in order to maintain its exalted peace of mind." That vast effort is exerted in the service of masking any disturbing reality.

Benjamin's concept of aura has been critical in this discussion. It, as well as mask, holds the possibilities of both revealing and concealing, nimbus or fog. The critical point of Benjamin's formulation is that the "seen," the phenomenal world, does not count for aura. While he theorizes about the aura surrounding the sacred object and the disintegration of aura with the invention of mechanical means of reproduction, his own descriptions of photographs encourage further speculation about the imagined existence of aura. The aura of the photograph is the aura of the very temporality Benjamin recognizes in photography, the aura of reality, contradicting his first premise, that the phenomenal world does not have aura.

The aura of reality: no matter what the culture, intentions, predispositions, deceptions, or philosophical beliefs of the photographer, the camera, in some fundamental sense, does not lie. Distortions and even ineptitudes are registered in a sane, optically logical system that can be understood. When the photograph shows a bowed side of a building, or a building preternaturally big at the bottom and small at the top, the viewer does not for an instant imagine that the structure curves or leans in that way but does not doubt for an instant that there was a building in front of the camera. Even when movie directors fool an audience by shooting a set constructed on small scale entirely in the studio, no one doubts that a physical structure was in front of the camera. The viewer must interpret where interpretation will disclose the original state of affairs to good purpose. The movie deception, however, depends upon willing suspension of disbelief on the part of the audience. Distraction from daily life by narrative film fiction is different from preservation of daily

life in still photographs because of that very suspension of disbelief in the one case and investment of belief in the other. Neither is pure; reactions to both cover a spectrum of belief/disbelief; but in general the opposition is useful.

In still photographs, the act of preservation, the historical seizure of the object in the moment, is itself both a tribute to worth and a defining factor in establishing worth. Factual information about the contexts of photographs, about the persons, places, and circumstances involved in terms of both individuals and society, will contribute the innumerable particulates that help constitute the secular aura of the *subjects* of the photograph. What the photographer chooses to emphasize and isolate constitutes the formal organization within the photograph. Interpretation is necessary for the viewer. It is not accumulated documentation alone that constitutes aura, for after the critical process of gathering and offering the facts comes the language of interpretation itself. Looking, thinking, discriminating, and expressing characterize the investments in the language of secular aura.

Secular aura, as well as the traditional aura of the sacred, has to have something real to associate with itself. It cannot just float around like smoke. Satisfaction in the solidity of the real is a basic element in response both to a solid artifact and to its aura. Creations of the hand and mind which shape the world by art are admirable in invention and execution, yet at the same time a stubborn residue of skepticism exists about formulations that contradict or weaken apprehension of the world as real and solid outside the self. This skepticism is not appropriate for photography because the photograph must be imprinted with what has been presented to the camera; it must literally receive something physical from out there, if only what can be described as interrupted light. This is the factuality of the photograph. The photograph authenticates the objects. The objects authenticate the photograph. The pleasures of factuality consist in acquiring or recognizing information, in achieving through verisimilitude the "resonance of the specific," the "resonance of fact."[1]

If the specific has resonance, it is in subservience to a larger referential scheme. The question in photography is how to substantiate a claim that such a scheme may exist, when the limiting condition of the photograph is that its subject matter cannot be the invention of the photographer. Here again, a way to think about photography is to abjure absolute def-

initions and try for useful approximate definitions. As Martin Price observed in writing about narrative form, the "double aspect of the concrete detail [is] at once a condition of revelation and a threat of irrelevancy."[2] To condemn photographs as trivial on the grounds that they lack the shaping power of imagination is to emphasize the threat of irrelevancy, to insist that only contingency governs choice of subject from the world of possibilities. That is one absolute. The other end of the continuum is the view that the photographer exercises such choice and discrimination that his work on paper has been entirely invented. Stated so, both are obviously false, yet often photographs are judged with implicit reference to one or the other.

A persuasive case is made by Joel Snyder and Neil Walsh Allen that photography has its formulas, conventions, and standardizations like other mediums of representation, but they end their article restrictively: "We do not need more philosophizing about photographs and reality, or yet another (this time *definitive*) definition of 'photographic seeing,' or yet another distillation of photography's essence or nature. The tools for making sense of photographs lie at hand, and we can invent more if and when we really need them." The tools are questions asking "what it [the photograph] means, who made it, for whom it was made, and why it was made in the way it was made."[3]

These are the same questions John Tagg was emphasizing in his objections to Barthes's *Camera Lucida*. Invoking imagination arouses distrust. The questions above, at least who made the photograph, for whom was it made, and why it was made one way rather than another, may be unanswerable; but the question of what the photograph means comprehends more than the answers to the other questions; therefore the answer to what it means may be attempted even in the absence of other specific knowledge. Every bit of knowledge is useful, and every attempt at making a meaningful interpretation is useful. But some interpretations are more interesting than others, and among the most interesting I find those of writers who imagine a meaning. As Lowell wrote,

> We are poor passing facts,
> warned by that to give
> each figure in the photograph
> his living name.

Camera instrumentality offers meanings specific to the physical nature of the camera and lens. One may emphasize the conventions that governed the construction of the camera's perspective vision, the distortions or corrections of vision involved in use of one lens or another, the accidents of blur and focus, without changing the basic fact that light acting on the emulsion is the way the picture is formed. It has become clear that descriptions of photographs alter one's perception, not just by producing relevant facts but by directing a viewer's attention so that what is actually seen will be sharper and more inclusive. For Danto's red squares, the descriptions create the response. The fact that descriptions—not of paintings that come, so to say, equipped with the aura of "painting" and the "history of painting"—but descriptions of photographs, which are introduced into one's comprehension accompanied by the boredom of prolixity, can be compelling and persuasive is a tribute to the power of words but also and especially to the power of imagination.

Photography is essentially a way of making the world look back at the viewer. The fascination of photographs consists partly in the knowledge that peering into a photograph, studying it closely, will result not in finding ideas but in recovering what may be identified as reality; then in an instantaneous process ideas will be constructed to account for that reality. Ideas may exist already prepared to seize the appropriate visual conformation. Research into who, what, when, where, how, and why might provide valuable information, but just as in the case of the sociological information about the Hill/Adamson photographs, the answers to these factual questions may not account for the interest of the photograph. The secular aura of the photograph is constituted by investment and endowment, just as the aura of the sacred object is constituted. Overlapping descriptions from different sources, words recognized as accurate in naming the qualities or depictions of the secular object, will establish the secular aura. The individual figure, photographer or viewer, enters a looking-glass land with eyes wide open, but cannot immediately interpret what he sees. To photograph is one way of arresting time in order to contemplate it.

REFERENCE MATTER

Notes

<center>❖</center>

Chapter 1

1. Susan Sontag, *On Photography* (New York: Farrar, Straus and Giroux, 1977), p. 106.

2. Interesting discussion of this point occurs in Käte Hamburger, *The Logic of Literature*, trans. Marilynn J. Rose (Bloomington: Indiana University Press, 1973), pp. 218–31. She points out that the experience of seeing a movie is more like that of experiencing three-dimensional space than of seeing a play, in paradoxical relation to the fact that the screen is actually flat and the stage actually three-dimensional. Her concluding comment is that "the film, unlike photography *per se*, belongs not to the realm of the plastic arts, but to that of literary art." Although this suggests that still photography ("photography *per se*") is a plastic art like painting or sculpture, the suggestion can be taken as limited to the fact that each example of these forms can be the object of contemplation singly; each is a single separate entity, each still photograph, each painting, each sculpture.

3. Arthur Danto, *The Transfiguration of the Commonplace* (Cambridge, Mass.: Harvard University Press, 1981), pp. 48–49, 1–3.

4. Rosalind Krauss specifies the relation between light and the surface upon which the impression is made as indexical; the one-to-one relationship between objects and the print "arises as the physical manifestation of a cause, of which traces, imprints, and clues are examples." "Notes on the Index: Part 2," in Krauss, *The Originality of the Avant-Garde and Other Modernist Myths* (Cambridge, Mass.: MIT Press, 1985), p. 211. A Marxist critic, John Tagg, also calls the nature of the photograph indexical ("the causative link between the pre-photographic referent and the sign") but claims that the link is "highly complex, irreversible, and can guarantee nothing at the level of meaning." Tagg, *The Burden of Representation: Essays on Photographies and Histories* (Amherst: University of Mas-

sachusetts Press, 1988), p. 3. I can't agree that the link is highly complex, if he means the physical link, which is simple to think about even if its physical aspects can be explained only by complex formulas. Irreversible? That must mean that the photographer can't take it back; he can only do it again. I don't agree that the link can guarantee nothing at the level of meaning. The link guarantees only itself, but the guarantee limits meaning and in that way guarantees something.

5. Stanley Cavell, "What Photography Calls Thinking," *Raritan* 4 (Spring 1985): 1–21, esp. 3–4; Umberto Eco, "Critique of the Image," in *Thinking Photography*, ed. Victor Burgin (London: Macmillan Education, 1988), pp. 32, 33. Eco correlates the physical operation of light on film to received impressions on the retina of the eye but then goes on to formulate the disconnection between real objects and photographs of real objects by using the same term as Cavell, transcription.

6. "Image without a code" is Roland Barthes's term, *Camera Lucida: Reflections on Photography*, trans. Richard Howard (New York: Hill and Wang, 1981), p. 88. A. D. Coleman makes the point that the photographic image *encodes* "a specific instant of 'reality,'" but his "encodes" refers to what I prefer to call transcription, without minimizing either the disjunction between the reality and the image or the correlation between reality and image. *Encodes* is a word borrowed from structural linguistics, which itself borrowed the word from the late nineteenth-century invention for substitutions on the telegraph wire so that messages might be kept private even though they were publicly transmitted. Included in its connotations is the one-to-one correlation between every point on the image with the point on the original scene it transcribes and also with the removal of identity of every point from every point in the original scene it transcribes. Coleman, "The Directorial Mode," in *Photography in Print: Writings from 1816 to the Present*, ed. Vicki Goldberg (New York: Simon and Schuster, 1981), pp. 480–91, esp. 483.

Umberto Eco, in "Critique of the Image," also specifies that the photograph has no code, but he continues that the photograph is nevertheless to be understood in terms of codes, just as the upside-down retinal image is rectified by other sensuous experiences. Among the codes Eco mentions are those of taste, sensibility, rhetoric, and style. One deduces codes from the photographic depiction and also furnishes them from experience.

7. William Henry Fox Talbot, *The Pencil of Nature* (London: Longman, Brown, Green and Longmans, 1844). Talbot invented the negative-positive technique of making photographs.

8. Cavell, "What Photography Calls Thinking," pp. 3–4.

9. Barthes, *Camera Lucida*, pp. 88–89. For a review of *Camera Lucida* that situates it and Barthes within a philosophical framework and describes the affiliations of some of the critics, see "The Heresy of Sentiment," *Afterimage* 9 (November 1981): 6–7.

10. Tagg, *Burden of Representation*, p. 3.

11. Barthes, *Camera Lucida*, p. 9.

12. Tagg, *Burden of Representation*, pp. 4–5. The quotations in the following two paragraphs are from this source.

13. Ibid., chap. 5, "God's Sanitary Law: Slum Clearance and Photography," esp. p. 146.

14. Victor Burgin, "Photographic Practice and Art Theory," in *Thinking Photography*, ed. Burgin (London: Macmillan Education, 1988), p. 75.

15. David Lodge, *Nice Work* (New York: Penguin Books, 1990), pp. 154, 157.

16. Erving Goffman, "Picture Frames," in *Gender Advertisements* (New York: Harper Colophon, 1979), p. 13.

17. Ibid., pp. 46–47.

18. Sontag, *On Photography*, p. 105.

19. The position is more explicit in Walter Benjamin, "The Author as Producer" (1934), in *Reflections*, trans. Edmund Jephcott, ed. Peter Demetz (New York: Harcourt Brace Jovanovich, 1979), p. 230; and Benjamin, "The Author as Producer," trans. Anna Bostock, in *Thinking Photography*, ed. Burgin, p. 24. See also Sontag, *On Photography*, p. 9.

20. Sontag, *On Photography*, pp. 11–12.

21. Ibid., pp. 19–21. For an earlier generation, *Foxe's Martyrs* gave similarly shocking illustration of man's inhumanity to man. William M. Ivins, Jr., was thus impressed at the age of ten. Ivins, *Prints and Visual Communication* (1953; rpt. Cambridge, Mass.: MIT Press, 1978), p. 18.

22. Sontag, *On Photography*, p. 24.

23. Rosalind Krauss, "A Note on Photography and the Simulacral," *October* 31 (Winter 1984): 49–68, esp. 63.

24. Ibid., pp. 59–68. Krauss contrasts the photographs by Cindy Sherman with certain photographs by Irving Penn to Sherman's advantage. Sherman openly professes copying; the concept of imitation is her subject. Penn has arranged and photographed still lifes using emblems of the vanity and transience of human life—skulls, for example. In doing so, and in making platinum prints with fine detail, he sets up a rivalry with the unique arts of painting and drawing. But far from being worthy to set beside examples of these arts, the Penn still lifes remind Krauss only of the double-page spread advertising format, in which, as she points out, Penn excels. The finer his print, the more it suggests to Krauss "art debauched by commerce." Another reason for not liking the Penn still lifes, if one does not, is precisely because those photographs attempt what painting does better, and did first, that is, to use objects as emblems. Copies of arranged realities are easy to see through and hard to take seriously. Penn's still lifes of emblematic objects are not copies but imitations. A photographic copy of a painting is a reproduction. Penn's still lifes are arranged objects that demand an ancestral lineage

within the realm of painting, an idea unfortunate in its conception and artificial in its connection to a painted still life.

25. Ibid., pp. 62, 52.

Chapter 2

1. Rudolf Wittkower and Margaret Wittkower, *Born Under Saturn* (1963; rpt. New York: Norton, 1969), pp. 4–5. "The social position of the artist in the Greek city-state [reflects] disdain for the work of painters and sculptors because it is manual labor." Ernst Kris and Otto Kurtz, *Legend, Myth, and Magic in the Image of the Artist*, trans. 1934 by Alistair Lang, rev. by Lottie M. Newman (New Haven: Yale University Press, 1979), p. 39.

2. Edgar Wind, *Art and Anarchy*, Reith Lectures, 1960, revised and enlarged (New York: Vintage Books, Random House, 1969), pp. 69, 82.

3. Walter Benjamin, "The Work of Art in the Age of Mechanical Reproduction" (1936), in *Illuminations*, trans. Harry Zohn, ed. Hannah Arendt (New York: Schocken Books, 1973), pp. 217–51; partially reprinted in *Photography in Print: Writings from 1816 to the Present*, ed. Vicki Goldberg (New York: Simon and Schuster, 1981), pp. 319–34.

4. Nelson Goodman, *Languages of Art: An Approach to a Theory of Symbols* (Indianapolis: Bobbs-Merrill, 1968), chap. 3, "Art and Authenticity," pp. 99–123.

5. Paul Rosenfeld, *Port of New York* (Urbana: University of Illinois Press, 1961), p. 244.

6. George Bernard Shaw, "On the London Exhibitions" (1901), in *Photography in Print*, ed. Goldberg, p. 223.

7. John Russell, *The Meaning of Modern Art* (New York: Museum of Modern Art and Harper & Row, 1981), p. 365.

8. László Moholy-Nagy, "From Pigment to Light" (1936), in *Photography in Print*, ed. Goldberg, p. 341.

9. Ibid., pp. 342–43.

10. John Ruskin, *Modern Painters*, 5 vols., 1843–1860 (London: Smith, Elder, 1860–1868) 4:63.

11. Goodman explains that his use of the term *languages* in the title should, strictly, be replaced by *symbol systems* (*Languages of Art*, p. xii). The troubling question is whether photography is a symbol system at all. In his section on imitation (I, 2), Goodman says, "An aspect is not just the object-from-a-given-distance-and-angle-and-in-a-given-light; it is the object as we look upon or conceive it, a version or construal of the object. In representing an object, we do not copy such a construal or interpretation—we *achieve* it. And this is no less true when the instrument we use is a camera rather than a pen or brush. The choice

and handling of the instrument participate in the construal. A photographer's work, like a painter's, can evince a personal style" (p. 9 n.).

12. Charles Baudelaire, "The Salon of 1859," in *Baudelaire: Art in Paris, 1845–1862*, ed. Jonathan Mayne (London: Phaidon, 1970), p. 152. Baudelaire is intensely doubtful about the changes produced by the industrial revolution: "Each day the painter becomes more and more given to painting not what he dreams but what he sees. . . . Could you find an honest observer to declare that the invasion of photography and the great industrial madness of our times have no part at all in this deplorable result?" (p. 155). Erich Auerbach describes this aspect of Baudelaire: "The poet of *Les Fleurs du mal* hated the reality of the time in which he lived; he despised its trends, progress and prosperity, freedom and equality; he recoiled from its pleasures; he hated the living, surging forces of nature." Auerbach, "The Aesthetic Dignity of the *Fleurs du mal*," in *Baudelaire, A Collection of Critical Essays*, ed. Henri Peyre (Englewood Cliffs, N.J.: Prentice-Hall, 1962), p. 165.

13. Roger Shattuck, *The Banquet Years* (New York: Vintage Books, 1967), p. 320.

14. Nadar, "My Life as a Photographer," trans. Thomas Repensek, *October* 5 (Summer 1978): 8.

15. According to Bernice Rose, Sol LeWitt (b. 1928) employs draftsmen and supplies instructions for execution of his work. "As long as he is the control, he does not care whether or not he is the direct agent in the sense that his hand is involved." She suggests that this is treating drawing as pure ratiocination and compares LeWitt's drawings to the *sinopie* of the Italian fresco paintings, the underdrawings sketched in wet plaster by the master and executed in paint by him or others. Rose, *Drawing Now* (New York: Museum of Modern Art, 1976), p. 76.

16. Eadweard Muybridge, *Animals in Motion*, ed. Lewis S. Brown (New York: Dover, 1957), p. 30 and illustration 2.

17. *Peter Milton: Complete Etchings, 1960–1976*, ed. Kneeland McNulty (Boston: Impressions Workshop, 1977), p. 115. *Daylilies* is illustrated p. 112 and discussed by Milton pp. 113–17.

Chapter 3

1. Roy Strong, "D. O. Hill and the Academic Tradition," in *An Early Victorian Album*, ed. Colin Ford (New York: Knopf, 1976), pp. 49–64, esp. 54.

2. Walter Benjamin, "A Short History of Photography" ["Kleine Geschichte der Photographie," 1931], trans. Stanley Mitchell, *Screen* 13 (1972), reprinted in *Classic Essays on Photography*, ed. Alan Trachtenberg (New Haven: Leete's Island Books, 1980), pp. 199–216.

3. Walter Benjamin, "The Work of Art in the Age of Mechanical Reproduction" ["Das Kunstwerk im Zeitalter seiner technischen Reproduzierbarkeit," 1936], in *Illuminations*, trans. Harry Zohn, ed. Hannah Arendt (New York: Schocken Books, 1973), pp. 217–51; partially reprinted in *Photography in Print: Writings from 1816 to the Present*, ed. Vicki Goldberg (New York: Simon and Schuster, 1981), pp. 319–34.

4. Benjamin's note reads: "Helmuth Th. Bossert and Heinrich Guttmann, *Aus der Frühzeit der Photographie, 1840–70. Ein Bildbuch nach 200 Originalen*. Frankfurt, 1930. Heinrich Schwarz, *David Octavius Hill. Der Meister der Photographie. Mit 80 Bildtafeln*. Leipzig, 1931." [*David Octavius Hill: Master of Photography*, with 80 reproductions made from original photographs and printed in Germany, is the English translation of Schwarz by Helen E. Fraenkel (London: George C. Harrap & Co., 1932). The first volume will be referred to as Bossert; the second, as Schwarz, specifically the English translation.]

5. Bossert, Plates 34 and 123.

6. Rosalind Krauss, "Tracing Nadar," *October* 5 (Summer 1978): 30.

7. Nigel Gosling, *Nadar* (New York: Knopf, 1976), pp. 29, 39.

8. Benjamin, "Short History," in *Classic Essays*, ed. Trachtenberg, p. 201.

9. Ibid., p. 200. For the political, economic, psychological, and cultural implications of Benjamin's work, see Terry Eagleton, *Walter Benjamin, or Towards a Revolutionary Criticism* (London: Verso Editions and NLB, 1981), esp. pp. 27–78; W. J. T. Mitchell, *Iconology: Image, Text, Ideology* (Chicago: University of Chicago Press, 1987), pp. 180–81. For Benjamin's relation to the work of Theodor Adorno, see Martin Jay, *Adorno* (Cambridge, Mass.: Harvard University Press, 1984), esp. pp. 74–77 on experience, memory, tradition, and language and pp. 123–24 on aura.

10. Helmut Gernsheim and Alison Gernsheim, *A Concise History of Photography* (London: Thames and Hudson, 1971), pp. 116–17.

11. Benjamin, "Short History," in *Classic Essays*, ed. Trachtenberg, p. 202. Ruth Hein (see n. 21) suggests that "relaxed and seductive shame" would be better translated as "an indolent, seductive modesty." The photograph is published under either of two titles: *Elizabeth Johnstone of Newhaven* or *Mrs. Elizabeth Hall of Newhaven*.

12. Schwarz, *David Octavius Hill*, p. 39.

13. Ibid. The equipment Hill (in fact, Adamson) used, according to Schwarz (p. 35), was "a short-focus, achromatic, landscape lens," not "the large-aperture portrait lens invented in May 1840 by Professor Josef Max Petzval."

14. Benjamin, "Short History," in *Classic Essays*, ed. Trachtenberg, p. 207.

15. Ibid., p. 206.

16. Ibid., p. 207.

17. George Bernard Shaw, "On the London Exhibition" (1901), in *Photography in Print*, ed. Goldberg, p. 223.

18. Santayana said in an address to the Harvard Camera Club that just as the photograph is produced by a machine, so "images of fancy and memory are produced by a machine," the brain ("The Photograph and the Mental Image," in *Photography in Print*, ed. Goldberg, p. 263). Claude Lévi-Strauss (*Tristes Tropiques*, trans. John Weightman and Doreen Weightman [1955; rpt. New York: Viking Penguin, 1992], p. 63) gives the definitive modification to that notion of the revival of experience as if it were intact when he says that "remembering is one of man's great pleasures, but not in so far as memory operates literally. . . . Memory is life itself but of a different quality." Stories of hardship and danger give pleasure to teller and listener when there was no pleasure in the actual dangers or the actual hardships. The brain as a camera, or brain and camera as machines, survive as uneasy metaphors. Even calling the camera a machine eliminates from the vocabulary appropriate to mechanics the equally appropriate inclusion of optics and chemistry. The brain as a machine has survived primarily in a reverse query, namely, whether there is ever going to be a machine invented that can equal the operations of the brain.

19. George Santayana, "The Photograph and the Mental Image," in *Animal Faith and Spiritual Life*, ed. John Lachs (New York: Appleton-Century-Crofts, 1967), pp. 395, 397, 399, 400, 396, reprinted in *Photography in Print*, ed. Goldberg, pp. 258–66.

20. Benjamin, "Short History," in *Classic Essays*, ed. Trachtenberg, p. 209.

21. Ibid., passages on Atget, pp. 208–9; I am indebted to Ruth Hein, a professional translator from German, for help throughout this chapter with Benjamin's original German texts.

22. Walter Benjamin, *Reflections*, trans. Edmund Jephcott, ed. Peter Demetz (New York: Harcourt Brace Jovanovich, 1979), p. xxxv.

23. Benjamin, "Short History," in *Classic Essays*, ed. Trachtenberg, p. 210.

24. Benjamin, "Surrealism," in *Reflections*, ed. Demetz, p. 183.

25. Man Ray refers to his "assistant Boiffard" in *Self Portrait*, (Boston: Little, Brown, 1963), pp. 270, 281.

26. Roland Penrose, *Man Ray* (Boston: New York Graphic Society, 1975), p. 69. Man Ray conveys his ability to distance himself from immediate controversy as well as to be amused by it in a typical passage from his *Self Portrait*, pp. 215–16: "I invited him [Matisse] to come to my studio for a new portrait. . . . As I finished the sitting, André Breton, founder of the Surrealist movement, appeared. I knew that Matisse was not in high favor with the Surrealists—after his first iconoclastic works he had degenerated, they thought, painted to please people and counted on his reputation to obtain high prices for his work. . . . An interesting dialogue followed in which Matisse assumed a didactic attitude defining what good painting meant to him. Among other remarks he declared that a hand should have some anatomical quality in a painting, not look like a bunch of bananas. Breton did not agree with him and did not contradict him, who gave

the impression that he was talking like a schoolteacher. *I saw that the men could not even come to grips with one another, as if they were conversing in two different languages. For my part, I smiled inwardly*—if any painter had painted hands as if they were bananas, it certainly was Matisse. And toes also. This had been one of his first breaches with the academy. Was the man trying to hoodwink us?" (emphasis added). Breton didn't contradict Matisse. Man Ray smiled inwardly. The scene illustrates Man Ray's grasp of personalities at the same time that he kept his head and judgment clear of flattery or subservience to either fame (Matisse's) or friendship (Breton's). There was always some sense in which Man Ray played Connecticut Yankee at King Arthur's court or the man from Missouri who has to be shown.

27. J. H. Matthews, *André Breton* (New York: Columbia University Press, 1967), p. 10; André Breton, *Nadja*, trans. Richard Howard (New York: Grove Press, 1960), p. 12.

28. Breton, *Nadja*, pp. 151–52.

29. Wendy Steiner, *The Colors of Rhetoric* (Chicago: University of Chicago Press, 1982), p. 146.

30. Sander conceived a panoramic view of society which he called "Man of the Twentieth Century." The first photographs in the project, meant to be completed in several books, were published as *Face of Our Time* (Munich: Kurt Wolff/Transmare, 1929). *Men Without Masks* from the project was published by the New York Graphic Society in Greenwich, Connecticut, in 1973. *Aperture* published a special issue devoted to Sander, Nos. 83–84 (1980), preface by Beaumont Newhall, pp. 6–9; historical commentary by Robert Kramer, pp. 11–38.

31. Kramer, *Aperture*, Nos. 83–84, pp. 11–13.

32. A brilliant novel by Richard Powers called *Three Farmers on Their Way to a Dance* (New York: Beech Tree Books, William Morrow, 1985) takes off from Sander's photograph of that name and invents circumstances, a history, and a future to incorporate it. Two other books of fiction specifically deal with photography. *Picture Palace* by Paul Theroux (Boston: Houghton Mifflin, 1978) is an account of a professional woman photographer whose body of work gradually directs attention to her personal failures in life. *A Family Album* by David Galloway (New York: Harcourt Brace Jovanovich, 1978) uses album snapshots to discover and invent lives to match.

33. Gernsheim and Gernsheim, *Concise History of Photography*, p. 207.

34. Kramer, *Aperture*, Nos. 83–84, p. 13.

35. See notes 2 and 4. Benjamin's bibliography in "Short History," in *Classic Essays*, ed. Trachtenberg, p. 215; Blossfeldt quotations ibid., p. 203.

36. Page references hereafter given in the text are to the complete essay in Benjamin, *Illuminations*.

37. Walter Benjamin, "Moscow Diary," trans. Richard Sieburth, ed. Gary Smith, *October* 35 (Winter 1985): 106 n. 163.

Chapter 4

1. Walter Benjamin, "The Work of Art in the Age of Mechanical Reproduction," in *Illuminations*, trans. Harry Zohn, ed. Hannah Arendt (New York: Schocken Books, 1973), p. 226.

2. Michel Foucault, *This Is Not a Pipe*, trans. and ed. James Harkness (Berkeley: University of California Press, 1982), p. 20.

3. Michael Brenson, *New York Times*, Arts Section, January 3, 1988.

4. Janet Malcolm, *Diana and Nikon: Essays on the Aesthetic of Photography* (Boston: David R. Godine, 1980), pp. 101, 102.

5. Brenson, *New York Times*, Arts Section, January 3, 1988.

6. "But as has been pointed out about Weston's 'originals,' these are already taken from models provided by others; they are given in that long series of Greek kouroi by which the nude male torso has long ago been processed and multiplied within our culture." Rosalind Krauss, "The Originality of the Avant-Garde," in *The Originality of the Avant-Garde and Other Modernist Myths* (Cambridge, Mass.: MIT Press, 1985), p. 168, with note citing Douglas Crimp, "The Photographic Activity of Postmodernism," *October* 15 (Winter 1980): 98–99. See Gisela M. A. Richter, *A Handbook of Greek Art* (New York: Phaidon, 1965), illustrations 191, *Hermes with the Infant Dionysos, by Praxiteles, c. 350–330 B.C., Olympia, Museum*; 194, *Bronze statue of a boy, from the Bay of Marathon, c. 340–300 B.C., Athens, National Museum*; 210, *The Apollo of Belvedere, c. 350– 320 B.C., Roman copy. Vatican, Museum*.

7. *Edward Weston: Seventy Photographs*, Biography by Ben Maddow (Boston: Aperture, New York Graphic Society, 1978), p. 42.

8. "The decisive moment" of Henri Cartier-Bresson is possibly the same, although Cartier-Bresson seems to restrict the definition to intuitive principles that inform his own peculiar genius of recognition.

Chapter 5

1. Oscar Rejlander, "An Apology for Art-Photography" (1863), in *Photography in Print*, ed. Vicki Goldberg (New York: Simon and Schuster, 1981), pp. 145–46, 144–45. *The Two Ways of Life* is illustrated in Peter Pollack, *The Picture History of Photography* (London: Thames and Hudson, 1963), pp. 176–77.

2. Walter Benjamin, "A Short History of Photography" ["Kleine Geschichte der Photographie," 1931], trans. Stanley Mitchell, *Screen* 13 (1972), reprinted in *Classic Essays on Photography*, ed. Alan Trachtenberg (New Haven: Leete's Island Books, 1980), p. 204.

3. David Bunce, *Sun Pictures: The Hill-Adamson Calotypes* (Greenwich, Conn.: New York Graphic Society, 1973), p. 22. In fact, painters often require their models to pose for long periods. Pierre Schneider (*Matisse*, trans. Michael

Taylor and Bridget Strevens Romer [New York: Rizzoli, 1984], p. 324) quotes Matisse describing a scene in which Madame Matisse was posing as a guitar player in a position awkward to hold. Eventually cramped and still not allowed to move, she began to pluck the strings and continued to do so even after admonishment. The sound increasingly irritated the absorbed painter. Finally he got so mad he kicked his easel down and made a mess of canvas and oil. Madame Matisse instantly threw her guitar on the pile of debris and they both burst out laughing. The long time of posing is satirized in Virginia Woolf's play *Freshwater*, ed. Lucio P. Ruotolo (New York: Harcourt Brace Jovanovich, 1976), p. 10:

> Ellen Terry [posing for Modesty at the feet of Mammon which G. F. Watts is painting]: "Oh, Signor, can't I get down? I am so stiff."
> Watts: "Stiff, Ellen? Why you've only kept that pose for four hours this morning."

Woolf's comedy punctures more than one pose of her Victorian forebears, including her great-aunt Julia Margaret Cameron (a part taken by Vanessa Bell). Benjamin has imposed his view of the Hill-Adamson pictures on us by his powers of description and his expression of an intuitive grasp of the power certain photographs have and has prevented our recognizing that certain modern photographs have the same power even though their transcription was instantaneous.

4. Walter Benjamin, "On Some Motifs in Baudelaire," in *Illuminations*, trans. Harry Zohn, ed. Hannah Arendt (New York: Schocken Books, 1973), p. 186.

5. Benjamin, "Short History," in *Classic Essays*, ed. Trachtenberg, p. 202. Helmuth Th. Bossert and Heinrich Guttmann, *Aus der Frühzeit der Photographie 1840–70. Ein Bildbuch nach 200 Originalen* (Frankfurt: Societäts-verlag, 1930), illustration (Karl Dauthendey, 1819–96) no. 128. The caption reads: "The photographer Karl Dauthendey with his betrothed after their first attendance at church," not quite the bridal commemoration Benjamin took it to be but the only picture in the volume that fits his description.

6. Roland Barthes, *Camera Lucida: Reflections on Photography*, trans. Richard Howard (New York: Hill and Wang, 1981), pp. 95–96.

7. Helmut Gernsheim, *Julia Margaret Cameron: Her Life and Photographic Work* (Millerton, N.Y.: Aperture, 1975), p. 191, note on Mary Hillier.

8. Mike Weaver, *Julia Margaret Cameron, 1815–1879* (London: Herbert Press, for John Hansard Gallery, The University, Southampton, 1984), p. 31.

9. Ibid., p. 96.

10. A. Bredius, *Rembrandt: The Complete Edition of the Paintings*, rev. H. Gerson (London: Phaidon Press, 1969), reproduced p. 517.

11. Svetlana Alpers, *The Art of Describing: Dutch Art in the Seventeenth Century* (Chicago: University of Chicago Press, 1983), p. 212.

12. Bredius, *Rembrandt, The Man with the Golden Helmet*, p. 115. Svetlana

Alpers points out that even if this painting can be attributed only to the Rembrandt studio, rather than principally to the artist himself, *The Man with the Golden Helmet* is an "essential or canonical Rembrandt." Alpers, *Rembrandt's Enterprise* (Chicago: University of Chicago Press, 1990), p. 122.

13. Weaver, *Julia Margaret Cameron*, pp. 96, 97.

14. Carol Armstrong, "Reflections on the Mirror: Painting, Photography, and the Self-Portraits of Edgar Degas," *Representations* 22 (Spring 1988): 133.

Chapter 6

1. Roland Barthes, *Camera Lucida: Reflections on Photography*, trans. Richard Howard (New York: Hill and Wang, 1981), p. 73.

2. Ibid., p. 34.

3. Reproduced ibid., p. 35.

4. Richard Avedon, *Portraits* (New York: Farrar, Straus and Giroux, 1976), unpaginated. The Eisenhower portrait is on the last page of the introductory essay, "A Meditation on Likeness," by Harold Rosenberg. According to Patricia Bosworth (*Diane Arbus* [New York: Avon Books, 1984], p. 221), Diane Arbus loved Avedon's portrait of Eisenhower "because Ike's expression is like he came out of the womb too soon."

5. *Many Are Called*, photographs by Walker Evans, two-page introduction by James Agee (Boston: Houghton Mifflin, 1966).

6. *Karsh Portfolio*, photographs by Yousuf Karsh (Toronto: University of Toronto Press, 1967), p. 10.

7. *Diane Arbus* (Millerton, N.Y.: Aperture, 1972), p. 3. All Arbus photographs mentioned are in this monograph unless otherwise specified. Photographs are unpaginated.

8. *Jacques-Henri Lartigue*, Aperture History of Photography Series (Millerton, N.Y.: Aperture, 1976), p. 19. The picture of the four children (*My cousin, Bouboutte; Loulou, Bob and Zissou*) is also in *Diary of a Century*, text and photographs by Lartigue (Harmondsworth, Middlesex: Penguin Books, 1978), unpaginated.

9. *The Photographs of Jacques-Henri Lartigue* (New York: Museum of Modern Art Bulletin 30, No. 1, 1963): cover photograph. Lartigue's most memorable photographs are joyful and often witty. He does not offer a view of Paris and Parisians that can be related to Proust's Paris, though they are sometimes incongruously yoked. Proust offers a description of women strolling in the Avenue of Acacias comparable to Lartigue's visual observations, but Proust's shaping of his account of the avenue discloses an attitude far from Lartigue's. Lartigue should never be used as if he were illustrating Proust, no matter that the literal setting was the same. Proust vivifies the setting; Lartigue obliterates it except as a hazy background for a woman who stands out like "a golden pheasant when

it's surrounded by chickens." For all we can tell from Lartigue's backgrounds, the avenue might as well be the race course at Nice. Novelist and photographer both have intense feeling for scenes of display by women of fashion, but Proust incorporated delight in the natural world with the sensuous appeal of beautiful women: "Long before I reached the acacia-alley, their fragrance which, radiating all around, made one aware of the approach and the singularity of a vegetable personality at once powerful and soft, then, as I drew near, the glimpsed summit of their lightly tossing foliage, in its easy grace, its coquettish outline, its delicate fabric, on which hundreds of flowers had swooped, like winged and throbbing colonies of precious insects, and finally their name itself, feminine, indolent, dulcet, made my heart beat" (Marcel Proust, *Remembrance of Things Past*, 3 vols., trans. C. K. Scott Moncrieff and Terence Kilmartin [New York: Vintage Books, Random House, 1982], 1: 452). The trees are described in terms of the women. The women whose appearance Marcel holds dear in memory, moreover, live at an earlier time than those Lartigue photographed. Marcel looks with nostalgic reference to the earlier, purer, simpler style, in this way: "All the hats now were immense, covered with all manner of fruits and flowers and birds. . . . But how could the people who watch these dreadful creatures hobble by beneath hats on which have been heaped the spoils of aviary or kitchen-garden, how could they even imagine the charm that there was in the sight of Mme Swann in a simple mauve bonnet or a little hat with a single iris sticking up out of it?" (1: 460–61). Lartigue photographs these women in their immense hats with charming amusement. Proust, born 24 years before Lartigue, condemns the women in immense hats as a late vulgar flowering in contrast to the "Graeco-Saxon tunics, pleated à la Tanagra, or sometimes in the Directoire style" in which Mme Swann "walked like a queen" (1: 460). Proust's vision of the Avenue of Acacias has the quality of dream or of brilliant images seen in a darkened room. Lartigue has not only the freshness of youth but of outdoors, of sunshine. Lartigue was seventeen in 1912, when many of his most affectionate photographs of women in the Bois de Boulogne were taken.

10. *The Photographs of Jacques-Henri Lartigue*, unpaginated. Photographs can be identified only by title.

11. Avedon's statement is quoted in Ed Barber, "Some Approaches to Portraiture," *Camerawork* (London: Half Moon Photography Workshop, 1979). Rosenberg is quoted in Avedon, *Portraits*.

Chapter 7

1. William M. Ivins, Jr., *Prints and Visual Communication* (1953; rpt. Cambridge, Mass.: MIT Press, 1978), pp. 128–29. The only reference to exactly repeatable visual statements comparable to Ivins's own witty statements is by Robert Musil in his novel *The Man Without Qualities* (for complete bibliograph-

ical note see Chapter 8 note 8): "But logic presupposes the existence of experiences that can be repeated. It is clear that wherever events followed upon each other as in a vortex where nothing ever returns we could never formulate the profound discovery that A equals A or that the greater is not the lesser. . . . This quality of repeatability, which is inherent in morality and intellect, is also inherent, and to the highest degree, in money" (2: 251). Of course the surprise ending is comic, and Musil goes on to speak of money as symbolic. The point here is that paper money is an exactly repeatable visual statement, although its function is not visual except for determination of authenticity by bank tellers or forgers. Its tools are the tools of engraving. Some paper money (in a barroom or restaurant, the first dollar earned) is framed, yet money is not to look at, or teach us how to see, or convey an idea. Indeed, it is repeatable far beyond the resources of the simple photograph, which compared to paper money is fragility itself.

2. Ivins, *Prints and Visual Communication*, p. 59.

3. Ben Lifson, "Gary Winogrand's American Comedy," *Aperture*, No. 86 (1982): 34.

4. Ivins, *Prints and Visual Communication*, p. 134.

5. Ludwig Wittgenstein, *Philosophical Investigations*, trans. G. E. M. Auscombe (New York: Macmillan, 1968), I, para. 494.

6. Text by Attilio Colombo adapted by Carole Naggar, trans. Lydia Davis, in *Fantastic Photographs*, works by international photographers selected by Lorenzo Merlo and Claude Nori (New York: Pantheon Books, 1979), unpaginated.

7. John Berger, *Ways of Seeing* (Harmondsworth, Middlesex, and London: Penguin Books and British Broadcasting Corporation, 1972), p. 30.

8. Ibid., p. 31.

9. Lucretius, *On the Nature of the Universe*, trans. Ronald Latham (Baltimore: Penguin Books, 1965), pp. 153, 134–35.

10. Nadar, "My Life as a Photographer," trans. Thomas Repensek, *October* 5 (Summer 1978): 9. Balzac discourses on his belief in emanations as source of the daguerreotype in *Cousin Pons*, trans. Norman Cameron (London: Hamish Hamilton, 1950), pp. 147–48, 150.

11. Oliver Wendell Holmes, "The Stereoscope and the Stereograph" (1859), in *Photography in Print: Writings from 1816 to the Present*, ed. Vicki Goldberg (New York: Simon and Schuster, 1981), p. 112; in *Classic Essays on Photography*, ed. Alan Trachtenberg (New Haven: Leete's Island Books, 1980), p. 81.

12. Roland Barthes, *Camera Lucida: Reflections on Photography*, trans. Richard Howard (New York: Hill and Wang, 1981), p. 9.

13. Walter Benjamin, "On Some Motifs in Baudelaire," in *Illuminations*, trans. Harry Zohn, ed. Hannah Arendt (New York: Schocken Books, 1973), p. 188.

14. Ibid., p. 187.

15. Ibid., p. 188. Benjamin is quoting Proust.

16. Ibid., p. 200, n. 17.

17. Ibid., pp. 188–89. Benjamin is quoting Valéry.

18. Ibid., p. 187.

19. Beaumont Newhall, *History of Photography* (1964; rpt. London: Secker and Warburg, 1972), reproduction and quotation from Evans, p. 110. Stone staircases in some schools have similar wavy curves made by generations of students. Their aura is different.

20. Benjamin, "On Some Motifs in Baudelaire," p. 189.

21. Ibid., p. 188. 22. Ibid., p. 187.

23. Ibid., p. 194. 24. Ibid., p. 158.

25. Ibid., p. 175.

26. Roland Barthes refers to "that rather terrible thing which is there in every photograph: the return of the dead" (*Camera Lucida*, p. 9).

Chapter 8

1. Marcel Proust, *Remembrance of Things Past*, 3 vols., trans. C. K. Scott Moncrieff and Terence Kilmartin (New York: Vintage Books, Random House, 1982), 1: 936. Further references to this edition are given parenthetically in the text.

2. Cf. Henri Matisse's statement, "Photography can rid us of previous imaginations," from his "Statement to Tériade," reprinted in Jack D. Flam, *Matisse on Art* (New York: E. P. Dutton, 1978), Text 10. Siegfried Kracauer also comments on Proust's passage: "Photography, Proust has it, is the product of complete alienation." Kracauer goes on to say that "the onesidedness of this definition is obvious. . . . Even Proust's alienated photographer spontaneously structures the inflowing impressions . . . to organize the visual raw material in the act of seeing," in "Photography," in *Classic Essays on Photography*, ed. Alan Trachtenberg (New Haven: Leete's Island Books, 1980), pp. 258–59, from *Theory of Film: The Redemption of Physical Reality* (New York: Oxford University Press, 1960). Is a witness alienated from the scene witnessed? Is a stranger alienated from that to which he bears witness as a stranger? Separate, disengaged, uninvolved, without prejudice, rather. Alienation is tainted with hostility, and that is not what Proust is suggesting. Kracauer's argument that a photograph is spontaneously structured by the brain and eye in its very inception, and a little further on that if it is not so directly spontaneously structured but, like an aerial photograph taken by a camera with preset functions, seems entirely a result of automation, in which case "it falls to the spectator to do the structuring," is not so much faulty as partial. The automatic camera functions in ways determined by the presetting but also by the course of the pilot over terrain, both the result of human thought and foresight. The resultant photographs, like all photographs, are in addition structured by the one who looks at the photographs to determine

their use. Kracauer says the unidentifiable shapes in such aerial photographs "cause the spectator to withdraw into the aesthetic dimension." Such a spectator would not be the persons or institution for whom aerial photographs are made; aerial photographs reproduced outside the context of their use would by this very fact carry a bias toward aesthetic interpretation. Still, Kracauer's conclusion, that the photographer mixes "realist loyalties and formative endeavors," is one with which I am entirely in agreement.

3. Roland Barthes, *Camera Lucida: Reflections on Photography*, trans. Richard Howard (New York: Hill and Wang, 1981), pp. 70–71.

4. Robert Lowell, "Epilogue," in *Day by Day* (New York: Farrar, Straus and Giroux, 1977), p. 127.

5. Barthes, *Camera Lucida*, pp. 66–67.

6. "Mirror with a memory" is the evocative and memorable description of the photograph used by Oliver Wendell Holmes. *Mirrors and Windows: American Photography Since 1960* is the title of John Szarkowski's essay and catalog of photographs published by the Museum of Modern Art, New York, 1978. The distinction is between photographs that are "a means of self-expression" (mirrors) and those that are "a method of exploration" (windows) (p. 11). James Merrill, in an early poem, "Mirror," uses the mirror with a Magritte-like complication of images—layer upon layer of reflection, one might say, as the mirror engages with the window. John Hollander, who called the poem to my attention, has written about it in "A Poetry of Restitution," *Yale Review* 70 (Winter 1981): 161–86.

7. *The Letters of John Keats, 1814–1821*, ed. Hyder Edward Rollins, 2 vols. (Cambridge, Mass.: Harvard University Press, 1958), 1: 193–94.

8. Robert Musil, *The Man Without Qualities*, 3 vols., trans. Eithne Wilkins and Ernst Kaiser (London: Picador, Pan Books, 1982), 2: 436. Originally Vol. 1 was published in 1930, Vol. 2 in 1932, and Vol. 3 posthumously (after 1942) and privately. The fourth volume, the remaining unfinished material, has not so far appeared in English. Further references to these volumes are given parenthetically in the text.

9. I have appropriated Musil's "strange confined space" as the title of this book for its evocation of frame and shadow and for its defamiliarization, that phenomenon comparable to the stripping of aura from reality.

Chapter 9

1. Frank Brady, "Fact and Factuality in Literature," in *Directions in Literary Criticism*, ed. Stanley Weintraub and Philip Young (University Park: Pennsylvania State University Press, 1973), pp. 93–111.

2. Martin Price, "The Irrelevant Detail and the Emergence of Form," in *Literary Criticism: Idea and Fact*, ed. W. K. Wimsatt (Berkeley: University of California Press, 1974), p. 526.

3. See Joel Snyder and Neil Walsh Allen, "Photography, Vision, and Representation," pp. 90, 89; and Carl Chiarenza, "Notes Toward an Integrated History of Picturemaking," pp. 209–36, in *Reading into Photography: Selected Essays, 1959–1980*, ed. Thomas F. Barrow, Shelley Armitage, and William E. Tydeman (Albuquerque: University of New Mexico Press, 1982). A. D. Coleman ("The Directorial Mode," in *Photography in Print: Writings from 1816 to the Present*, ed. Vicki Goldberg [New York: Simon and Schuster, 1981], pp. 480–91) also emphasizes how the camera sees ("photography institutionalizes Renaissance perspective") following Joel Snyder's discrimination between some ideal or other way of seeing and the one-point perspective of the camera lens. Only stereopticon pairs created a once convincing illusion of space, which now is an illusion feebly achieved and hardly sustained because our eyes, taught by the camera, require more thorough and sophisticated illusions like the moving pictures of film or television screen. The depiction of space, of, not an object, but the positioning of objects in such relation to each other that a physical body imagined moving among them becomes rational, is more difficult in a still photograph (and even in a drawing or painting) than in a narrative medium like film in which one does not imagine space but actually sees people moving about.

Illustration Credits

1. Reproduced by permission of Peter Milton
2. Courtesy of the Board of Trustees of the Victoria and Albert Museum
3. Courtesy of Beinecke Rare Book and Manuscript Library, Yale University; © 1994 C. Herscovici / ARS New York
4. © 1994 ARS, New York / VG Bild-Kunst, Bonn
5. © 1994 ARS, New York / VG Bild-Kunst, Bonn
6. © 1994 ARS, New York / VG Bild-Kunst, Bonn
7. © 1994 ARS, New York / VG Bild-Kunst, Bonn
8. © 1994 ARS, New York / VG Bild-Kunst, Bonn
9. Courtesy of Los Angeles County Museum of Art; purchased with funds provided by the Mr. and Mrs. William Preston Harrison Collection
10. © 1981 Center for Creative Photography, Arizona Board of Regents
11. Courtesy of Alinari / Art Resource, N.Y.
12. © 1981 Center for Creative Photography, Arizona Board of Regents
13. Courtesy of the Royal Photographic Society, Bath
14. Courtesy of Prints and Photographs Division, Library of Congress
15. Courtesy of the Royal Photographic Society, Bath
16. Courtesy of the Royal Photographic Society, Bath
17. Courtesy of Musée du Louvre
18. Courtesy of the Royal Photographic Society, Bath
19. Courtesy of Berlin-Dahlem, Gemäldegalerie
20. © The New Haven Register
21. Courtesy of Museum of Fine Arts, Boston; gift of Mrs. J. D. Cameron Bradley
22. Courtesy of Gernsheim Collection, Harry Ransom Humanities Research Center, the University of Texas at Austin
23. Courtesy of Gernsheim Collection, Harry Ransom Humanities Research Center, the University of Texas at Austin

24. © Estate of Walker Evans
25. © Estate of Walker Evans
26. Courtesy of Woodfin Camp & Associates, Inc., New York
27. Courtesy of Association des Amis de Jacques-Henri Lartigue
28. Courtesy of Association des Amis de Jacques-Henri Lartigue
29. Courtesy of Association des Amis de Jacques-Henri Lartigue
30. Courtesy of the International Museum of Photography at the George Eastman House

Index

In this index an "f" after a number indicates a separate reference on the next page, and an "ff" indicates separate references on the next two pages. A continuous discussion over two or more pages is indicated by a span of page numbers, e.g., "57–59." *Passim* is used for a cluster of references in close but not consecutive sequence.

Adams, Henry, 22
Adamson, Robert, 37–45 *passim*, 96, 177
Adorno, Theodor, 186n9
Agee, James, 121, 123, 132, 173f
Albert, Prince, 90
Alexandre, Maxime, 54
Allen, Neil Walsh, 176
Allen, Woody, 140
Alpers, Svetlana, 101, 104, 190f
Anderson, Marian, 124f
Antonioni, Michelangelo, 74
Aragon, Louis, 54
Arbus, Diane, 28, 72, 118, 124–27, 130, 191n4
Architecture, 68
Arcimboldo, Giuseppe, 83
Armory show (1913), 51
Armstrong, Carol, 114–15
Art (-s), definitions of, 30–31

Atget, Eugène, 5, 46–50, 60, 64
Auerbach, Erich, 185n12
Aura, Benjamin's metaphor of: sacred and secular, 20f, 93, 173–75, 177, 194n19; and authenticity, 23f; of early photographs, 42f; the uses of, 46–50, 61–63, 133f, 141–47, 149, 153, 163, 166, 172; of actor, 65–66; of nudes, 82
Austerlitz, Battle of, 151
Authenticity, 23–25, 63, 95, 175, 193
Avedon, Richard, 28, 76–77, 113–14, 118–19, 124, 132f, 191

Balzac, Honoré, 38–39, 139–40, 193n10
Barthes, Roland, 13, 21, 141, 173, 182n6n9, 194n26; and Tagg, 8–10, 176; on Gardner, 95–96; and photograph of his mother, 117, 156–57, 161–66, 172; on Avedon, 118–21
Baudelaire, Charles, 28, 31, 39, 93, 146f, 185n12
Beatles, the, 73
Bell, Vanessa, 111, 190
Benjamin, Walter, 5, 24, 35f, 83, 111; "The Work of Art in the Age of Mechanical Reproduction," 23, 37–38, 61–62, 65; "A Short History of Photography," 37–43, 46, 53, 55, 60–65 *passim*; and Santayana, 43–46; on

Library of Congress Cataloging-in Publication Data

Price, Mary, 1915–
The photograph—a strange confined space /
Mary Price.
p. cm.
Includes bibliographical references and index.
ISBN 0-8047-2308-7 (alk. paper):
1. Photographic criticism. I. Title.
TR187.P75 1994
770'.1—dc20
93-31698
CIP

⊗ This book is printed on acid-free paper.